W9-CCD-045

DIGITAL
FAMILY ALBUM™
Basics

DIGITAL FAMILY ALBUM™
Basics

Tools for Creating Digital Memories

Janine Warner
Tom *and* Mindy McCain

Watson-Guptill Publications/New York

I dedicate this book to the tradition of family storytelling and to all who appreciate the power of shared memories. I hope the lessons and designs in the *Digital Family Album* books will inspire you to share your pictures, stories, and dreams. And may you always be surrounded by those you love.

About the Author

Janine Warner combined her personal experience with family and friends with a 10-year career as a journalist and Internet expert to create the *Digital Family Album* series.

A recognized Internet expert known for making technology fun and accessible, Janine has been a featured guest on radio and television programs, and her articles have appeared in such diverse publications as the *Miami Herald*, *Shape* magazine, and the *Point Reyes Light Newspaper*. Since 1995, Janine has written more than ten books, including the best-selling *Creating Family Web Sites for Dummies* and *Dreamweaver for Dummies*.

Janine is a popular speaker at conferences and events in the United States and abroad. She serves as a judge for a series of Latin American Internet contests (www.arrobadeoro.com) and helped create an Internet literacy program for students in Central America (www.operacionred.com). She has also been a part-time faculty member at the University of Southern California and at the University of Miami.

From 1998 to 2000, Janine worked full-time for the *Miami Herald* as their Online Managing Editor and later as Director of New Media. She also served as Director of Latin American Operations for CNET Networks.

An award-winning former reporter, Janine earned a degree in Journalism and Spanish from the University of Massachusetts, Amherst. She lives with her husband in Los Angeles. To learn more, visit www.jcwarner.com and www.digitalfamily.com.

Copyright © 2006 by Janine Warner

First published in 2006 by Watson-Guptill Publications,
a division of VNU Business Media, Inc.
770 Broadway, New York, NY 10003
www.watsonguptill.com

All rights reserved. No part of this publication may be reproduced or used in any form or by any means—graphic, electronic, or mechanical, including photocopying, recording, taping, or information storage-and-retrieval systems—without written permission from the publisher.

Library of Congress Cataloging-in-Publication Data

Warner, Janine, 1967-
 Digital family album basics : tools for making digital memories / Janine Warner, Tom and Mindy McCain.
 p. cm.
 Includes index.
 ISBN 0-8174-3801-7 (alk. paper)
 1. Photographs—Conservation and restoration—Data processing. 2. Photograph albums—Data processing. 3. Scrapbooks—Data processing. 4. Photography—Digital techniques. I. McCain, Tom. II. McCain, Mindy. III. Title.

 TR465.W37 2005
 006.6'86—dc22

 2005015276

Executive Editor: Victoria Craven
Editor: Michelle Bredeson
Designer: Pooja Bakri
Production Manager: Hector Campbell

Manufactured in China

First printing, 2006

2 3 4 5 6 7 8 9 / 14 13 12 11 10 09 08 07 06

✳ **Acknowledgments** ✳

Let me start by thanking my husband, David LaFontaine, for his patience, love, and delightful sense of humor. I love you more than anyone and I look forward to creating my own family with you. Your intelligence and creativity inspire me and your love brings me such happiness.

It has been delightful to include so many people in my own family in this book, especially my uncle tom (whose preference for lowercase letters is just one of his charming quirks) and his wife, Mindy. Both are professional graphic designers and they created several of the lessons and examples in these pages. My uncle John shared his research into our family ancestry, my father shared his color printer, and my mother wrote some of the exercises.

But it is my sister-in-law Stephanie who deserves credit for inspiring this book and many of the designs in these pages. I can't thank her enough for sharing all of her cards and scrapbooks. Thanks also to my brother Kevin, who has been a solid source of support in my life, and to their three daughters who bring me joy and serve as my favorite models.

Thanks to all four of my fabulous parents, Malinda, Janice, Helen, and Robin. Thanks to my brother Brian and all of my extended family, which now includes David's large and wonderful collection of relatives—Gail, Dave, Linda, Beth, Sarah, and everyone else in the LaFontaine, Roos, and other clans.

Throughout these pages you'll find pictures of my family and friends, as well as the work of some outstanding professional photographers, from my friend Zach Goldberg, whose California-based business specializes in weddings and special events (www.frozenphoto.com), to Mary Bortmas in Michigan whom I discovered after my nieces visited her toy-filled studio (www.unforgettablephotos.org), to my uncle Tom's friend John Maxwell in Indiana, to my friend Ken Riddick, whose SCUBA photos provide the colorful ocean scenes in this book.

Special thanks to all of the beautiful people in these pages. I love looking at your smiles, and your antics bring this book to life. I hope all of you who appear in these designs—from my three adorable nieces, to my friends in Spain, Miami, India, and beyond—appreciate how much you mean to me. Thanks also to the creators of a few featured Web sites: BusyMom.com, TrixieUpdate.com, and the Fleming family blog (at www.rfleming.net).

Thanks to the editorial and design teams at Watson-Guptill, from Victoria Craven, who helped turn this book into a series, to Michelle Bredeson, who reviewed every word and helped create the design, to Pooja Bakri, who deserves credit for the cover and book design and layouts, and finally to my agent, Margot Maley, and her beautiful family.

Over the years, I've thanked many people in my books—friends, teachers, mentors—but I have been graced by so many wonderful people now that no publisher will give me all the pages I'd need to thank them all. So let me conclude by thanking everyone I've ever known so I can go to sleep tonight and know I haven't forgotten anyone. And then let me thank my lucky stars that this book is finally done. Complete. Finished. This is it. (And don't even tell me those aren't complete sentences.)

—Janine Warner

While we both can thank our family and friends for being such wonderful sources of inspiration and encouragement, we mostly want to thank niece Janine for the opportunity to coauthor a book with her. Certainly, this collaboration will be among our favorite memories of moments spent with Janine, on a par with the time when she was five years old and she . . . oh, maybe we should save that story for the next book in the *Digital Family Album* series.

—Tom and Mindy McCain

CONTENTS

The Inspiration for This Book

My sister-in-law Stephanie enjoys creating scrapbooks with photos of her husband and kids, quotes, and other snippets of their active lives. I like to snuggle into their comfortable sofa and flip through the pages when I visit. My nieces love that these special books are filled with people and stories they know.

A couple of years ago, I gave Stephanie a digital camera to help with her scrapbooking (and to get more photos of my nieces), and I was delighted to see how quickly she started taking more pictures. But as she prepared for the birth of their third child, she was too busy to keep up with her photo projects and I realized she could save time (and money) by doing some of her design work on a computer.

That is what inspired me to create the *Digital Family Album* series. Like many families, ours is spread across the country. We rarely see each other except at holidays and other special events, so photos and family stories are especially important to us. After watching piles of old photos collect dust in our closets and waste away on our hard drives, I wanted to do something to help my family stay better connected—and then I realized other families would benefit from the same lessons. That's why I wrote *Digital Family Album Basics:* So you can create your own digital memories, and share them with family and friends, whether you want to send your special projects through snail mail or via the Internet!

I've written many how-to books about Web design over the years, but most of them are for people who are relatively technically savvy. *Digital Family Album Basics* is for everyone. It's for people like my brother and sister-in-law who are more interested in photos than Photoshop, and who don't have time to master new software programs. My goal is to help families like theirs (and yours) create simple, yet elegant, projects you will treasure for years to come.

JANINE WARNER

Introduction:

✱ Create Digital Memories? Yes, You Can! ✱

Family storytelling is nothing new. We've been sitting around the hearth, or dinner table, or living room for generations telling tales. But as so many of us get busy or move farther and farther away from each other, we need new ways to share family lore. I believe computers can help us bridge the physical distances that separate us, and help us keep in touch without taking up too much of our precious time.

That's why I wrote *Digital Family Album Basics*—to help you share your stories with family and friends, whether they live down the street or across the country. My goal is to help you create beautiful digital memory projects, personalized gifts, and a living history for your family.

You'll Find More on Our Web Site

As I wrote *Digital Family Album Basics,* I worked hard to design projects that are elegant and timeless—yet still easy to create—by combining simple instructions with pre-designed templates you can download from our Web site at www.digitalfamily.com. On the Web site, you'll also find loads of other goodies, including photos and artwork you can use in your designs, and links to other Web sites where you can find more help and ideas.

To access all these resources, go to the Web site and follow the links to the Digital Family Album section. There you'll find all the instructions you need to get your secret password and to locate the templates and artwork that go with each exercise in this book.

FIND MORE ONLINE
Look for more great tips, tricks, and templates on our Web site at www.digitalfamily.com.

How This Book Can Help You

Let me assure right away that you don't have to love your computer to love what it can do for you and you don't have to spend lots of time to create the projects in this book. Think of computers and the Internet as tools and this book as your personal instruction manual.

In these pages you'll find lots of basic instructions for using common programs, such as Microsoft Word and Photoshop Elements, to create a wide variety of projects, and you'll find a few advanced tips and tricks to help you polish those skills. If you're anxious to get started on a particular project—say, for example, your wife is going into labor as you read this and you want to get the new baby pictures out right away—jump ahead to Chapter 6 where you'll find everything you need to e-mail photos as soon as the baby is born. (Just make sure you take care of your wife first!)

Digital Family Projects Can Help Those You Love

Your three-year-old loves Fluffy the family cat a little too much and has the scratches to prove it, and your five-year-old is nervous as the first day of kindergarten approaches. You can help both of them by creating special storybooks, cards, and calendars with family photos and personalized stories. For example, you can give your toddler a storybook about Fluffy, showing how family members gently pet and cuddle her. And you can make your five-year-old a calendar that shows what happens from the first day of school to summer vacation, using photos of his own home, school, and family to ease his anxiety.

You can also use personalized books and cards to help an older child adjust to the arrival of a new sibling or the loss of a pet, or a teenager adjust to a move to a new home. In addition, books and calendars with family photos are a great way to keep everyone feeling close if Mom or Dad travels frequently. When you become your own publisher by using the templates and instructions in this book, you'll be amazed at how many projects you can think up for your family.

What Your Computer Can Do for You

Computers make creating beautiful page designs simple. With just a few clicks, you can make your photos bigger or smaller, rotate them, create special effects, and add fancy borders, artwork, and text.

Whether you want to create scrapbooks, albums, or calendars to send by email, publish to a Web site, or print and send via snail mail, you'll find many advantages to going digital, including:

- You can make unlimited copies of your projects, at little or no extra cost.

- Computers are forgiving, so you can keep refining your projects until they're exactly the way you want them—no ruined photos or messy scrapbook pages! Better yet, as you learn new skills, you can revisit earlier projects and improve on them.

- You can customize projects by creating a single file and then personalizing it for different family members or friends.

- With your treasured photos safely scanned and archived, you'll never have to worry about losing precious memories.

- You can save money by cutting down on the cost of supplies and postage.

- Most important, you'll be delighted with the ease and versatility of digital storytelling.

When you combine your own creativity with the power of your computer, there's no limit to the knowledge and traditions you can record for your own enjoyment and for generations to come.

Peek a boo!
We can't wait to see you!

WHEN YOU CARE EVEN MORE
You can create personalized greeting cards for any occasion using the instructions in Chapter 7. This little elf was sent to family members as they were preparing to come home for the holidays. (Photo by Stephanie Kjos Warner.)

In the first few chapters of this book, you'll find a primer that starts with suggestions for gathering the tools for your projects and for developing the prose that can bring your stories to life. To help you develop your writing skills, I've included a collection of writing tips culled from my 20+ years as a professional writer and from conversations I've had with many other authors and journalists. To help you improve your photography skills, I offer tips for taking better pictures in Chapter 2, and in Chapter 3 I introduce you to the magical world of image editing with Photoshop Elements, a software program that's easy enough for beginners, yet powerful enough to create professional-looking projects.

The rest of the chapters of this book are project-specific, meaning they cover a particular kind of project you might want to create, such as a Web site (Chapter 5) or personalized calendars (Chapter 8). You can jump ahead to any of these chapters and dive right in to begin creating the projects you are most interested in, or you can read this book from the beginning to make sure you've mastered the basics before you move on to creating your own family projects.

Now let's try a couple of quick projects to get you started sharing your photos right away.

Understanding the Step-by-Step Instructions

Throughout this book, you'll find step-by-step instructions for techniques and projects. Here are a few tips for following those directions.

- Follow the steps in order (computers are very particular about order).

- The instructions in this book are designed for Windows-based computers. Where possible, I've included alternatives for Macintosh computers. Sometimes you will find these as parenthetical instructions, such as, "Press Enter (Return on a Mac)." If the instructions are significantly different, they may be included in a box.

- If you see an arrow, such as this one →, it indicates the option you should select. For example, "Select File → New" means you should select the File menu at the top of your screen and choose the New option from the pull-down list.

- If you see the command "right-click," it means that you should press the right button on your mouse. If you are using a Mac, the same option is often available by holding down the Control key while pressing the button on the mouse.

PROJECTS FOR EVERY DAY OF THE YEAR
In Chapter 8, you'll find instructions to make several types of personalized calendars to show off your family photos and help you stay up-to-date.

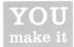 # Personalized Desktop Wallpaper

One of the easiest ways to share photos with friends and coworkers is to use a personal photo as your desktop image, or wallpaper (the background you see on your computer when you first turn it on). If you already have some photos in a digital format, you can easily use one on your desktop to create your own personalized wallpaper for your computer. If not, you'll find instructions for getting images into a digital format at the end of Chapter 1. The instructions in this project and the one on the next page are written for Windows computers. If you're using a Mac, see instructions on page 14.

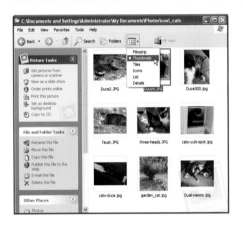

1. Go to the My Documents folder on your computer by clicking Start (in the lower left corner of your desktop) and then My Documents.

Open any folder of photos. Make sure the view is set for Thumbnails or Filmstrip. These settings enable you to see a small image of each photo. To change the view, choose the View menu at the top of the folder window.

2. Locate the photo you want to use as a background photo (wallpaper). Right-click on the photo and choose Set as Desktop Background. That's all there is to it. The photo you chose should now be your wallpaper. When you want to change it, just follow the steps again and choose a different photo.

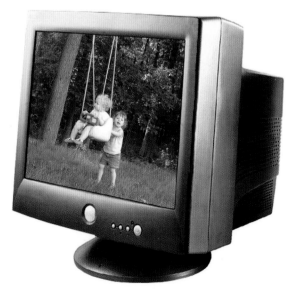

DRESS UP YOUR DESKTOP
You can add any still image to your computer's opening screen. There are never too many ways to display cute photos of the kids and pets! (Photo by Stephanie Kjos Warner.)

Slideshow Screen Saver

A screen saver is another great way to show off photos of your children, pets, or hobby on your computer at home or at the office. Creating a slideshow to use as your screen saver enables you to put a whole selection of cherished images on view. You can use photos you scan, download from a digital camera, or copy from a CD in your screen saver. (You'll find instructions for how to get images into your computer at the end of Chapter 1.)

Gather Your Photos

The first step is to put all of the photos you want in your slideshow into their own separate folder. A good place to keep images is in the My Pictures folder inside the My Documents folder (usually available by default in Windows). Open up the My Documents folder, then double-click on the My Pictures folder to open it.

Create a new folder inside the My Pictures folder by choosing File → New → Folder. You can name the folder whatever you like, such as the date when you took the photos or the event where you took them—the important thing is to give it a name that's easily identifiable. Next you need to copy all of the photos you want to use in your screen saver into your new folder.

Let's assume you called your new folder "Cool Cats Screen Saver" and you want to include a bunch of photos you've taken of your cats that are already in your My Pictures folder. Look through all of the photos of your cats, and when you see one you want to use, right-click on it and choose Copy. Then open the Cool Cats Screen Saver folder, right-click, and choose Paste. The photo will now be in the Cool Cats Screen Saver folder and ready to be included in your new screen saver.

Copy and paste all of the photos you want to include in the same way. Once you have all of the photos you want in your new folder, you're ready to create the screen saver.

Rotating Images

If the photo you want is sideways, right-click on it and choose Rotate Clockwise or Rotate Counter Clockwise. Otherwise, it will appear sideways in your screen saver.

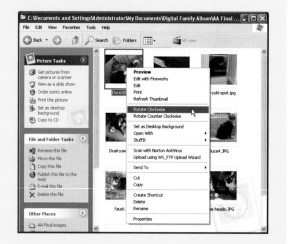

GET IT STRAIGHT
Before you create your screen saver, make sure all your images are vertically aligned.

Tip
You can have as many photos as you'd like in your screen saver, but five to ten is usually more than enough. Remember, you can always add more and you can change the photos whenever you have new ones you'd like to use.

Set Up Your Screen Saver

Windows includes a built-in feature that makes it easy to create a screen saver for your computer.

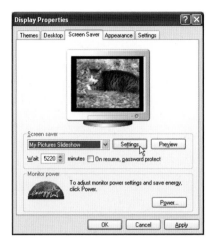

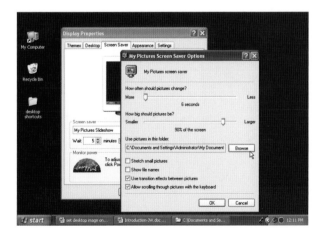

1. Right-click on the desktop and choose Properties. The Display Properties window will open. Click on the Screen Saver tab at the top of the Display Properties window. Then, under Screen Saver, click on the down arrow and choose My Pictures Slideshow. Click on the Settings button next to the box that says My Pictures Slideshow. The My Pictures Screen Saver Options dialog box will open.

2. To select the images for your screen saver, click on the Browse button in the Settings window. The Browse for Folder dialog box will open with the message "Choose a directory from which to display images." You should see a list of folders that are in your My Documents folder.

Click the plus sign next to any folder to reveal its contents and then click to select the folder with the images for your screen saver. In my example, I opened the My Pictures folder by clicking on the plus sign and then selected the Cool Cats Screen Saver folder.

3. In the Settings window, move the sliders to specify how fast images should transition and how large they should appear on your screen.

At the bottom of the Settings window are four items: "Stretch small pictures," "Show file names," "Use transition effects between pictures," and "Allow scrolling through pictures with the keyboard." In general, I recommend the "Use transition effects…" option because it makes the slideshow look better as the images change, and the "Allow scrolling…" option because you can move through the images manually, as well as having them automatically play on your screen.

Click OK to return to Display Properties. The computer at the top of the Display Properties window will show a preview of your screen saver.

In the Display Properties window, next to the option marked "Wait," you can adjust the number of minutes your computer should be inactive before the screen saver starts playing. If you choose four minutes, for example, the screen saver will begin playing four minutes after you stop using the mouse or keyboard.

Creating Wallpaper & Screen Savers on a Mac

If you use a Macintosh computer, follow these instructions to use your own images as wallpaper or a screen saver on the desktop. These directions are written for use on a Mac OS X or Mac OS 9 computer. Because each version of the Mac operating system requires slightly different instructions, and we can't include them all in this book, if you have an older system, refer to your manual or to your computer's help files.

Creating Wallpaper with Macintosh OS X

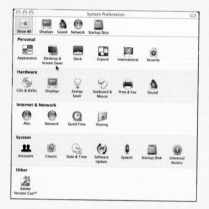

1. From the Apple menu or the Dock, choose System Preferences and click the Desktop & Screen Saver icon.

2. Click the Desktop tab, then click Choose Folder to locate your photo album. Click an image to select it; it will immediately become the desktop picture. Click the button in the upper left corner of the Desktop & Screen Saver dialog box to close.

Creating a Screen Saver with Macintosh OS X

Macintosh OS X features a built-in screen saver feature. If you are using an earlier version of the Macintosh operating system, this feature is not included.

1. From the Apple menu or the Dock, choose System Preferences and click the Desktop & Screen Saver icon.

2. Click the Screen Saver tab, then click Choose Folder to locate your album.
Use the controls to set Options and then click the upper left button in the Desktop & Screen Saver dialog box to quit System Preferences.

Creating Wallpaper with Macintosh OS 9

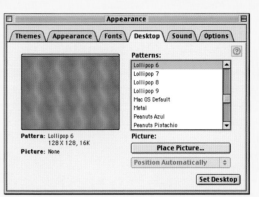

1. From the Apple Menu (upper left), scroll down to Control Panels, then over and down to click on Appearance.

2. In the Appearance dialog box, click the Desktop tab, then select a default system pattern or click Place Picture to select a photo of your choosing.

Click an image to select it and view a preview, then click Open. Use the controls in the Appearance dialog box to set the position of the image, then click Set Desktop.

You're Just Getting Started

Creating a slideshow as a screen saver or using a personal image as your wallpaper are two easy ways to start showing off your digital images. But don't stop there. Throughout this book you'll find many more ways to share your photos and stories through a variety of projects that you can print out and show off on paper, bind into books, or send over the Internet. These days, children are learning to use computers at a younger and younger age, but don't be intimidated. Even if you're over ten years old, you can still learn enough about the computer to tackle the projects in this book.

LET ME TRY!
They're still a little young, but already my nieces are starting to learn to use a computer to create their own personalized books and artwork. (Photo by Mary Bortmas.)

We Love autumn!

What a day to enjoy nature. It was a little chilly but the girls and Kevin had a great time playing on the swings and chasing each other around. It was amazing to me that we were the only ones in the whole park!

Dave and Janine - Microsoft Internet Explorer

View Favorites Tools Help

Search Favorites

Create Photo Browser Date View

Size: 13 px Mode: Brush Opacity: 100%

Halloween-card.psd @ 33.3% (Happy Halloween! , R...

kitty-jessica.jpg @ 100% (RGB/8)

HAPPY HALLOWEEN!

CHAPTER 1

Getting Organized:
Gather Stories, Tools & Photos

Gathering all the elements for your projects is the first step toward creating beautiful designs that will keep your family following the links through your digital creations and turning the pages of your printed projects. In this chapter, you'll learn techniques used by the pros to gather tools and materials for your projects, and discover how to:

- **Keep track of and organize all the elements you'll need**
- **Make sure you have all the papers, software programs, and other tools that will make your task as simple as possible**
- **Write great stories to go with your digital projects**
- **Archive and protect your treasures**
- **Gather your images by scanning them or downloading them from the Internet or a digital camera**

Once you've gathered all of your images, stories, and tools, you'll be better prepared to create the greeting cards, calendars, Web sites, and other family projects you will learn about in the rest of this book.

✳ Basic Tools: What You'll Need ✳

What will you need to make the move from paste and scissors to digital? Here are a few items you'll want to get before you start working:

Computer

A computer is essential for almost every project in this book. You don't need anything fancy or high powered, but if your computer is more than seven years old, consider investing in a new one. Even bottom-of-the-line computers (which retail for $500 or less these days) are better than a machine you may have paid as much as $2,000 for a few years ago. Although you may be happier with a faster machine and a bigger monitor, you don't need a lot of power and could use even a very old computer to create many of the projects in this book.

Digital Camera

You don't have to have a digital camera to use this book, but most people who've invested in a digital camera report that the money they save on buying and developing film more than covers the cost of the camera. I also find that people take a lot more photos when they have a digital camera. Taking more pictures will give you more choices and a better chance of getting great images for your projects.

> ### Note
> Chapter 2 has great tips for choosing a digital camera, as well as techniques and ideas for taking better photos.

Scanner

A scanner is a device you connect to your computer that lets you capture images and save them to your computer. Many people scan photographs so that they can turn them into digital images. This is not only important if you want to use digital images in your projects on the computer; it's also an excellent way to make copies of pictures to protect and save them. In addition to photos, a scanner can be used for drawings, paintings, and other artwork. You can scan diplomas, certificates, and awards to preserve them and use them in your computer art projects. You can even scan three-dimensional objects, such as coins or small keepsakes, and fabrics to use as background patterns.

Internet Access

An Internet connection is essential if you plan to e-mail your creations to others or if you want to create a Web site. You'll also need Internet access to download the templates, artwork, and other goodies created for this book from the DigitalFamily.com Web site. Although you don't have to have the high speed of a cable modem or DSL line, you'll love what they can do for your Internet experience—and you're likely to use the Internet a lot more if you have a faster connection.

Color Printer

If you don't have a color printer, you may be happy with some of the printing services available through Web sites, such as Ofoto.com or Shutterfly.com, which will print digital images and mail them to you when you submit them over the Internet. (You'll find a regularly updated list of online printing resources at www.digitalfamily.com.) If you plan to do a lot of printing, I recommend you invest in your own color printer. The cost of color printers has dropped dramatically in the last few years, but beware of the high price of ink cartridges. Always compare the cost of ink cartridges, as well as printers, when making a purchase. Spending a little more money up front can save you a lot in the long run if you get more prints per cartridge. As a general rule, laser printers produce higher quality prints and get more pages out of an ink cartridge, but most ink-jet printers are a lot less expensive and produce excellent prints these days.

CD Burner

A CD burner is a great way to create backups of your digital photos and other creations. Creating CDs is also useful for sharing images with friends and family. Most new computers come with a CD burner built in, but you can buy one separately if your computer didn't come with a burner.

Keeping Track of Treasures

Before you settle yourself in for an afternoon of scrapbooking, Web site design, or any other creative endeavor, it's worth taking a little time to gather all the keepsakes, such as photos, ticket stubs, invitations, poems, and other memorabilia, you'll want to include in your projects.

One of the biggest challenges in creating memory projects is that it's so easy to lose these precious keepsakes. To help keep track of all your treasures, I recommend keeping a box or basket somewhere convenient to collect goodies as soon you bring them into the house. Tell everyone in the family that this is where to put greeting cards, programs from school events, and the like. I don't suggest you use this system for long-term storage, but it's an easy way to manage your initial collection process.

GATHERING KEEPSAKES
A box or basket near the front door of your home is a great place to collect memorabilia.

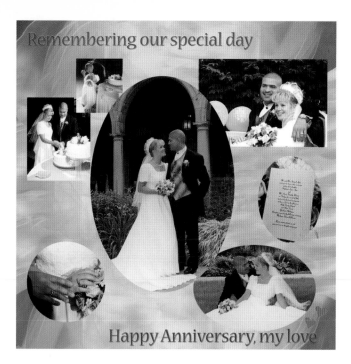

Remembering our special day

Happy Anniversary, my love

SOMETHING OLD, SOMETHING DIGITAL
You can use an image-editing program to resize your photos and make them any shape you want, then put them together to make beautiful scrapbook pages. (Photos by Rawlinson Photography.)

Image-Editing Software

If you want to crop, enhance, or otherwise edit your digital images, an image-editing program is essential. You'll find detailed descriptions of a variety of image-editing programs in the next section of this chapter.

Papers, Envelopes, and Albums

Regular white copy paper is fine for quick prints or for testing your work, but you'll have much better results if you print photos and other graphic images on photo-quality paper. You can find photo-quality paper at any office or art supply store. Most papers will work with any printer, but you will find that some papers are designed for ink-jet printers and others are better suited to laser printers.

Art-quality papers (the kind you'll find at art supply or craft stores) are ideal for creating greeting cards and calendars and for preserving printed images so they won't fade over time. If you want to protect and preserve your images, look for papers that are labeled "archival." To dress up a greeting card or letter, consider handmade or textured papers.

If you plan to mail your creations, you'll want to have envelopes in various sizes for sending greeting cards (like the ones you'll create in Chapter 7) and oversized projects (like the calendars you'll create in Chapter 8).

Greeting card papers are made from a heavier stock than regular paper. There are also pre-cut and pre-folded papers specially designed for greeting cards. Most modern printers can handle these thicker papers just fine, so you won't need any special printing equipment. You'll find a variety of card-stock and pre-cut papers at office supply stores as well as art supply and craft stores.

Binding kits, scrapbooking supplies, and photo albums are available at craft stores, art supply stores, and even office supply stores. These kits and packages are ideal for creating baby books and other special keepsakes.

If you want to improve the way your images look—balance the light, clean up red eye, or crop out clutter in the background—you'll want a good image-editing or graphics program. But if you start trying to figure out which program you should get, you're likely to become overwhelmed with all the choices. My goal in this section is to help you understand the strengths and weaknesses of the most popular programs so you can find the tools that are best for you.

Adobe Photoshop CS

By far the most popular image-editing program in the history of computer design, Photoshop CS (www.adobe.com) is a powerful tool that enables you to create, edit, and manipulate images in extraordinary ways. This is a professional tool, with a professional price tag (about $650). Unless you're a serious photographer or designer, or you have a huge budget, it's probably not the right choice for you.

Adobe Photoshop Elements

Photoshop Elements (www.adobe.com) features many of the same powerful editing abilities of Photoshop CS, but it is easier to use and costs less than $100. Elements provides more than enough power for all of the projects featured in this book and it's a good tool to start out with if you're new to working with images on a computer. Chapter 3 contains lots of tips and exercises to get you started with this program.

CS Versus Elements

The difference between the two versions of Photoshop boils down to this: The expensive version (CS) is used by magazine editors, photographers, and other design professionals to do painstaking, exacting work, such as preparing photos that have to look flawless on the cover of a magazine or a billboard. Given enough time, you can use Photoshop CS to make a giraffe look like a turtle. For the rest of us, who just want to clean up a few photos, or maybe make it look like the cat was riding a motorcycle, Photoshop Elements is a fine option.

PHOTOSHOP ELEMENTS WORKSPACE
Photoshop Elements looks and acts much like its big brother, Photoshop CS. You can use it to edit images and even create complex designs, such as the card shown here.

Macromedia Fireworks

This image-editing program has many general editing features, but it is especially suited to creating images that download quickly and look good on the Web. A few years ago, Fireworks (www.macromedia.com) was the best image-editing program for the Web, but that's no longer true due to enhancements to Photoshop Elements and other programs listed here. Today, the main reason for choosing Fireworks would be if you use Dreamweaver as your Web design program, because the two programs are fully integrated.

CorelDRAW Graphics Suite

Although not as popular as Adobe Photoshop, CorelDraw (www.corel.com) is a professional-grade image-editing program that is rich in features. This suite of programs costs less than Adobe Photoshop CS but more than Photoshop Elements. Professional designers who favor Corel tend to like its interface better and appreciate its excellent drawing tools, but both versions of Photoshop also include drawing features.

Ulead PhotoImpact

This image-editing program often comes bundled with the software for digital cameras and scanners. PhotoImpact (www.ulead.com) is easy to use and has a wide range of features, including several automated correction features. The ExpressFix Photo Wizard, for example, helps correct common photography mistakes, such as red eye and lens distortion. You'll also get everything you need to edit and convert images for the Web—and at a lower price than Adobe's or Corel's products.

PICTURE PERFECT
If you are up to the challenge of creating your own Web sites with Macromedia Dreamweaver (see Chapter 5 for more on Web sites), you may want to try using Fireworks as your image editor.

Apple iPhoto

Often bundled with Apple computers as part of the iLife suite, iPhoto (www.apple.com) is an excellent image editor and a great choice for Mac users. If you have iPhoto, you have everything you need to edit and create digital images for the projects in this book.

Any Image Program Will Do

Although I recommend Photoshop Elements because it is a feature-rich program that's not too complicated or too expensive for most beginners, almost any image program will work for the exercises and examples in this book. If you have another image editor, such as Ulead PhotoImpact, you don't have to buy a new image editor. Just beware that some of the instructions in this book are specific to Photoshop Elements, and if you work with another program you may have to make some minor adjustments to the order of the steps or look for menu items and other features under different names.

Every family has a seemingly endless list of funny, silly, and touching stories. Even the most mundane aspects of life can become humorous and captivating when told well. If you're a grandparent, you probably love to talk about your grandchildren; if you've just returned from a trip, you may be bursting with adventure stories from your travels. Whether you are creating a greeting card, digital scrapbook page, or Web site, the words you use to tell your stories are a key part of the mix. But when you sit down to write these stories, it might not be as easy as you thought to capture these precious moments in words.

A common misconception among those who are new to writing is that it's easy for professional writers and authors to produce perfect prose. Trust me, it's not. Writing is hard work, even if you enjoy it most of the time. Most writers struggle with the craft, producing drafts that are revised many times and edited before they are ready to be published. If you study books about writing, you'll find many common themes.

Here are a few tips that may help you with your own writing:

Just Do It

Every professional writer I've ever known would agree with this tip. The hardest part of writing is sitting in the chair and getting started. Don't fret too much, and don't expect your words to come out perfectly the first time—just sit down and get started.

Take Notes

One of the best ways to make sure you can write a good story is to take notes as you go along. If you're taking pictures at an event, keep a notebook handy and record the names of the people in your images and notes about what they are doing. Jot down interesting comments, jokes, and incidents—especially the funny ones.

Interview Family Members

Grab a notebook or a tape recorder and interview each family member to collect the best stories and the intimate details that will bring a biography to life. Ask lots and lots of questions, especially during and after events, and try to get other members of the family to record their thoughts and stories, as well. You'll find more interviewing tips and a list of suggested questions in Chapter 10. E-mail is another great way to share and collect stories.

Add Fictional Characters

Not all of the voices in your stories have to be real, or human. When my husband and I eloped, we created a special Web site to explain to family and friends why we chose not to have a big wedding. To keep the story light, we came up with the idea of using our cats as narrators. The result was a humorous collection of answers, first in his words, then in mine, then in the words of our cats. Most people quickly caught on to the fact that the cats were the only ones who consistently told the truth in our family.

ASK THE CATS FOR THE REAL STORY
Using fictional characters or pets to help tell a story is an easy way to add humor.

SUNDAY IN THE PARK WITH DADDY

Sometimes you need only a few words to get your point across. When making scrapbook pages, don't overwhelm your beautiful photos with too much text.

Create Your Own Order

You don't have to write in chronological order. Instead of starting a wedding book with the standard fair— "Deb and Keith were married in January"—consider beginning with the most dramatic part of the story. For example, try starting with something like, "It snowed so much during the reception after Deb and Keith's wedding that most of the guests had to stay the night in the hotel. Maybe January wasn't the best month to plan a northern Indiana wedding, but we still had a wonderful time." Then go back and fill in the details after you've got your readers' attention.

Avoid Clichés Like the Plague

We've all seen the opening line "Once upon a time" so many times it's become almost comical. Your stories will be stronger if you avoid common phrases and clichés and instead look for creative and unusual ways to tell your story. Choose active verbs, colorful adjectives, and details, lots and lots of details.

Write About What Interests You

If you don't care about what you're writing, why should anyone else want to read it? As you write your story, focus on the points that most impressed you and make sure to include the details that caught your attention. Not only are the things that you find interesting more likely to interest others, but if you're interested in a topic, you're almost certain to write about it in a more interesting way.

Write the Way You Speak

A common mistake among writers is that they sound more serious in their writing than they do when talking. The result is overly formal, stiff, and dull writing. To avoid this trap, try writing your family stories as if you were writing a letter to a favorite aunt or talking to a friend.

Write a Little at a Time

Anyone who has ever sat down to write "The Great American Novel" can tell you there is nothing more intimidating than taking on too much at once. Instead of trying to write all the text you want in your baby book, or all the biographies and descriptions you want for your Web site, in one sitting, focus on one small part of the story at a time. Start with the intention of writing just the beginning of a favorite family story, or just the basic information about your first child. Then move on to the next child or come back and finish the story later.

Cover All the Most Important Points

Journalists are taught that every story should answer five questions: who, what, where, when, and how. Remembering these provocative little words gives you a great tool for making sure you've covered the key points in a story. As you go over your work, ask yourself each of these questions. They are also helpful if you get stuck and aren't sure what else needs to be said.

Revise, Revise, Revise

Don't expect to write perfect prose the first time you put pen to paper (or fingers to a keyboard). If you do, you'll have a hard time getting anything on the page because you'll be criticizing your own work so much you won't want to continue. Write your first draft without worrying about whether it even makes sense, then go back and revise it and make it stronger. Approach writing in two parts: the creative process that is just about getting words on the page, and then the editing process during which you revise your work over and over again. In his book *On Writing* (Scribner, 2000), Stephen King says that he always writes a first draft of his books, which he puts away for six months before revising and writing the final manuscript.

Don't Go On and On and On

One of the most important parts of editing and revising is cutting all of the unnecessary words. Filling space on a page is a bad habit too many of us learned in school as we struggled to write five-page papers at the last minute. The goal is to say more with fewer words, a process that takes far more time than most people realize. I know many journalists who would tell you that they could write 1,000 words on a topic in an hour, but if they had to cover the same topic in only 200 words, it would take them at least twice as long.

Hire an Editor

Finding the mistakes in your own work is nearly impossible, because you are too close to it and you know what you intended to say. Before you let your words go, ask someone with a good eye for detail to look over your work. Ask your editor to look for more than just misspelled words or bad punctuation. You want someone who will tell you if something you've written doesn't make sense or if it could be briefer or more detailed. Try not to take an editor's suggestions personally. Ultimately, editing is about improving your writing, not criticizing what you've done. The best writers always appreciate good editors.

BUMPER CARS
Sometimes you don't need many words at all. You can let the image tell the story. (Learn how to add text to a photo on page 57.)

In the old days, photos faded, slides got lost during family moves, and people accidentally taped *Baywatch* over their wedding videos. (I hope nothing like that has ever happened to anyone in your family.) With today's computer technology, you can easily save and copy your most important images and even keep copies somewhere outside your house for added insurance. Whether you create your family projects on the computer or on paper, you should take steps to protect and preserve your work so that you can share it for years to come. Here are a few tips for protecting your treasures.

Scan Photos and Other Memorabilia

Taking the time to scan your images and other keep-sakes is an ideal way to preserve and protect them. Once you have scanned your treasures, you can save the digital images on a CD, external hard drive, or other memory device as a backup. (You'll find tips for scanning, downloading, and gathering images at the end of this chapter.)

Photograph Oversized Keepsakes

If your piece is too big for a scanner, you may find it easier to take digital photos of it than to scan it. This technique works well for awards, large pieces of art-work, and other memorabilia. Again, once you have a digital image in the computer, you can incorporate it into your projects.

Make Copies and Backups

I recommend you back up everything and save your images in multiple places. Compact discs wear out and get scratched, hard drives crash, and, tragically, houses burn down—the list of ways you can lose your keepsakes is heartbreakingly long. Once you've backed up your work, I strongly recommend you get a copy of it out of the house. For example, keep copies of all your photos on CDs at a friend's place so you can rest easy knowing your memories are truly safe.

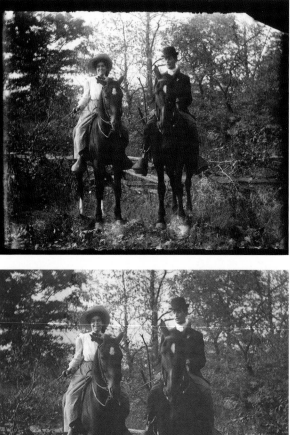

PROTECT AND REPAIR OLD PHOTOS
Old photos like this image of my great-grandparents are vulnerable to damage over the years. Already this print has been torn and is fading (top). Once it's scanned into a computer, a program like Photoshop Elements can be used to repair the damaged corner and clean it up (bottom). See Chapter 10 for tips on resurrecting old photos.

To make the projects in this book you'll need to have your photos and other images in a digital format. You can scan them, copy them from a camera, or download them off the Internet. If you're a pro at all of these tasks, you can skip this section, but if you're still not sure about all the ways there are to gather images for your projects, these tips and instructions will quickly bring you up to speed.

Scanning Images and Objects

Scanners have become exceptionally easy to use. With most modern scanners all you have to do is connect the scanner to your computer and install the scanner software. Every scanner is different, so you should follow the instructions that come with your system, but they all essentially work by taking a picture of whatever you place on the bed of the scanner.

To scan an image, place it so it faces the scanner's glass plate (be careful not to scratch the glass plate as this is the most delicate part of the scanner). Position the image or object you want to scan by following any symbols (such as arrows or dots) or picture instructions (icons that look like a sheet of paper) that appear along the edges of the plate.

As a general rule, you have two primary options for scanning. You can use the scanning software that came with your scanner, or you can scan directly into an image editor, such as Photoshop Elements. I prefer the latter option as you often get more choices for controlling the scan. (For details, follow the specific instructions that came with your scanner or your image-editing program.)

When you scan an image or object, you usually have the option to preview the scan before you scan it. This is an important step because it enables you to adjust the boundaries of the scanned area for a cleaner and more efficient scan.

You can scan just about anything you can fit on the glass plate of a scanner: printed photographs, certificates and diplomas, greeting cards, invitations, even three-dimensional objects, such as medals, coins, ceramic plates, and fabrics.

You can scan your images at a high resolution to preserve as much detail as possible, or you can scan at a low resolution, creating a smaller file with less detail. If you plan to edit the image or you want to print it, scan it at a higher resolution (300 ppi is a good choice). (See Chapter 3 for more on resolution.)

YOU CAN SCAN (ALMOST) ANYTHING
Scan fabrics and other objects to use as backgrounds and textures in your projects.

Color Versus Black & White

You can scan in color or in black and white, regardless of the nature of the original. In fact, it's often best to scan black-and-white photos as color, because it gives you more image content to work with when you're editing the image later. Scanning in color is especially important if you want to use a program such as Photoshop Elements to add color to a black-and-white image after it's scanned.

Copying Images from a Digital Camera

Most digital cameras offer multiple ways to copy images to your computer. You can connect your camera to your computer with a special cable and then use a software program to download the images to your hard drive. Or, if you have the right card reader in your computer or printer, you can simply remove the memory card from your camera, slide it into your computer, and copy the files to your hard drive as you'd copy images from a CD or floppy disk.

Most digital cameras use Compact Flash cards, SmartMedia cards, or some other kind of removable storage device. Many computers now come with all these card readers built in. However, if your computer doesn't have what you need, you can buy adapters that will let you insert the card into a PCMCIA slot or USB port. (Check with your local computer store to find the right adapters for your system and consult the documentation that came with your digital camera for the best options for your system.)

Downloading Images from the Internet

You can copy nearly any image you see on the Internet to your own computer in just a few easy steps. But just because you can doesn't mean you should, or that it will be worth your effort. First, you should respect copyright, meaning you should not use someone else's photos, cartoons, or other images without permission. And second, it may not be worth your effort anyway because images on the Internet are usually in a very low resolution; they download faster, but it also means that they don't look very good if you print them or try to enlarge them.

All that said, if you see an image on a Web page that you want to download (and you know it's OK to do so), here's how you do it:

1. Use a Web browser to view the image you want on the Internet.

2. Place your cursor directly over the image and right-click (in Windows) or click and hold (on a Mac).

3. In the pop-up menu that appears, choose Save Picture As.

4. Change the name of the file to anything you want to name it and click Save.

That's it. Once you've saved the image, you can use it as you would any other image on your hard drive.

DOWNLOAD IMAGES OFF THE WEB
You can quickly and easily copy almost any image on the Web to your computer.

Note
If you follow these steps and the Save Picture As command is dimmed, the site's designer has protected the image from copying and saving, and you won't be able to download it to your hard drive.

Downloading Images from E-mail

If friends or family send you pictures via e-mail, you can also save them to your computer to print out and use in your projects. How you save them to your computer depends on what kind of e-mail program you use, but they all work in the same general way. Here are a few tips for some of the most common e-mail systems.

If you receive an e-mail with a photo and want to see what the image looks like, double-click on the image icon; it should automatically open in a viewer or image program, like you see in the image on the next page.

If you want to save an image that you receive in an e-mail to your computer, follow these steps:

1. Open the e-mail message.

2. Place your cursor directly over the image icon and right-click (in Windows) or click and hold (on the Mac).

3. In the pop-up menu that appears, choose Save As.

4. Change the name of the file to anything you want to name it and click Save.

VIEW IMAGES IN E-MAIL
If you double-click on an image icon in Microsoft Outlook, it will automatically open in the Windows viewer.

SAVE IMAGES FROM E-MAIL
You can save any image you receive in e-mail to your computer's hard drive.

From Start to Finish

It's easy to have big ideas when you're still at the planning and gathering stage. But when you get down to the task of developing your projects, you may find that accomplishing everything you want to do is not as easy as you thought it would be.

One of the only ways I've seen to get things finished—whether you're working on a business project or a personal one—is to make sure that all of the people involved are given deadlines.

The first challenge is setting realistic deadlines. The second is making everyone involved believe that the deadlines are important. If you want to set deadlines that family members will stick to, consider planning your projects around special dates or events. For example, plan to get your digital scrapbook finished in time to show Grandma when she comes to visit in August, build your family Web site in time to surprise Mom on her birthday, or finish your hobby brag books before the kids' first day back to school. Choose a date that's special to you or your family and one that will help keep everyone motivated.

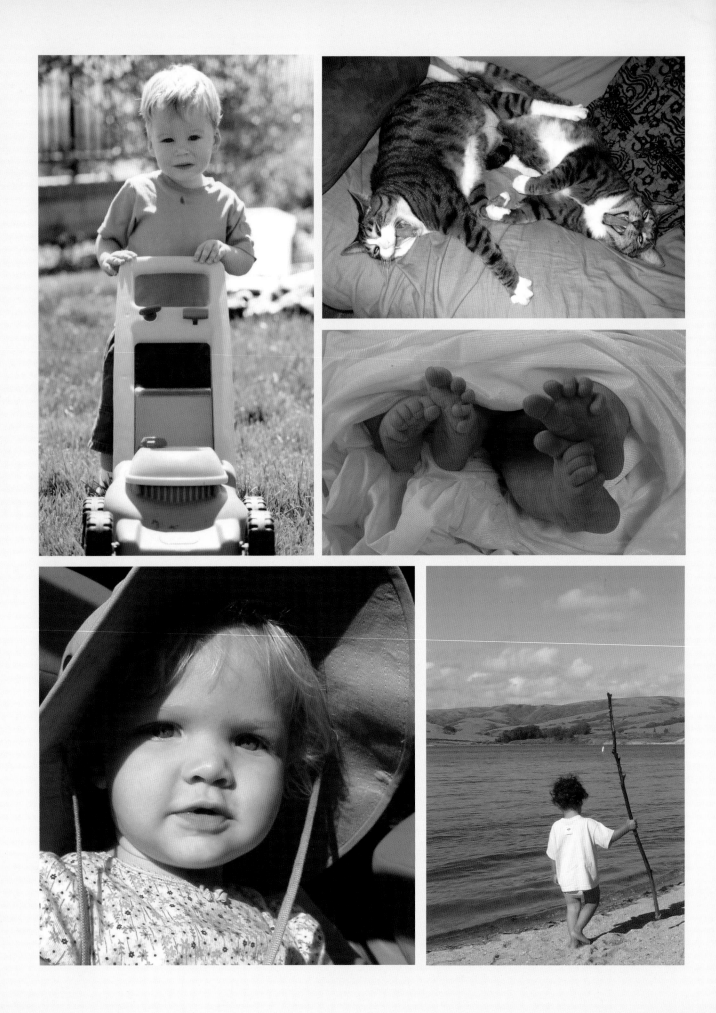

CHAPTER

Smile for the Camera:
Take Better Photos

When you set out to make a special meal, you look for the best ingredients: the freshest vegetables, the finest meats, fruit that is in its peak season. A successful digital family project begins the same way, and good photos are one of the most important ingredients. So what are the secrets to snapping great family photos? In this chapter, you'll discover some of the most important techniques employed by professional photographers, such as:

● **How to thoughtfully compose an image**
● **The best ways to illuminate your subjects**
● **Tips for taking portraits that make everyone look good**
● **How to choose the best digital camera**

As with any skill, you can get better at photography by learning the fundamental rules and practicing. This chapter is designed to help you with the first part of that equation; the rest is up to you and your favorite models.

✳ You Can't Take Too Many Pictures ✳

Professional photographers take hundreds of images without hesitation because they know that the more pictures they have to choose from the better chance they'll get just the right one. Most of the photos you've seen in magazines or newspapers were selected from dozens or even hundreds of shots taken in succession.

Although you can learn ways to better compose a picture and to ensure that the lighting and other elements are properly set, you can't control the expression on your model or the chance that a bird will fly into the scene or a person will walk in front of you just when you push the shutter. Always try to take more than one shot—at least four or five is good for most candid situations. You'll be more likely to wind up with at least one great photo, and you may even capture something wonderful and unexpected.

Fortunately, digital cameras make taking lots of photos more affordable than ever before. As a journalism student many years ago, I struggled to pay the film and developing costs for all the photos I wanted to take, but today's digital cameras don't require such expense. Digital cameras use memory cards, which can be filled with images, cleaned off after those images are transferred to a computer, and filled with images over and over again. (You'll find tips for choosing the best digital camera at the end of this chapter.)

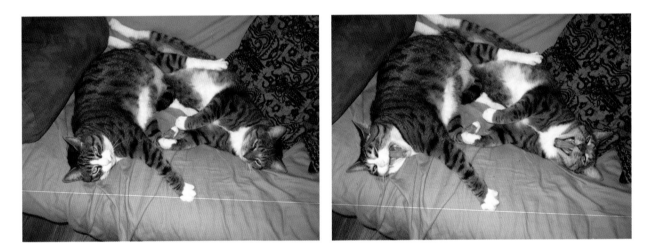

DUALING YAWNS
I thought the first shot of these two cats was cute, but when the flash led them to yawn simultaneously, I was able to capture a very rare dual pose. If I hadn't been ready to take a few photos in a row, I'd probably have missed that surprising (and fleeting) moment.

Tip
After you've taken all the photos you think you should take, look around again for a new angle, new vantage point, or another activity you can engage your subjects in to make the image more interesting. You may see a shot you hadn't seen before.

It's easy to point a camera at a subject and press the shutter, but to capture the most impressive images, you'll need to put some thought into the composition.

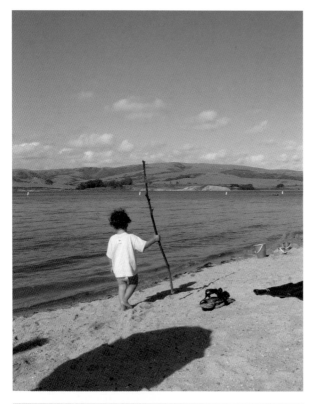

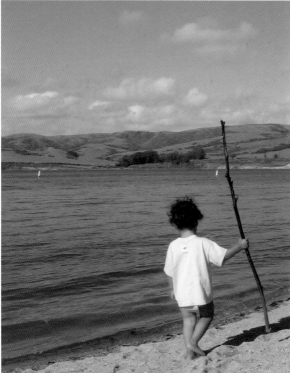

Focus on What's Important

The most dramatic photos usually have one principal subject that tells a single, often simple, story. When you're taking a photo, you might be tempted to include everything in sight—the whole playground at the neighborhood park or the entire living room at your sister's house, for example. Those may be fine photographs if you want to show the environment, but if you want to tell the strongest story, focus on one key figure in the frame. For most family photos, and perhaps especially for photos you want to use in scrapbooking and the other projects in this book, people will be the most important subject matter. If you want to create compelling images of your family and friends, keep the camera on their familiar faces and don't get distracted by all the clutter and scenery that surrounds them.

Extra Details Help Tell the Story

It may seem a little contradictory after telling you to focus on your subject in the previous tip, but including *some* background or foreground elements can improve your images. For example, posing Grandma next to a recognizable feature of her house (such as a stained-glass window), can give a sense of place. Showing her cutting roses in her garden can provide a clue to how she spends her time. You still want to make sure that your subject is the focal point, and you don't want to end up with a photo that is more house or garden than grandma, but including details that help set the scene, the time, or the place can help you tell a better story.

CUT THE CLUTTER
When you cut out the distractions, like the shadow and the shoe in the foreground of this picture (top), the result is a much stronger image (bottom). It's best if you can get close to your subject when you take a photo, but if you need to crop an image afterward, you'll learn how in Chapter 3.

Seek Out Different Vantage Points

Lie down on the ground and look up at your subject; climb a tree and look down on your subject (but please be careful; it's easy to lose your balance when you're looking through a camera lens). Not only will your photos have more refreshing viewpoints, your subjects may surprise you with their delighted or surprised responses. Your antics in setting up the pose might even elicit a spontaneous giggle that makes your toddler that much more adorable. By crawling into a tube at the playground behind her grandson, my aunt Mindy (who helped write this book) was able to capture the determination of a baby making one of his first solo journeys.

❄ ❄ ❄ ❄ ❄ ❄ ❄ ❄ ❄ ❄ ❄ ❄ ❄ ❄

Pointers for Portraits

Candid photos are often the most entertaining and engaging, but sometimes you want to make sure you get a nice portrait with everyone smiling and looking at the camera at once. When that's your goal, keep these tips in mind:

■ You don't have to include your subject's entire body. Often a portrait of a person is strongest when it is composed of just the head and shoulders.

■ Ask your subject to turn sideways and look over her shoulder at you. This can be a wonderfully flattering angle, even for people who claim they never photograph well.

■ If you're taking a head shot of an adult, shoot from above not below to help hide that double chin we all dread as we get older.

■ Dress your subjects in solid colors or subtle patterns, rather than busy plaids, stripes, or loud prints. For variety, have them change clothes a couple of times; then you can choose what looks best after you've taken the images.

■ Avoid busy or distracting backgrounds: If you want to make it look like you've gone to a professional studio, invest in a few yards of solid-colored muslin to create your own backdrops.

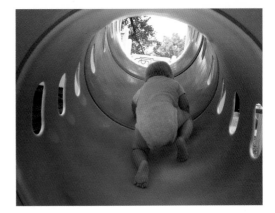

GET DOWN LOW
The vantage point of this image draws you into the scene and makes you want to cheer the baby on—and yes, he did make it to the top.

GET UP HIGH
Getting up above your subjects creates an active feeling in an image and often elicits special smiles from people who think the photographer is rather silly.

LOOK UP AT THE CAMERA
Here's a clever idea for a family self-portrait from my friends Carlos and Teresa. Have everyone lie down on the ground with their heads close together. Whoever has the longest arms holds the camera over your heads to take the picture. (Photo by Carlos Ariza.)

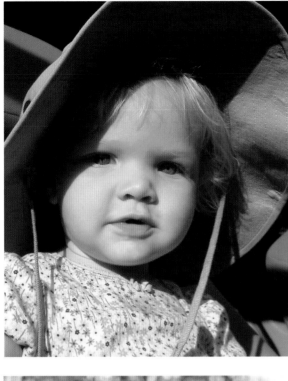

Get Up Close and Personal

Too many photographers take all of their pictures from the same distance, often about 6 to 8 feet from their subjects. If you've fallen into this rut, try this: Take a photo like you always do, then take two steps forward and take another photo; take two more steps and take another photo; then two more steps until you are right in your subject's face. When you study the images later, you may be pleasantly surprised by how much stronger your pictures are when you get close to your subjects.

WHO'S UNDER THAT HAT?
Moving in close to your subjects so that their faces fill the frame creates more intimate and captivating images. (Photo by Stephanie Kjos Warner.)

Rotate the Camera

It may seem obvious, but many photographers don't think to rotate a camera sideways for vertical images. It's easy to get used to shooting with the camera horizontal because that's how it's most comfortable to hold, but if you fall into this habit, you'll miss many of the best details at the top and bottom of a scene. Or you'll be forced to include lots of distracting background on the left or right of the image to get all of your subject in the photo. Experiment with different camera positions—you may even find that turning your camera to an unusual angle helps capture the energy of the moment.

THINK VERTICAL
The vertical picture format echoes the shape of the long handle of this little lawn mower. (Photo by Zach Goldberg.)

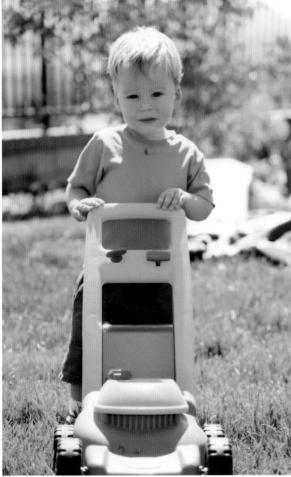

Tip
When you're photographing friends and family, don't just take shots of them standing around looking at the camera. Look for action, search out things they can interact with, and don't be afraid to ask them to do something. Your images will be more interesting, and the photo shoot will be a lot more fun.

Zoom In on the Details

Show off your daughter's engagement ring by focusing on just her left hand, capture your son's cool new glasses by taking a photo of the top part of his head, illustrate how dainty a baby is by focusing on just her hands or feet. Not only are these kinds of images wonderfully intimate, but having a variety of images, including some that just focus on a detail or two, can help you later when you want to design more interesting scrapbook pages, baby books, and other family projects.

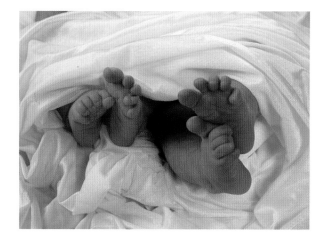

LITTLE FEET
Focus in on a baby's hands or feet to bring out the dainty details and create images that add variety to your scrapbook pages and baby books. (Photo by Mary Bortmas.)

Lenses & Focal Length

The focal length of your lens can have a dramatic impact on your image. Lenses come as fixed lengths (meaning a lens may have a focal length of 50mm, for example) or as zoom lenses, which provide a range (for example 35- to 70mm). Either way, you'll have a better chance of achieving your desired effects if you use the right lens for the job. Here's a quick primer to help you shoot like the pros:

As a general rule, a 50mm lens is considered "normal" because it creates a photo that looks similar to what you see with your eye. Any lenses that are numbered smaller than 50mm (35mm is common on many zooms) are considered wide-angle lenses because they take a "wide" look at a scene. These can be useful if you want to take a picture of a small space and can't get back very far or if you want to photograph a dramatic landscape. Journalists are fond of using wide-angle lenses for capturing a lot of information in one image, but be careful when you take photos with a wide-angle lens because it can distort your subjects. Okay, if you want to make your little brother's nose look five times bigger than it is, this is the way to do it.

Lenses that are numbered higher than 50mm (such as a 70mm, 150mm, or 300mm) are considered "long" lenses and they help you get closer to your subject. They also shorten the distance between objects in the scene and they often have short focal lengths so you usually get a blurry background around the subject. A long lens (200mm or longer) is great for shooting wildlife, since most animals will run or fly away before you can get close to them. Mid-range lenses in the 75- to 120mm range are best for taking portraits. If you can get a little distance from your subject and use one of these longer lenses, you'll almost always get a more flattering picture because longer lenses focus more sharply on your subject and provide a crisper, cleaner image.

SILLY FACE
You can tell this photo was taken with a longer lens because the background is out of focus and the subject's face is so crisp you can almost feel his goofy expression. (Photo by Zach Goldberg.)

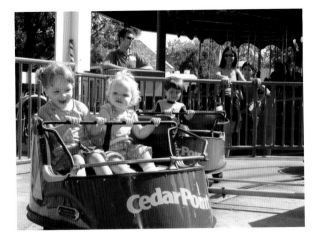

HERE WE GO!
Leave room next to the subject of a photo where the action is about to take place, such as in front of the car on an amusement park ride. (Photo by Stephanie Kjos Warner.)

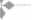

Tip
Don't clutter your images with the time stamp. You can always write the date and time on the back of your prints after your film is developed, and if you use a digital camera, the information is automatically saved with the details of the file. To see the time an image was created on your computer, adjust your folder settings to include details.

Don't Center Everything

Your main subject should be the center of interest, but not necessarily the center of the image. Moving your subject to the left or right side of the frame can create the illusion of movement, give the eye something to follow, or just make room for other points of interest that help tell the overall story. If there is any action happening in an image, it's especially important that the subject not be centered because you want to leave room for the viewer to imagine the action taking place within the frame of the image.

Always make sure you leave room on the side of the image where the action is about to occur, e.g., in front of the runner, not behind her. For example, a photo of a girl running for first base will better convey the action of her sprint if she is on the left of the image, and first base is on the right.

The rule of thirds is a common guideline photographers and other artists use when composing images. The idea is that if you divide an image into thirds, vertically and horizontally, the four points where the lines intersect are the best places to position the most interesting elements in the image—not the center of the image.

THE RULE OF THIRDS
The rule of thirds can help you create balance in a photo. The idea is for points of interest to land approximately on the intersections of lines drawn at one-third intervals. Here, the fact that the turtle's eye is not in the center of this image makes it a much stronger picture. (Photo by Ken Riddick.)

Professional photographers often spend hours setting up elaborate lighting systems in their studios and carry lots of lights and reflectors with them when they go on location to take pictures. Although you may not have all the fancy equipment of the pros, you can dramatically improve the quality of your images if you keep these lighting tips in mind when you set up your photographs.

Shoot During the "Golden" Hours

About an hour or two after the sun rises and again before it sets, the sun casts the softest, warmest, and most flattering light. If you want to make your subjects look their best, whether you're shooting a friend in the backyard or taking a photograph of a landscape or landmark on vacation, start early or wait until the end of the day.

Move into the Shade

When photographing people on a bright sunny day, there are two good reasons to move them into the shade (if possible) before you take their photo. First, most people don't squint as much in the shade (and no one looks very good when they're squinting). Second, the light in a shaded area is softer and more even, which helps eliminate the problems of backlighting (see below) and dark shadows.

Flatter Your Subjects with Sidelighting

One of the nicest and most flattering ways to light a subject is with sidelighting. An easy way to do this when you're inside is to bring your subject over to a bright window and have him stand right beside it. If you and your subject are both standing sideways, close to the window, you should get a nice sidelight on your subject's face. Ask your model to look slightly toward the window so that the shadow is not too harsh on the side of the face that is away from the window. For more dramatic results, ask your subject to look slightly away from the window to create a strong shadow.

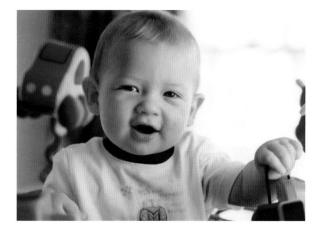

PERFECT LIGHT
You can tell this image was taken by a professional photographer. Despite the bright window in the background, the photographer was able to balance the light to get it just right on his son's adorable face. (Photo by Zach Goldberg.)

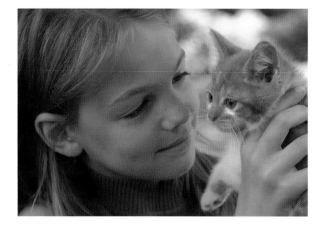

SOFTER SHADE OF LIGHT
You'll benefit from more even lighting (and less squinting) if you move your subject into the shade on a sunny day. You may have even better results if you use a flash to make sure your subjects' faces are well illuminated. (Photo by Mary Bortmas.)

Be Careful of Backlighting

One of the most common mistakes I see in family photographs happens when there is too much bright light in the background. The classic example happens when you seat a few people on a couch in front of a bright window and snap a picture. Your eye can adjust for the bright light so you may not notice the problem at the time, but the camera will be thrown off by the bright background, and when you see the photo later, you may be surprised that the people on the couch are lost in a murky darkness. There are two solutions to this problem: One is to use a flash to balance the light (more on that in the next tip) and the other is to move the people. If your subjects are facing a strong light source and the background is evenly lit, you'll get much better results.

Use a Flash in Daylight

Yes, you read that right; many photos are improved by using a flash in bright sunlight. The idea is that you want to balance the light and fill in any shadows. This is especially effective when you are taking photos of people on a bright sunny day, or when there is a bright light source behind them. You will probably have to manually set your camera to flash to do this because the sensor on your camera will not register that you need a flash. (Consult your camera's manual for how to set the flash manually.)

Tip
If you use a flash to shoot posed subjects indoors, position them far enough away from any walls or other backdrop so that the flash won't create a shadow (sometimes called a flash halo) behind them. Three feet or so is usually enough.

WATCH OUT FOR BACKLIGHTING
The photo on the left was taken without a flash, while the one on the right was taken with a flash to balance the light from the window. (Photos by Stephanie Kjos Warner.)

✳ Choosing a Digital Camera ✳

Although many people still use film cameras, I strongly recommend that you go digital. Most people who switch to a digital camera quickly find that it more than pays for itself because of the money they save on film and developing costs. As an added benefit, you'll be helping the environment because developing print film requires hazardous chemicals.

Professional photographers buy cameras that cost hundreds or even thousands of dollars. Fortunately for the rest of us, an inexpensive point-and-shoot digital camera is usually more than enough for family photos and snapshots (especially if you use the tips described in the first part of this chapter).

If you're considering buying a digital camera, I recommend that you visit a camera store and test out a few models to see how they feel, how things look through the lens, and how quickly the cameras respond when you take a picture before you buy. With most digital cameras, there is a slight delay between when you press the shutter and when the picture is taken. This is generally because of the time it takes to save the image to the memory card. Some have a longer delay than others—the more professional cameras have little or no delay, the cheaper cameras tend to have a longer delay.

When you're comparing digital cameras, there are a few things you should consider.

Some Helpful Terms

When you start looking around at digital cameras, you may encounter a number of unfamiliar terms. Here are some definitions to help you better understand your options.

Pixels and Megapixels
Digital images are made up of *pixels,* small dots of color that combine to create an image. A *megapixel* is one million pixels, and the more megapixels a camera captures, the sharper the images are. Digital cameras today range from 1 to 8 or more megapixels (most cell phone cameras capture only .03 megapixels).

Resolution and Pixels per Inch
Resolution describes the quality of an image and is measured in *pixels per inch* (ppi). The higher the resolution, the sharper the image.

Dots per Inch (DPI)
Print quality is measured in *dots per inch.* The more dots of ink per inch, the better the print quality.

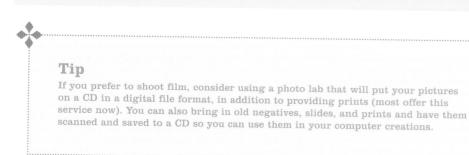

Tip
If you prefer to shoot film, consider using a photo lab that will put your pictures on a CD in a digital file format, in addition to providing prints (most offer this service now). You can also bring in old negatives, slides, and prints and have them scanned and saved to a CD so you can use them in your computer creations.

PIXELS LOOK LIKE DOTS
The number of pixels per inch greatly affects the clarity and sharpness of an image. The high-resolution image (left) is much sharper than the low-resolution image (right).

How Many Megapixels Do You Need?

Digital images are made up of pixels—the more pixels and image has, the higher the quality. But the more pixels a camera captures, the more expensive it is. How many pixels (or megapixels) you need depends on what you want to do with your images and how important print quality is to you. For the most part, any digital camera will take images that are good enough to put on a Web site or e-mail to friends, because you don't need a lot of pixels on a computer screen (you'll find more about preparing images for the Web in Chapter 3). The number of pixels in an image matters most when you're printing, because images with fewer pixels don't look as good.

How Resolution Affects Print Quality

This chart is designed to give you an idea of how many megapixels you need depending on how large you want to print your photos.

Number of megapixels	Image Resolution	Print Quality		
		Photo	Excellent	Good
0.3	640 x 480	n/a	n/a	2" x 3"
1	1,024 x 768	2" x 3"	4" x 6"	5" x 7"
2	1,600 x 1,200	5" x 7"	—	8" x 10"
3	2,048 x 1,536	5" x 7"	8" x 10"	—
4	2,400 x 1,600	8" x 10"	—	11" x 14"
5	2,592 x 1,644	8" x 10"	11" x 14"	—
6	2,036 x 3,060	11" x 14"	16" x 20"	—

Photo quality means that the image would look as good as an image that was taken with a film camera and printed from a negative. *Excellent quality* looks nearly as good as photo quality, especially to someone who is not used to scrutinizing images. *Good quality* would not make it in a professional magazine, but is probably still fine for most family projects.

Optical Versus Digital Zooms

Digital cameras feature optical and digital zoom lenses, and many offer both. The difference is that an optical zoom uses the optics (or lens) of the camera to control the zoom function. A digital zoom isn't really a zoom at all in the traditional sense. Digital zooms manipulate pixels to create the illusion of getting closer to your subject, thus making it seem like you have a longer lens. But beware that the quality of a digital zoom won't be nearly as good as an optical zoom. That's because a digital zoom essentially just crops out the center of the image area and enlarges it, much like you can do with any image-editing program. If you use an image-editing program like Photoshop Elements (covered in Chapter 3), you're better off avoiding the digital zoom and doing your own cropping and enlarging on the computer where you have more control and can get better results.

SIT AMONG THE FLOWERS
The yellow blossoms in the foreground provide a colorful contrast with the red of the Golden Gate Bridge. Manual controls allow you to adjust settings yourself, so you get exactly the image you want. (Photo by Ken Milburn.)

Looking for Digital Camera Reviews?

One invaluable resource for learning about digital cameras is Digital Photography Review, at www.dpreview.com. This Web site features in-depth reviews of current makes and models, galleries of sample photos taken with various camera models, a comprehensive glossary of terms, a buying guide so you can search for cameras based on a variety of features, side-by-side comparisons of camera models, and public discussion forums about cameras and techniques. Other sites you may find helpful are the Digital Camera resource page at www.dcresource.com, the product reviews at www.image-acquire.com, and the many reviews at www.cnet.com.

Manual Controls

Today's point-and-shoot cameras do a great job of taking care of all the settings for you, but if you want to be able to override those settings and have more control over your photos, you should choose a camera that also has manual focusing, flash, and speed controls.

Video Capabilities

These days most digital cameras can also capture short video clips. Even if your camera can capture only 30 to 60 seconds of video at a time, this feature still makes it possible to record things you can't do justice to with a still image—like a baby's first steps, a child's ballet class, or your friend's best joke. Short video clips like these work especially well on Web sites where long video takes too long to download, and they can bring the wonder of sound and motion to your Web pages.

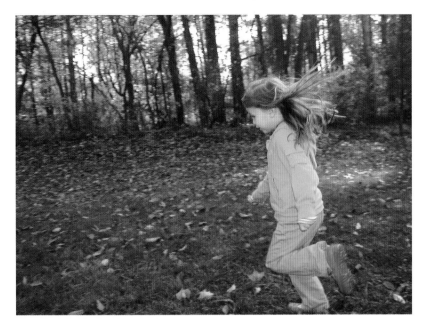

MEMORIES IN MOTION
The laughter of a child, a race to the finish line, and the simple joy of running through the park may be best captured with video. Many digital cameras include the ability to record short video clips that can be played on a computer or posted to a Web site.

Audio Capabilities

Most cameras that capture video also capture audio, a feature you can use to record the sounds of your subject or to make notes for yourself. This is a handy way to keep track of important details, like names and places, when you're out taking pictures.

Macro Features

If you love photographing flowers or anything else up close, you'll appreciate having macro features, which enable you to focus at a closer distance than most lenses. Macro lenses can also be great for shooting detail images, like a baby's hands or a fiancé's engagement ring.

Panoramic Features

Many digital cameras offer special features that enable you to take a series of pictures and then stitch them together to create one long image. If your family vacations take you to places like the Grand Canyon you may have fun with a camera that offers panoramic features.

Don't Throw Out Those "Bad" Photos

As you practice the tips and tricks in this chapter your photographs should look better and better. But what about all those less-than-perfect pictures you've already taken? Or the ones you may not get quite right in the future?

That's where photo editing comes in. You may be amazed by what a program like Photoshop Elements can do to balance bad lighting, clean up embarrassing blemishes, crop out distracting backgrounds, and even cut out small portions of several images and combine them into eye-catching montages. Follow the instructions in the next chapter to turn pictures you might have wanted to hide in the back of a drawer into keepsakes you'll want to display on the mantel.

▽ How To MORE

← → ⌂ 🖨

Learn more by clicking through these How To topics.

▽ Styles and Effects MORE

Effects ∨ All ∨

| Neon Nights | Oil Pastel | Photo Corners |
| Psychedelic St... | Quadrant Col... | Recessed Fra... |

▽ Layers MORE

Normal ∨ Opacity: 100% ▶

Lock: ⊠ 🔒

I▶ Palette Bin

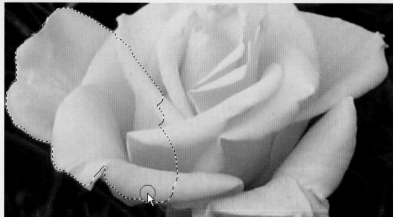

Preset Options: ▼ Width: ⇄ Height: Resolution: pixels/inch ∨ Front Image Clear

Rotate Canvas ✕

Angle: 4 ○ °Right OK
 ⊙ °Left Cancel

3

Photo Magic:
Edit & Enhance Your Digital Images

If you've ever given your friends and family red eyes with a flash, or wished you had done a better job of composing a photo—or if you just want to add some digital magic to your images—you'll appreciate the tips and tricks in this chapter. In the following pages you will learn more about digital photos and editing techniques, including how to:

- **Crop, rotate, and resize images**
- **Clear up red eye**
- **Adjust lighting and color problems**
- **Combine images to create collages and other designs**
- **Understand resolution and choose the best format for printing, e-mailing, or Web design**
- **Optimize images so they download fast on the Internet**

Modern software programs have made it possible for anyone to do subtle—and not so subtle—image editing with remarkable ease. With a little experience and a program such as Photoshop Elements, you can do almost anything you can imagine, even make it look like your guinea pig can drive the motorboat.

Adobe Photoshop Elements, like other image-editing software, has a seemingly endless array of tools and tricks. An exhaustive look at all the options would require a book just about Elements. In this section, I introduce you to the main features of the program and give you some basic tips to help you put your best photo forward.

I recommend you begin by exploring the program, looking at the options under the various menus, opening palettes, trying out different tools. If you've worked with any other software program before, many of the items in the Menu bar, Shortcuts bar, and Toolbox may look familiar to you. For example, when you select the Text tool you'll find common options across the top of the main work area, which look just like the ones you find in Microsoft Word.

Other features may not be as familiar, such as the Options bar and the Toolbox, which runs down the left side of the screen and provides quick access to the main tools of Photoshop. As you follow the exercises in this chapter, you will be introduced to the main tools and shown how to use them.

Photoshop Elements is Packed with Features

I chose to feature Photoshop Elements in this book because I think it's the best image-editing program for the price. It has most of the features of Photoshop CS, yet it's easier to use and costs a lot less. You can even download a free trial version for Mac or Windows by visiting www.photoshop elements.com. The trial lasts for thirty days, which should give you plenty of time to test it out on the exercises in this chapter.

Other programs may use slightly different names for the tools, palettes, or menus, but you should be able to apply the basic concepts and instructions in this chapter no matter which program you use.

THE PHOTOSHOP ELEMENTS WORK AREA

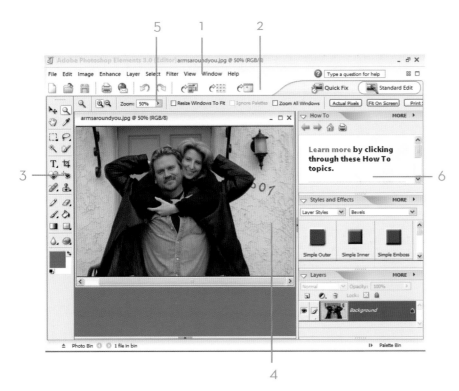

1 The Menu bar, with pull-down menus for tasks.
2 The Shortcuts bar, with common commands you can complete with one click, such as Save and Print.
3 The Toolbox, which provides easy access to drawing and other tools.
4 The Active Image area is the main work area where you create and open images to work on.
5 The Options bar, which features settings for each tool as it is selected (in this image the Text tool is selected, revealing the text formatting options).
6 The Palette Well, where palettes such as Help, Styles, and Layers display (all three of these are shown open).

The Photoshop Elements Toolbox

One of the first things you have to get used to when you use a program such as Photoshop Elements is that before you can do something, like enlarge or crop an image, you have to select the correct tool from the Toolbox. This works much like the toolbox you may have in your garage; you choose a hammer when you want to pound a nail, a screwdriver when you want to turn a screw.

Selecting a tool is easy: You just click on the icon that represents the tool you want, such as the T for adding text to an image. The tricky part is knowing which tool to use for the job (which is kind of like understanding the difference between a flat-head and a Phillips-head screwdriver).

The following list of tools is designed to help you appreciate what's possible in Photoshop, as well as which tool you'll need to accomplish each task. Open an image in Photoshop you can practice on and as you go through this list, try each tool to see how it works.

MOVE TOOL

Use the Move tool when you want to select any part or all of an image. This is the tool you want when you are using menu options to do things like change the physical size or resolution of an image, correct color or lighting, apply filters, and so much more. If you find that an option in the menu is not working, it's often because you have not selected this tool before choosing the menu option.

ZOOM TOOL

Use the Zoom tool to enlarge or reduce the display size of an image. As the magnifying glass implies, this tool lets you zoom in on an image so you can see details better or back out to get a better overall look without changing the actual size of the image.

HAND TOOL

Use the Hand tool to move around within an image. For example, if you zoom in to magnify an image, you can then use the Hand tool to move the image until you see the area of the image you want to work on.

EYE DROPPER

Use the Eye Dropper to select any color on your screen. This is a great trick when you want to do something like create text that is the same color as part of an image. Simply select the Eye Dropper, click in an area of the image that is the color you want, and notice that the Foreground Color Well (at the bottom of the Toolbox) changes to show the selected color.

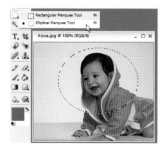

MARQUEE TOOLS

Use the Rectangular and Elliptical Marquee tools to make square or circular selections. First, notice the small arrow at the bottom of this tool icon. Right-click on the arrow to reveal both Marquee tools and then select the one you want to use. With these tools, you can click and drag to select an area of an image in either a circular or rectangular shape, an important first step when you want to do things like copy and paste an area of an image into another image.

LASSO TOOLS

Use the Lasso tools to select a section of an image in any shape. The Magnetic Lasso assists in the selection by "sticking" to the edges of a selected object. (You'll find more about how to make selections with the Lasso tools on page 61.)

MAGIC WAND TOOL

Use the Magic Wand tool to automatically select areas in an image with the same or similar colors. For example, if you want to select just the silhouette from a photo, you can use this tool to click and select only the darkest pixels. When you choose this tool, you can use the Options bar at the top of the screen to specify the color range, or tolerance, to help control how sensitive the tool is to variations in color selection.

SELECTION BRUSH TOOL

Use the Selection Brush tool to select an area of an image by clicking and dragging, or "drawing," over it. This is a great way to select unusually shaped areas when you want to create combinations of images, such as selecting just the cat out of one picture so you can paste it onto your mom's head in another. (You'll find more on how to use the Selection Brush tool on page 60.)

TYPE TOOL

Use the Type tool to add text to any image. Notice the small arrow at the bottom right of this tool: It reveals other Type tools, such as the Vertical Type tool, which enters text from top to bottom of an image instead of from left to right. Also notice that the Options bar across the top changes to reveal font and other formatting options. (You'll find more on adding text to images on page 57.)

CROP TOOL

Use the Crop tool to cut an image. Simply click and drag with this tool to indicate how much of the sides, top, and bottom you want to remove. Once you have made a selection, you can click and drag on any of the corners to enlarge or reduce the crop area. When you are satisfied, double-click in the middle of the image to make your crop. (You'll find more on cropping images on page 52.)

RED EYE REMOVAL TOOL

Use the Red Eye Removal tool to (you guessed it) remove red eye. (You will find detailed instructions for how to use this tool on page 53.)

HEALING BRUSH TOOL

Use the Healing Brush tool to fix minor defects in an image, clear up blemishes, and make other corrections. (You'll find detailed instructions for how to make these kinds of edits on page 54.)

COOKIE CUTTER TOOL

Use the Cookie Cutter tool to crop an image in any of several special shapes, including a heart, butterfly, and snowflake. To specify the shape, select the tool and then use the pull-down menu in the Options bar at the top to choose the shape you want to use. Notice that the small arrow to the right of this pull-down reveals many more shapes and options. To use this tool, simply click and drag to select the area of the image you want, then double-click in the middle to complete the crop.

CLONE STAMP TOOL

Use the Clone Stamp tool to sample an image and then use that sample to paint over other areas. This is another great tool for clearing up minor defects and blemishes, and can also be used to expand an area of an image, like making it appear that there is more grass or more waves in an image. (You will find detailed instructions for using the Clone Stamp tool on page 55.)

PENCIL TOOL

Use the Pencil tool to draw hard-edged, freehand lines. Notice that when the Pencil tool is selected, the Options bar at the top of the screen displays settings for the size, opacity, and style of the line you draw. Use the Foreground Color Well at the bottom of the toolbar to specify the color of the pencil line.

ERASER TOOL

Use the Eraser tools to remove parts of an image to reveal the background color or transparency, if the image is set to transparency. (See page 61 for more on using the Eraser tools.)

BRUSH TOOL

Use the Brush tool to draw hard- or soft-edged, freehand lines, and even simulate airbrushing and other effects. Again, notice that when the Brush tool is selected, the Options bar at the top of the screen displays settings for the size, opacity, and style of the line you draw with the brush. Use the Foreground Color Well at the bottom of the tool-bar to specify the color of the brush line.

PAINT BUCKET TOOL

Use the Paint Bucket tool to fill in a selected area of an image with a solid color selected as the foreground color or with a selected pattern.

GRADIENT TOOL

Use the Gradient tool to create a range of colors. For example, if you select this tool and then click in one color of an image and drag until the cursor is in another color, the result will be a new gradient area that ranges between the two colors.

SHAPE TOOLS

Use the Shape tools to draw lines, rectangles, rounded rectangles, polygons, ellipses, and custom shapes within an image.

BLUR, SHARPEN, AND SMUDGE TOOLS

Use the Blur tool to soften lines and edges, the Sharpen tool to make lines and edges crisper, and the Smudge tool to create the kind of effect you get when you run your finger through wet paint.

DODGE, BURN, AND SPONGE TOOLS

Use the Dodge tool to lighten any area of an image, the Burn tool to darken any area, and the Sponge tool to change the color saturation or vividness.

COLOR WELLS

Click on a Color Well to select colors that can be applied using the other tools described above. Use the double-headed arrow to swap the two colors from background to fore-ground, and the small black and white boxes to return the Color Wells to black and white.

The Photoshop Elements Palette Well

The Palette Well provides easy access to floating palettes, including:

- The **How To** palette, which features tips and instructions for many tasks in Photoshop.

- The **Styles and Effects** palette, which includes bevels (ideal for creating buttons that look three-dimensional) and filters (so you can add a wide range of special effects to your images).

- The **Layers** palette, which enables you to manage different parts of an image so you can edit them separately. (You'll find out how to use layers starting on page 58 when you learn how to add text to images and create photo montages.)

THE PALETTE WELL

Make note that the Layers and Styles and Effects palettes are in the Palette Well; these are important tools you'll need later in this chapter.

Image-editing programs enable you to do everything from make it look like your two-year-old can walk on the moon to more common tasks, such as resizing and cropping photos and adding text to create greeting cards. This section starts with a few basic image-editing tasks and progresses to more advanced techniques and effects.

Keep in mind that retouching photos takes practice and that the best results often require a process of trial and error. Remember too that there is almost always more than one right way to edit your images. Your best bet is to try one technique or setting with a photo, see how that looks, and then try another, building slowly until you find what works best for you. The saving grace in all of this is that most software programs allow you to "undo" your steps so you can easily back up if you make a mistake, and try again.

Opening an Image

Now that you have a sense of the tools and options in Photoshop Elements, it's time to dive in and start editing images. But before you can edit an image, you have to open it, so let's start with the basics and find out how to preview images to be sure you open the one you want.

To open an existing image, choose Open from the File menu at the top left of your screen. This will open the Open dialog window. Find the photo you want in your image gallery, click to select that image and then click Open. The picture will appear in a new window ready for you to edit.

Note

If you know a particular photo should be there but it doesn't appear in the Open dialog box, change the Files of Type field at the bottom of the dialog box to read All Formats. Every image in the folder should now appear in the file list and become selectable.

Edit Copies of Your Images

It's a good habit to work on copies of photos when you're making changes in a program like Photoshop. You can use the File → Save As option to create a copy of any image simply by giving it a new name. I do this routinely, often ending up with two photos named something like, Dave.jpeg and Dave-edited.jpeg. Then I make changes to the copy with the confidence that I can always go back to the original image if I really mess up or decide I want to try a different technique.

To further protect your images, I strongly recommend you make backup copies. You'll find information on creating CDs and DVDs in Appendix B, Sharing Your Digital Creations.

THUMBNAILS

To display your images as thumbnails like I have done in this image, choose Thumbnails from the View option at the top of the Open dialog window.

Rotate a Little or a Lot

You may need to rotate a photo a lot if it was taken vertically and displays sideways on your screen; or you may just want to rotate an image a little because the lines are slightly out of square. Without a tripod, it can be tricky to get all the elements in an image lined up properly.

Fortunately, Photoshop Elements makes it easy to fix these problems. If you have an image that was taken with the camera held vertically, choose Rotate from the Image menu, then use the Rotate 90° option and

choose Left or Right. In some programs you may have to choose Clockwise or Counterclockwise but the effect is the same.

Perhaps the most useful option, and the most complicated to get just right, is the Custom option (called Arbitrary in some programs), which enables you to specify any number of degrees before you rotate an image. I find it doesn't take much for most photos, even ones that are noticeably out of alignment. Don't worry that the image doesn't fit the canvas right after aligning it. On the next page I'll show you how to crop an image to get rid of problems like that.

TILT YOUR HEAD

Turning the camera to better frame your subject is a good practice, but you'll end up with sideways photos. It's easy to rotate images once you open them in Photoshop Elements. (Photo by Stephanie Kjos Warner.)

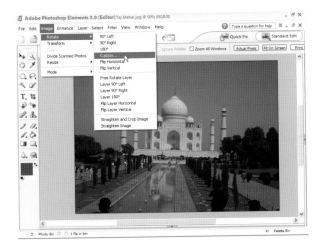

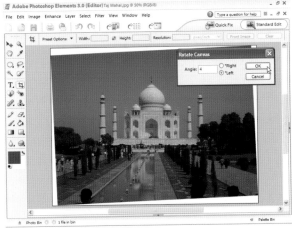

THE LEANING TAJ OF INDIA

I was a bit distracted by the crowds in Agra, India, and had trouble getting the Taj Mahal lined up in this photo. Here you see how much of a difference rotating an image just 1 degree can make.

Flip or Flop

When designing a scrapbook page or any design, you want to help the viewer's eye move easily through your composition. For example, if you use a photo in which someone is looking to the side, your viewer is likely to look in the same direction. Therefore, it usually helps if your photo subject is looking into the page layout.

What do you do, then, if the subject is looking the wrong direction? Flip it! (Some programs may refer to this with the terms Flop or Mirror.) From the Image pull-down menu, choose Rotate and Flip Horizontal. You can also flip images vertically—a clever way to make it look like Grandpa is standing on his head.

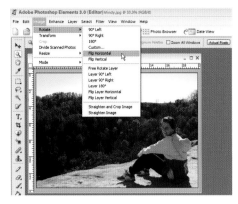

Tip

If your photo contains type, as on a T-shirt or sign, you won't want it to be backwards. Look also for recognizable background items such as a skyline or building shape, or subtle items such as a birthmark, a wedding band, or the valves on a musical instrument that might look strange after the image is flipped.

WHICH WAY DID SHE GO?
You can flip an image like this one to make the subject face in the opposite direction.

Cropping Your Photos

Cropping is a very useful tool. It's an easy way to fix a composition by getting rid of distracting background elements, and helping focus the viewer's attention on your subject.

Before you start using the Crop tool, take a good look at the photo you're considering cropping—this is one of the most important moments in the photo's life, because you are going to decide what to keep and what to discard. In this example I cropped the image to get rid of the edges after I aligned it, but I didn't want to lose too much of the image because I like the reflecting pool in the foreground. In some images, you'll want to crop a lot more. Don't be afraid to experiment, you can always choose Edit → Undo and try again if you're not happy with the result.

CUT OUT THE CROWD
Select the Crop tool and then click and drag on the image to mark the area you want to crop. When you've got the cropping frame just where you want it, double-click in the middle of the frame to complete the crop.

As you get comfortable with Photoshop Elements, you should feel more daring about trying more advanced editing techniques to remove red eye, adjust and balance light, remove blemishes, and even crop and combine images. In this section, you'll find instructions for these and more editing options.

Easing Those Red, Irritating Eyes

Does anything ruin a photo more than a pair of ghoulish red eyes? Fortunately, with Photoshop Elements those red eyes (which are caused by a camera's flash) are pretty easy to eliminate. In the Toolbox of Photoshop Elements, you'll find the Red Eye Removal tool, designed exclusively for this common task. Here's how to use it:

1. Open the image you want to fix in Photoshop Elements. Select the Zoom tool (the one that looks like a magnifying glass in the Toolbox) and use it to enlarge the eyes so they are big and easy to work on.

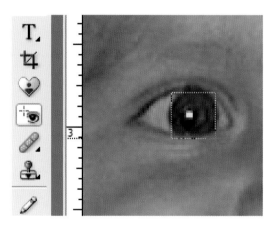

2. Select the Red Eye Removal tool from the Toolbox. Click and drag to create a box over the red eye and let Photoshop automatically fix it.

Undo Until You Get It Right

The Undo feature in a program like Photoshop Elements enables you to back up one or many steps. Knowing this, you should feel confident to experiment with any image because you can always undo your actions if you're not pleased with the results, and then try something else. In most programs, you'll find the Undo command under the Edit menu. You can also use a key command to undo by holding down the Control key and pressing the letter Z (in Windows) or holding down the Command key and pressing Z (on a Mac).

3. Red eyes removed, this precious child is his adorable self again.

Correcting Imperfections with the Healing Brush Tool

If you've ever wished you could remove that zit from the end of your nose in a school picture or clean up the run in your mascara in a wedding photo, you're going to love the Clone Stamp and the Healing Brush tools. You can also use these tools to replace a missing portion of an image, content you've accidentally deleted, or even a section of a photo that was torn in an original image before it was scanned.

The Healing Brush tool is great for filling in areas with patterns. In this example, I wanted to get rid of the ugly hole in this front lawn. With the Healing Brush, it was the easiest gardening I've ever done, as you see in these steps:

1. Open the image you want to work on in Photoshop Elements and select the Healing Brush tool from the Toolbox.

In the Options bar at the top of the screen, set the size of the brush to be relative to the area you want to fix. If you make it too big the repairs will be more obvious, too small and it will be tedious to apply. You don't need to change any other settings.

Position the cursor over an area of the image you want to use to replace the bad part, and press the Alt key and click at the same time (on a Windows computer) or press the Option key and click (on a Mac).

2. Move your cursor to the area you want to cover, and click and drag to paint the area with the selected pattern. The Healing Brush not only paints the pattern, it adjusts the pixels around the area to help blend it in.

3. In the final result, only a well-trained eye would notice that anything was changed. Anyone else would think this house had a nice green lawn. And I didn't even get any dirt under my fingernails.

Tip

It's a good idea to zoom out periodically to check your progress and see the overall effect. Pixels can look very different when you zoom in and out on the details.

Correcting Imperfections with the Clone Stamp Tool

The Clone Stamp tool can be used to make a precise replica of a selected area that you can paste into another area to create such a perfect patch even your best girlfriends won't notice you've cleaned up your acne. To use the Clone Stamp tool, open the image you want to work on in Photoshop Elements and follow these steps:

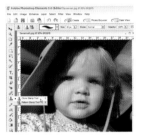

1. Select the Clone Stamp tool from the Toolbox. In the Options bar, set the size to be relative to the area you want to fix.

Position the cursor over an area of the image you want to sample. To see more detail, select the Zoom tool and click to enlarge the area you want to work on. Don't forget to reselect the Clone Stamp tool when you're done with the Zoom tool.

2. Place your cursor over the area you want to copy and press the Alt key and click at the same time (on a Windows computer) or press the Option key and click (on a Mac).

Move your cursor to the area you want to cover, and click and drag to paste. The sampled content will automatically fill in the area.

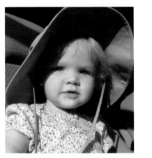

3. If you're still having trouble getting the edges of the cloned area to look smooth, click to select the Smudge tool and click and drag around the cloned area.

Balancing Colors and Contrast

When the color and contrast in your photos aren't balanced, nothing looks quite right. Backgrounds get overexposed and lack details, and foregrounds get so dark you can't see people's eyes or expressions. Fortunately, Photoshop Elements offers a few Quick Fix tools to help you adjust these image problems.

Start by clicking the Quick Fix button at the top right of the main application window. Experiment with the manual and auto settings to find what works best for your image.

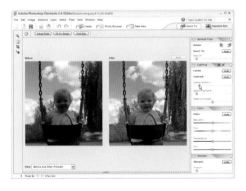

BRIGHTEN YOUR SMILE
Even a backlit image like this one can be adjusted with the Quick Fix tools. (Photos on this page by Stephanie Kjos Warner).

■ Use the **Smart Fix** option to make several adjustments at once, automatically altering the color and light. Or, you can click and drag the Amount slider to manually control these changes.

■ Use the **Levels** button to automatically adjust the contrast between the lightest and darkest pixels in your image (this made the most difference in the example shown here). Use the sliders to manually adjust Shadows, Highlights, and Contrast settings.

■ The **Color** settings let you manually adjust settings, such as Saturation and Hue, or you can click the Auto button to let Photoshop work its magic for you.

■ And finally, you can use the **Sharpen** options to clear up blurriness in your image.

If your image has very dark (underexposed) or very light (overexposed) areas, you may get better results from the Dodge and Burn tools than from the Quick Fix tools covered in the previous section. Based on real-world darkroom procedures, these tools work in tandem, having opposite but related effects on the light and dark areas of an image. The Dodge tool lightens, and the Burn tool darkens.

You can adjust the size and exposure of the Dodge and Burn tools using the Brush tool options in the Options bar at the top of the screen.

1. Select the tool of your choice: Dodge to lighten, or Burn to darken. In the example shown here, I'm going to burn the background around this little girl's head so that it's not so bright.

In the Options bar at the top of the screen, adjust the size of the Burn or Dodge tool so that it is relative to the area you want to fix. Setting the Exposure to something less than 100 percent helps make the burning or dodging effects more subtle and natural looking. In this example, I set the Exposure to 75 percent.

Place your cursor over the area you want to lighten or darken and click and drag to dodge or burn.

2. I burned in the background to bring out the details of the trees and to soften the contrast between the girl's face and the bright sky behind her. In a photo such as this, cropping the image after you do as much as you can to adjust the lighting can help reduce the impact of an overexposed background.

Creating a New File in Photoshop Elements

You can create completely new images in Photoshop Elements, using the drawing tools to create artwork or the text tools to create headline images. To create a new document in Photoshop Elements, choose File → New. In the New file dialog box, enter a name for your file and specify the Height, Width, Resolution, Color Mode, and Background. (See the section on resizing and optimizing images on page 63 for more on resolution options.) I also set this image to RGB color because I want to use color.

STARTING FROM SCRATCH
You now have a blank canvas for painting, drawing, and making headlines, or anything you want to create.

You can make your scrapbook creations, Web pages, and other digital projects uniquely your own by including headlines and text. Using the Type tool, just place your cursor anywhere on the image and start typing. The Options bar provides easy access to fonts and other formatting options. And you can use the Move tool to drag text around until you get it just where you want it.

The Options Bar

You can adjust the style and format of your text quickly and easily in the Options bar at the top of the screen when the Type tool is selected.

■ Choose the T for horizontal text or the T with the small arrow next to it for vertical text. (You can set your text at an angle using the Move tool after you've entered it on your page.)

■ Use the drop-down menu to choose a font. In this example, I've chosen the Bambino font.

■ Specify the size of your text. In this example, I've chosen 50 pt, which is a relatively large text size, suitable for a headline.

■ Leave the Anti-aliased button (the icon with the two As) selected. This smoothes the edges of text.

■ Click to select the Bold, Italic, Underline or Strike Through icons if you want to apply these formatting options.

■ Select the Alignment icon to align your text left, center, or right.

■ The Leading option enables you to adjust the space between lines of text. It is set to automatically correspond to the font size you specify, but you can use the drop-down menu to increase or decrease this number.

■ Click in the Color Well to open the Color Picker dialog box, where you can select the color you want for your text.

■ Choose the Create Warped Text option to make your text to curve up or down.

1. First make a new, blank file (see box on the previous page) or open an existing file. Select the Type tool (the letter T) in the Toolbox. Specify the settings you want in the Options bar (see box at left).

Click to insert your cursor where you want to enter text. Begin typing and letters will appear where the cursor is blinking.

If you want to change the font or other formatting option after you enter your text, make sure the Type tool is selected, click and drag your cursor across the type to select it, and then make any adjustments you want in the Options bar.

2. With the type selected, you also can experiment with the Create Warped Text tool (the letter T on with the arc in the top right of the Options bar). Choose different styles and use the sliders to see the different effects you can produce.

You can change the rotation of your text and even stretch it by clicking to select the Move tool and then clicking to select any corner handle around your text block and dragging it.

One of the most confusing features in a program like Photoshop Elements is the way it divides different parts of an image into layers. Essentially, layers enable Elements to separate an image into different sections, which is what makes it possible for you to edit and move those sections independently.

This is useful, for example, if you open a photo, add text on top of it, and then decide you want to edit the text or move it to another place on the picture. Without layers, your text would get "stuck" on the photo after you type it and you wouldn't be able to change it again without damaging the picture. With layers, you can select just the text and edit it independent of the photo.

Adding and Editing Text in a Photo

Follow these steps to add text to a photo and then move and edit that text using the Layers palette:

1. Open a photo in Photoshop Elements.
2. Click to select the Type tool from the Toolbox and adjust the settings the way you want them in the Options bar (see the box on page 57 for more on these settings).
3. Click to insert your cursor where you want to add text on the page, and type.
4. If it's not already open, choose Window → Layers to open the Layers palette. Then, if you want to make changes to a block of text after you've added it to the page, you can click to select the corresponding layer in the Layers palette to select it. The active layer is shaded gray and appears darker than the other layers. Note that you still have to make sure you have chosen the correct tool from the Toolbox, such as the Move tool to change the position of a layer or the Type tool to edit or reformat text.
5. You can switch from one layer to another by clicking the desired layer, and you can even move layers in the Layers palette by clicking and dragging. If you want one layer to overlap another layer, for example, you can control which one is on top by moving it higher up the list.

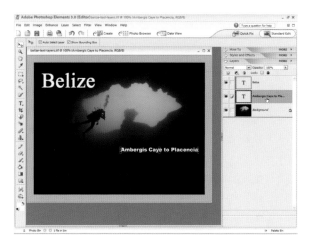

A PICTURE IS WORTH...
A picture may be worth a thousand words, but sometimes a headline or other text can help tell the story. (Photos by Ken Riddick.)

Note

To add two different kinds of text, enter the text, choose the Move tool, click in another area of the page, and then click to select the Type tool again. Otherwise, when you change the formatting options to reflect what you want for the second area of text, you'll apply those to the first text you entered.

With this exercise, you're just scratching the surface of how layers work and how important they are. In the next exercise, I'll build on this example, adding a few smaller images to this larger one to create a photo montage, like the ones featured in Chapter 4. As you add more and more parts to an image, you'll start to appreciate just how important layers really are.

Copying a Photo from One File to Another

You can create captivating designs by combining images to create photo montages and insets. Follow these steps to copy a photo or other image from one file into another:

1. With the image you want to add a photo to open in Photoshop Elements, choose File → Open and open the image you want to add to the first photo. Click to select the Move tool from the Toolbox.

Click anywhere in the image you want to copy to select it and choose Select → All to select the entire image. With the image selected, choose Edit → Copy.

With the Move tool still selected, click anywhere in the image you want to add this image to and choose Edit → Paste.

2. With the Move tool selected, you can click and drag to move the pasted content around on the main image.

3. (RIGHT) If you want to add more images, as I have in this example, repeat steps 1 and 2 for each additional image. When you're finished don't forget to save your work by choosing File → Save.

Common Key Commands

The commands to cut, copy, paste, and undo work the same in nearly every program, and they all have keyboard shortcuts that make them even easier to use. Here are the shortcuts for all four of these common tasks:

Command	Windows	Macintosh
Cut	Control + X	Command + X
Copy	Control + C	Command + C
Paste	Control + V	Command + V
Undo	Control + Z	Command + Z

Tip

If you need to resize the image or edit it in any other way, you should do so before you copy and paste it to another image. Also be aware that if your images are set to different resolutions, they may not appear as you would expect when combined. For the most predictable results, set both images to the same resolution before combining them. (See page 63 for more on resolution and resizing an image.)

When you're creating scrapbook pages or other family projects, you may want to use only part of an image, like a child's face without any background. In Photoshop Elements, you can do this in a variety of ways. For example, you can use one of the Marquee tools to trace around the outline of a person in an image, or use the Eraser tool to remove the background.

Once you've selected part of an image, you can use Edit → Copy and Edit → Paste to move it into another image. You can also use Edit → Cut to remove something (or someone) from an image. You can also apply formatting options and filters to selected areas of an image to create special effects.

Professional designers choose the best tool or technique based on the color, contrast, complexity, or shape of the area they want to select. Although making these kinds of selections is one of the more complex things you can do in Photoshop, it's also one of the most powerful. I definitely think it's easier than cutting a printed photograph with a pair of scissors, and a lot more forgiving. If you cut too much in Photoshop, just use the Undo command and start over (too bad

you can't do that with printed pictures). Perhaps even more than with other features in Photoshop, you may need to experiment to find what works best for you.

"Drawing" with the Selection Brush

One of the easiest ways to select an unusual shape within an image, such as the outline of a baby's head or the flower shown in this example, is with the Selection Brush tool. You simply drag your cursor over the image and "draw" to make a selection. This is also one of the more forgiving tools because you can stop and start without losing what you've selected. Here's how it works:

1. With the image open in Photoshop, select the Selection Brush from the Toolbox. In the Options bar at the top of the screen, set the size of the brush to correspond to the area you want to select.

To make your selection, click to place your cursor on a part of the object or area you want to select and drag to mark the selection area. Unlike many other selection tools, you can stop and start with this tool, releasing the button on the mouse and then reinserting the cursor by clicking again on the image in the same or a different place.

2. Use the Zoom tool to enlarge the area you're working on to better see the details, then choose the Selection Brush and continue with your selection. If necessary, you can zoom in close enough to select one pixel at a time.

You can make complex selections using the Selection Brush tool, even if you don't have perfect mouse control. (The more you practice with these techniques, the more you'll appreciate the importance of mouse control.)

Selecting Parts of an Image with the Lasso Tools

The Lasso tools are commonly used to select unusual shapes. You can select the Lasso, Magnetic Lasso, or Polygonal Lasso from the Toolbox and use them to trace outlines by moving your cursor around the image to draw a selection. The Lasso tools are tricky when you first start using them, which is why many people prefer the Selection Brush and the Eraser tool described in the previous two sections, but these are powerful tools and commonly used for these functions.

The Magnetic Lasso is cool because it automatically snaps itself to pixels that are similar to each other and in contrast to other parts of an image, such as the orange nose of a snowman against his white face. To use this tool, select the Magnetic Lasso from the Toolbox and click to place your cursor in an image where you want to begin making a selection. Then carefully move the cursor to trace a little ways along the outline, click again, move your cursor a little more, and click again. Although it's not a prefect science, the selection line should snap to the object's outline, helping make sure you select just what you want. When you have completely surrounded an object, click the cursor on the same place you began your selection to complete it.

The Polygonal Lasso tool is good for selecting objects with straight lines. To use this tool, click to select it from the Toolbox, click to begin your selection at any corner of the subject, move your cursor to the next corner, and click again. Continue until you have completely traced the outline of the image.

GOT YOUR NOSE
The Magnetic Lasso makes it easy to select parts of an image, such as this carrot nose, that contrast with the rest of the picture.

Photoshop CS Makes Better Selections

Although Photoshop Elements is a great program capable of everything most people would ever want to do for a family project, I feel compelled to point out that making these kinds of special selections is faster and easier in Photoshop CS. At more than six times the price, the professional version probably isn't worth the expense unless you use it professionally, but you should know that the "pros" do have an advantage when it comes to some of these advanced editing techniques.

Erasing What You Don't Want

You can use the Eraser tool to remove parts of an image, including the background, and it makes a great cleanup tool if you're having trouble selecting exactly what you want from an image. After you've made your selection with one of the other tools, you can use the Eraser to remove any rough edges. Here's how that works:

1. Once you've selected the part of the image you want, choose Edit → Copy to copy the selected area.

Next create a new image (File → New), making sure you set Background Contents to Transparent. (That way you're not adding a new background to the selection you just made.)

2. Click to insert your cursor anywhere in the new image and use Edit → Paste to add your selection.

3. Next, select the Eraser tool from the Toolbox and use it to clean up any last details from the original image. In this example, I've used the Zoom tool to enlarge the image so I can more easily erase the last few pixels of the background. As with all of these tools, you can adjust settings, such as the size of the Eraser, in the Options bar at the top of the page.

4. Once you have the subject cleaned up the way you want, you're ready to paste it into its final destination. Choose Select → All to select the entire image, then use Edit → Copy to copy it again in its new cleaned-up form.

Open the image you want to past your selection into, click to place your cursor where you want to add the selection, and use Edit → Paste to add it.

If you want to adjust or reposition the pasted selection, click to select the Move tool in the Toolbox and then click and drag the pasted selection to move it.

LATITUDE ADJUSTMENT
With a program like Photoshop Elements you can copy part of one image and paste it into another image to transport yourself from the icy north to a tropical beach and create a card you can send to your friends while *they* are on vacation!

❋ Resizing & Optimizing Images ❋

Before you start resizing and optimizing images (a process that helps them download faster over the Internet), it's helpful to learn some basics about how resolution affects the quality of a printed digital image versus an image displayed on a computer screen.

Simply put, *resolution* indicates the quality of an image created by a digital camera or a scanner, often referred to in pixels per inch (ppi). *Pixels* are tiny building blocks that are arranged in orderly rows and columns. Each is a distinct color that blends with the pixels around it to make up an image that can be seen by the human eye. The more pixels per inch, the better the quality of the image. But because each pixel adds information to a file, having more pixels makes the file size larger. When you buy a printer you may notice that the quality it is capable of producing is measured in dots of ink per inch (dpi), not ppi.

When you're preparing an image for the Web, you want a low resolution, because that's what makes the file size small and the image download faster. Because a computer monitor can only display an image at 72 pixels per inch, no matter what the actual size of the image, there is no reason to use a higher resolution for an image you want to display on a computer. When you're preparing an image for printing, the opposite is true. Images with higher resolution print with much more clarity.

Unfortunately, you can't add pixels to a digital image to make it print better. Thus, if you receive an image via e-mail that is 72 ppi and you change the resolution to 300 dpi, you effectively reduce the physical size it will print. You can see this concept in action in the following exercise.

Saving Photos and Artwork to Be Printed

Here you will find out how to resize and save images for projects like greeting cards, calendars, or scrapbook pages that you want to print. For most printers, your best results will come from files saved at 300 ppi, but 150 to 200 ppi is often more than enough for consumer printers.

For the purposes of this exercise, I'm using a photo that was taken with a consumer-quality Canon Powershot digital camera that takes pictures that are around 8.5 by 11 inches at 180 ppi. For best print quality, I'm first going to adjust the resolution to 300 ppi, which will reduce the physical size of the image. Then I'm going to reduce the size of the image so that it is only 4 inches wide and will fit into a greeting card design. (If you are working with an image that is a different size or resolution, just adjust the values in these steps to fit your image.)

What About JPEGs?

You may have noticed that many cameras save images as JPEGs, and because this is the best format for photos on the Web, many images you download or get via e-mail will be JPEGs. Unfortunately, JPEG is a very poor file format for printing. That's because JPEGs use a special compression technique in which photo quality is intentionally discarded to save file size. That's great for downloading files quickly, but it can cause jagged edges when images are printed.

1. Open the photo in Photoshop Elements and choose Image → Resize → Image Size to open the Image Size dialog box.

To change the resolution, make sure that the Resample Image box at the bottom of the window is not checked (you don't want to resample when you're changing resolution).

2. Change the Resolution value. In my example, I changed it from 180 to 300. Notice that the size changes to 5.12 by 6.82 inches. If all you wanted to do was change the resolution and you were happy with the new size that resulted, you'd be done. If you want to make the image size smaller, as I do, continue on to step 3.

3. Before you change the size of the image, put a check mark back in the Resample Image box and make sure that Constrain Proportions is also checked, so that the image keeps the same proportions as it is reduced. (The brackets that appear next to the Height and Width boxes indicate that these fields are locked together so that changing one field automatically changes the other.)

In the Width field, enter the size you want your image to be. I entered 4 inches and the height automatically adjusted to 5.333 inches, as you can see in the Image Size dialog box shown here.

4. Click OK to save your changes and notice that the window displaying the photo gets physically smaller, reflecting the reduction in size.

To save my altered file, without altering the original, I choose File → Save As, and in the Save As dialog box, I use the Save In drop-down menu to find the folder "cool_cats" where I want to save this photo with my other cat images.

Finally, I use the drop-down menu next to the Format field box and choose TIFF.

Click Save to save your changes. If you are prompted with a dialog box with options of platform or color depth, you can leave this window unchanged unless you know you want to make adjustments.

❖

Note

On a Macintosh computer, your best format options for printing are PICT or TIFF files. On a PC, you should use TIFF or BMP files.

Optimizing and Saving Images for the Internet

Image-editing programs, such as Photoshop Elements, feature special settings that make it easy to *optimize* images so they download quickly on the Internet. If you're a little confused about ppi and resolution at this point, don't worry. The good news is that Photoshop Elements pretty much takes care of everything for you when you use the Save for Web dialog (available from the File menu). Since you're preparing images for display on a computer when you save them for the Web, what you see is really what you get when you go through this process (in contrast to images you want to save for print, which can look quite different on the computer than they do when they come out of the printer).

In this section, you first learn about the two image formats commonly used on the Internet, and why you should choose one or the other for your images. In the exercises that follow, you will find step-by-step instructions for saving any image for the Internet using the Save For Web dialog. The process of optimizing an image for the Web involves several steps, all of which can affect the appearance of an image as well as its file size, as you'll see in the following exercises.

Two file formats are commonly used on the Internet—GIF (Graphics Interchange Format) and JPEG (Joint Photographic Experts Group). You should choose the format that's best for the kind of photo or graphic with which you are working. As a general rule, use the JPEG format for multicolored images, such as photographs and highly complex artwork, and GIFs for line art, drawings, cartoons, and other images with fewer colors.

Save Drawings and Artwork as GIFs

The GIF format is ideal for graphics with limited colors, because this format enables you to reduce the number of colors to reduce file size. This can be a strange concept at first, but you're essentially taking away some of the colored dots (just the ones you don't really need). You do this because it helps you reduce the size, or optimize, your image. And, as you know by now, the smaller the file size, the faster an image downloads.

If you take away too many colors, the change can be dramatic and may not be worth the reduction in file size; but if you do it right, you may not even see the difference in quality, although the reduction in file size can be dramatic. GIFs can also be compressed, a process that further reduces file size. When you compress an image, you essentially remove unused space within the file. Follow these steps to save an image, such as this drawing of a baby, in GIF format and reduce the number of colors:

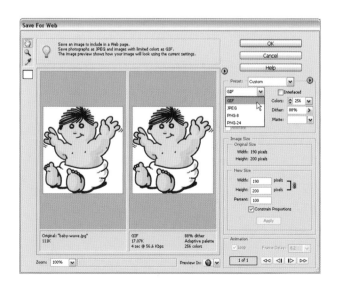

1. Open the image in Photoshop Elements. Choose File → Save For Web to open the Save For Web dialog box. In the file format list, choose GIF.

2. Set the number of colors in the Colors box. The fewer colors you use, the smaller the file size and the faster the image will download, but if you go too far, you'll adversely affect the image's appearance. The challenge is to find the lowest number of colors that still produces a good-looking image. When I set this example to only two colors (top right) the resulting image size was nice and small, but the quality of the image was terrible, so I increased back up to eight colors (bottom right).

Unless you have a lot of experience with creating images for the Web, leave the remaining settings unchanged and trust that Elements has made the best choices for you. Click OK and the Save Optimized As dialog box will open. Enter a name for the image and save it to your hard drive.

Note

At the bottom of the image preview window, Photoshop Elements displays the size of the image, as well the speed it will download. In this example, I have set the program to give me the estimated download speed on a 56K modem. Under the image on the left, you see that the original image was 111K; under the image on the right, you see that reducing the number of colors to eight resulted in an image that is less than 5K (4.583K to be exact).

E-mailing Images to Print

If you're e-mailing an image to friends and you want them to be able to make a good print, send a larger, higher resolution image in a format like TIFF that's best for printing. Just make sure your recipients have a high-speed Internet connection or are prepared for a long download time when they receive your message. You may also want to consider one of the online photo album sites featured in Chapter 5; they provide an ideal way to share print-quality images with family and friends without over-burdening their e-mail inboxes.

Save Photos as JPEGs

The JPEG format is designed for images that contain a nearly unlimited range of colors or shades of gray, such as color or black-and-white photographs. JPEGs use a compression method to remove information from an image in a way that is designed to "trick" the human eye, taking advantage of the fact that most of us are better at noticing brightness and contrast differences than minute changes in color tone.

Elements uses a compression scale of 0 to 100 for JPEG, with 0 being the lowest possible quality (the highest amount of compression and the smallest file size) and 100 the highest (the least amount of compression and the biggest file size). Low, Medium, and High represent compression values of 10, 30, and 60, respectively. You can use the slider in the dialog box to make smaller adjustments until you reach the best balance between image quality and file size.

The challenge with JPEGs is to compress them as much as possible without losing too much quality. In the following steps, you see how the Save For Web dialog makes it easy to optimize a JPEG without losing too much quality.

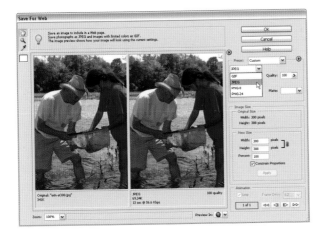 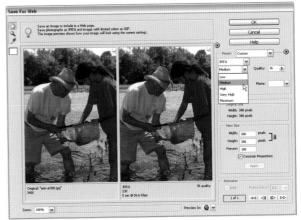

1. Open the photograph that you want to save as a JPEG, using File → Open. Choose File → Save For Web to open the Save For Web dialog box. In the file format list, choose JPEG.

2. Set the compression quality. You can use the pre-set options: Low, Medium, High, Very High, or Maximum from the pull-down list, or use the slider in the Quality field to make more precise adjustments. Lowering the quality reduces the file size and makes the image download more quickly.

Leave the other settings unchanged (unless you really know what you're doing). Click OK and the Save Optimized As dialog box will open. Enter a name for the image and save it to your hard drive. Repeat these steps for each image you want to prepare for your site.

Tip

Make sure you do any cropping, editing, and resizing of your images before you use the Save for Web dialog box. You'll get much better results when you edit an image at the highest quality before going through the optimization process.

Keep Practicing

Armed with the tips and suggestions in this chapter, you are ready to begin your own experimentation and learning with Adobe Photoshop Elements, or whatever image-editing software you choose, to create your family projects.

As you have seen, there are nearly limitless choices for applying tools and techniques. The most important lessons to remember are these:

■ Back up your digital images and work from copies whenever possible.

■ Be prepared to do, undo, and do again as you learn.

■ Experiment and then experiment some more (this is the best way to learn and as long as you're working on copies, you can't hurt anything).

■ Most importantly, have fun!

Hiking in the South West

Blaze a trail, climb a rock, leap over a stream.
What a great adventure we had, escaping the city
to explore the desert under that enormous sky.

my heart

CHAPTER 4

Digital Scrapbooking:
Make Your Pages More Memorable

Whether you're an avid scrapbooker looking for new ways to create captivating page designs, or you're new to creating scrapbooks and trying to figure out where to get started, this chapter will help you find the best ways to use your computer to create and enhance your projects. Adding computing power to your scrapbooking toolkit enables you to create complex layouts faster and easier, resize and copy photographs without a darkroom, and take advantage of an amazing collection of fonts to dress up your text.

In this chapter, you'll learn how to:

- **Preserve and share scrapbook pages you've created by hand**

- **Find the best software programs and online resources for digital scrapbooking**

- **Discover the value of templates, clip art, and special fonts**

- **Get inspired by digital scrapbook designs for travel, weddings, family events, and other occasions**

- **Learn how to use the most popular scrapbooking program on the market**

With just a few clicks, you can start building beautiful pages, or create sections of pages and print them out to paste into your handmade scrapbooks.

Handmade scrapbooks are a wonderful way to document family stories and all the colorful memorabilia that goes with them. For years, I've admired the scrapbooks my sister-in-law Stephanie makes and the way they chronicle the activities of her husband and children.

My desire to help Stephanie use a computer to preserve and enhance her scrapbook designs is part of what inspired this book. I knew that she could save time and money if she started doing at least some of her scrapbooking on the computer. It's not my intention to discourage her, or anyone else, from creating scrapbooks with all the fancy papers, glue, stickers, and stamps that grace so many handmade pages, but I do encourage her and anyone who wants to create scrapbook pages to at least add a computer to their toolkit.

Scanning Scrapbook Pages

Stephanie's scrapbooks are priceless records of her family's life, and it concerns me to know that they are irreplaceable, vulnerable to wear and tear over the years, and not easy to share between visits.

If you're already scrapbooking on paper, you may want to scan your pages to preserve them and even make copies for friends and family. Once your pages are in digital form you can save them on your hard drive, create backups, resize them, and print copies on any printer. You can also burn them to CDs and DVDs that you can play on computers or DVD players. (See Appendix B, Sharing Your Digital Creations, for more on creating CDs and DVDs, as well as e-mailing and printing your pages.)

Oversized pages don't fit on most scanners, but there are a few scanners on the market designed for large items that won't require you to dismantle your bound books. You may want to take your large pages to a copy shop or local printer, where you can pay to have your pages scanned on special commercial scanners.

LOOK WHAT MOMMY MADE!
My nieces love to look through their mother's handmade scrapbooks because they are full of images of themselves and people they know.

Find Rubber Stamps Online

Long a popular element of traditional scrapbooks, rubber stamps make it easy to add art and images to your pages. Even if you create your pages on a computer, remember you can stamp your pages after you print them. And, now that your computer is part of your scrapbooking tools, you may be delighted to find that you can find almost any rubber stamp you can imagine online. For an extensive list of companies that create all kinds of rubber stamps, go to www.rubberstampinglinks.com.

Photographing Scrapbook Pages

An even simpler way to preserve your oversized scrapbooks is to take photographs of your pages and then transfer them to your computer. You can do this best by taking pictures with a digital camera, or you can scan the printed pictures if they are a reasonable size.

If you try to photograph your books propped up at an angle, you're likely to get distortion that makes the top of the page look bigger than the bottom, or vice versa. Instead, try laying your book or pages flat on the floor and standing over them with the camera set to be as parallel as possible to the page (using a tripod can help you line up the camera and keep it steady).

Lighting is also an important consideration when photographing scrapbook pages. A bright light or flash is likely to provide uneven light or a bright spot in the middle of the page, especially if the page is coated with plastic. One of the easiest solutions, and best lighting options, is to take your book outside and photograph it in the shade on a bright sunny day. Even in the shade you should have more than enough light to illuminate your pages so you don't need a flash. Make sure the area is evenly shaded and bring a blanket or towel so you don't have to put your book directly on the ground. A neutral-colored background, such as black or white, is best for creating a clean-looking image.

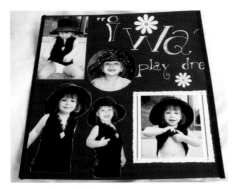

DON'T DISTORT YOUR PHOTOS
Taking a photo of a page leaned up against a wall can cause distortion, in this case making the bottom of the page seem larger than the top.

Note
You'll find instructions for scanning in Chapter 1 and lots more photography tips in Chapter 2.

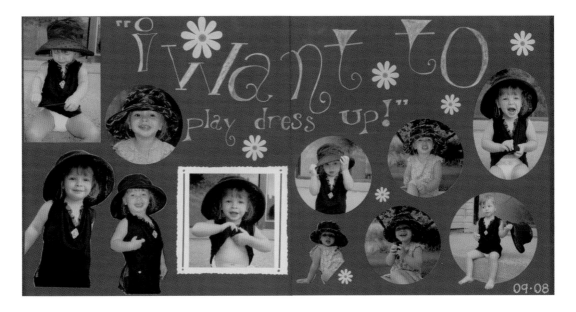

SHOOT IT STRAIGHT ON
Photographing your pages flat on the ground, or scanning them with an oversized scanner, results in clear images and makes it easy to combine two pages and have the pages fit together. (Photos and scrapbook design by Stephanie Kjos Warner.)

One of the reasons I prefer using the computer rather than creating scrapbook pages by hand is that I'm just not that talented with scissors and somehow always manage to get glue all over everything (something the cats are especially unhappy about).

Computers are so much more forgiving when you're trying to create a great design. You can crop a photo, then undo the crop if you don't like it, and try again. You can move images and text around the page, and then move them again if you change your mind—and you don't even have to worry about whether the glue has dried yet.

If you're new to working on a computer, you may not think it's easier at first. Like anything, you have to practice and get used to new tools and ways of doing things. Here are a few other advantages to scrapbooking on your computer:

- You can copy the same images over and over (without ordering extra prints), resize them, crop them, and even edit them to get rid of red eye, remove zits, or paste your sister's face onto the dog's body (you'll find instructions for editing images in Chapter 3).

- Cleanup is quick with digital scrapping because you just turn off the computer when you're done. No more piles of papers and other products all over the dining room table—and you certainly don't need to dedicate an entire room to storing your supplies.

- Digital scrapbook pages can be printed on any kind of paper—so you won't have to worry about running out of that special handmade paper in the middle of a project.

- If you're looking for just the right image for your pages, you can probably find it online and download it right when you need it. (You'll find a list of Web sites where you can search for clip art and other royalty-free images on the DigitalFamily.com Web site.)

- Digital scrapping makes it easy to make as many copies of the same page or book as you want, and you can even tailor your books to include personalized touches for friends and family. You can create page designs of any size on a computer, and even save the same page in different sizes. For example, you can reduce large page designs to create a small brag book that's easy to carry around with you.

- If you love 12- by 12-inch books (a common scrapbook size), you can get a printer capable of handling oversized pages, take your designs to a local print shop to have them professionally printed, use an online printing service, or print out your designs in pieces on a smaller printer and reassemble them in a large bound scrapbook.

SUPER HEROES
Computers make it so much easier to crop, resize, and combine images. Make your children the star of the show by cropping out the background of an image so their faces (and costumes) are the center of attention (find out how in Chapter 3).

✳ Tools for Digital Scrapbooking ✳

There are many different ways to create scrapbook pages on a computer and almost as many programs you can use to do so. If you're willing to invest a little in a new software program, your best bet is to purchase one of the dedicated scrapbooking programs described in the following section (they're not even that expensive, especially compared to all the papers, stamps, and stencils people buy to create scrapbooks the traditional way).

Word Processing and Image-Editing Programs

If you don't want to invest in a scrapbooking program, you can use any image-editing program or word processing program to create scrapbook pages, or sections of pages, for your books.

If you use an image-editing program, especially a sophisticated program like Adobe Photoshop Elements, you'll have the most design control and be able to do just about anything, but you'll also have the steepest learning curve, and you'll have to create your designs from scratch.

If you opt to use a word processing program, your options will be limited, but if you're already familiar with word processing, this may be the easiest option for you. You can still do some cool things, such as create titles and text blocks with fancy fonts that can be printed and pasted onto your pages (no more tedious calligraphy, paste-on letters, or crossed-out mistakes), and most word processors even have spell-check features to help you catch errors.

If you want to use a word processing program to create page designs, you'll find that the instructions in Chapters 6 and 9 can be applied to scrapbooks. If you need help with some of the basics of word processing programs, you'll find essential instructions—from how to create a new document to cutting and pasting text—in Appendix A, MS Word Quick Reference Guide. If you want to use an image-editing program, such as Photoshop Elements, the tips in Chapter 3 will help you edit and arrange images to create part or all of a scrapbook page.

Programs Designed for Digital Scrapbooking

As digital scrapbooking becomes increasingly popular, software programs have emerged that are specifically designed to create scrapbook pages. These programs include pre-designed templates, fonts, and clip art that make it easy to create complex page designs. Some include basic image-editing and text functions and enable you to customize templates or create your own original designs.

Choosing the best program depends on the kinds of designs you want to create, how much control you want in customizing your pages, and how much you want to spend. Here are two of the most popular scrapbooking programs you might want to consider. Both offer similar features and promise to get better with each new version:

Art Explosion Scrapbook Factory Deluxe by Nova Development (www.novadevelopment.com) makes it easy to create your own page designs with layout and graphics tools, and you can choose from an extensive collection of templates designed for a wide variety of special occasions and family events. Nova's marketing department reports this is the best-selling program on the market for scrapbooking, and for that reason I chose to feature it in this chapter (you'll find step-by-step instructions for creating scrapbook pages with Scrapbook Factory Deluxe at the end of this chapter).

In addition to scrapbooking features, this program includes a basic image editor that makes it easy to resize, crop, and do other very simple editing tasks. And you can do more than just scrapbooking because the four-CD set that comes with the program includes templates for a variety of projects, including journals, brag books, photo frames, and trading cards. The Scrapbook Factory program also includes 5,000 customizable templates and projects; more than 40,000 ready-to-use graphics and background textures to add to your projects; and 1,000 different fonts.

My Scrapbook by Ulead (www.ulead.com) also makes it easy to create scrapbook pages by customizing templates or creating your own designs from scratch. The program is bundled with background papers, clip art, and specially made text blocks.

Created by one of the leading developers of image-editing programs, My Scrapbook includes more sophisticated image-editing tools than Scrapbook Factory Deluxe, giving you greater options when it comes to balancing color and light, removing red eye, and other basic image-editing tasks, but you'll still have better image-editing tools in a program like Photoshop Elements (covered in Chapter 3). As a bonus, Ulead bundles a variety of related services from partner companies. For example, Club Photo provides printing and bookbinding services designed to fit Ulead's templates, and they make it easy to publish your scrapbook pages to the Web. The My Scrapbook program includes customizable, theme-based scrapbook templates; tools to create title pages and background papers; photo-editing features from a company known for its image-editing software; and thirty fonts and 300 clip art images

Note

At the end of this chapter, you'll find instructions for creating scrapbook pages with the best-selling program, Scrapbook Factory Deluxe.

A WALK IN THE PARK

Creating scrapbook pages is fast and easy with a dedicated scrapbooking program, such as Scrapbook Factory Deluxe, which I used to design this page. (Photos by Mary Bortmas.)

Dress Up Your Pages with Royalty-Free Art

One of the things that distinguishes scrapbooks from simple photo albums is the use of artwork and graphics. On the Internet you'll find a wide range of clip art, stock photos, and other royalty-free images, which you can use in your projects to help better tell your story. For example, if you're creating a scrapbook page about a picnic in the park, you may want to include a picnic basket in your page design. If you didn't get a good picture of your own picnic basket, don't give up on the idea. Instead, consider adding an illustration of a picnic basket from a clip art CD or Web site (you'll find a list of image resources on my Web site at www.digitalfamily.com).

As a bonus to you for buying this book, you get special access to the password-protected section of my Web site at www.digitalfamily.com, where you'll find a wide range of resources to help with your design work, including a collection of artwork created especially for this book. The graphic images on this page give you a sneak preview of some of the artwork you'll find there that you can add to your pages.

ARTWORK YOU CAN USE
These and many other images were created especially
for readers of this book and can be downloaded at
www.digitalfamily.com.

There are a seemingly endless number of ways to design a scrapbook page—whether you work on a computer, with paper and glue, or both. Your first challenge is to decide what you want to achieve with your design. Are you trying to capture a child's first smile? Record a family gathering? Commemorate a hobby or sports team?

If your answer is "all of the above," I suggest you focus on one project at a time, preferably starting with one of the simpler ones, so you can experiment and get more comfortable with the tools and techniques before you take on more complex projects. Here are a few general guidelines to get you started.

Keep It Simple

You'll have plenty of time to get fancy once you've mastered the basics, but as you attempt your first page designs on the computer, choose a project that's not too complicated, limiting yourself to just one or two images, a simple background, and text. That's more than enough for your first design.

Plan Ahead

Think about your goals and how you want to share your page designs before you start. If you want to create a book with large pages, you'll have more room in which to work and you can add more elements than if you want to create a small brag book to carry around with you. Making these kinds of decisions in advance can help guide you through the design process.

Create a Design Theme

If you're creating multiple pages to be bound in a book or otherwise grouped, your project will have a more cohesive and professional look if you develop one theme that carries through the entire project.

A good design theme may include a consistent set of colors that you use on each page or within each section and two or three fonts (any more than that and your page will look like a ransom note). You may also want to use a common motif, such as baseballs, or flowers, or balloons, throughout the pages to help create the feeling of a common theme. For example, if you're creating a brag book for your son's high school graduation and he has been a varsity soccer player, consider dressing up the pages with images of soccer balls to create a theme throughout the book.

Want to create a special anniversary scrapbook? Consider basing the theme on a location or collection of favorite places, such as the beach or a favorite city. The theme could then be made up of photos of the ocean with seashells and other beach-related embellishments from your summer cottage, or images of the skyline and landmarks from the city you visited for your honeymoon.

SCORE!
Hobbies and favorite sporting events make great themes for scrapbook pages.

Focus on the Story

It's easy to get caught up in all the tricks and cool stuff of scrapbooking, but don't lose track of the fact that what's most important is the story you want to tell. Go ahead and use the fancy fonts and artwork to dress up your pages, but only when it helps you tell your story.

Gather the Elements

Before you start working on your page designs, it's helpful to gather all of the photos, graphics, and text elements you'll want to use. Once you get into working on the design it can be disruptive to have to go looking for missing pieces. If you have everything in one place before you start, you'll get a better idea of how to pull everything together, and it will be easier to stay focused on creating the best design.

Experiment, and Then Experiment Some More

One of the best things about working on a computer is how easy it is to change and rearrange your designs. Don't settle for your first design unless you really love it.

Even professional designers rarely get it right on the first try. Instead, they create an initial design, study it, move the pieces around, and keep adjusting until they have it just the way they want it.

Save, Save, Save Yourself Some Grief

Whenever you are working on a computer, you should develop the habit of regularly saving your projects. It's heartbreaking to lose hours of work because the power goes out or someone trips over the electrical cord and unplugs your computer. If you've saved your work as you go along, you won't lose everything you've done, even if your family is full of klutzes.

Follow Your Heart

The best scrapbook designs bring out emotion, from the joy of a child's first steps to the sorrow of losing a beloved pet; you want your pages to convey the feeling, not just images and text. As you consider the elements you'll use—the color scheme, the fonts, the images—make your choices based on the mood you want to create and your pages will have greater impact.

*Mirror, mirror in her hand
She's the fairest in the land*

MIRROR, MIRROR
A series of related images shows a range of moods from this little girl, from her contemplative gesture as she gazes at herself in the mirror to her radiant smile as she looks up at the photographer and her mother in the background. (Photos by Mary Bortmas.)

✳ Digital Designs to Inspire You ✳

Sometimes he hardest part of creating a new design is facing a blank screen. Looking at other designs can be a great source of inspiration. I've included a few examples here to get you thinking about what's possible and to illustrate a few more tips you may find useful no matter what kind of page you want to create.

Go Beyond the Vacation Slideshow

For years in our family we were subjected to the classic post-vacation drill: Drag the dusty slide projector out of the hall closet, sit everyone around the darkened living room, and click through slides for hours. Despite my interest in travel, too many photos of the Paris skyline made it hard to stay awake on the couch.

A refreshing alternative to the vacation slideshow is a scrapbook of travel photos that friends and family can review at their leisure. Here are a few suggestions that can help you turn your travel photos into a scrapbook that will make your audience "ooh" and "aah" rather than yawn.

- Make the most of your images. A photo montage lets you show off several photos at once and makes a great cover for a travel brag book.

- Use the same design in different ways. For example, you might create a travel Web site to share photos with a cousin who lives far away, create a small brag book to give to your great uncle Joe, and then create a scrapbook to have at home for your own family.

- Use the best program for the job. I used Photoshop Elements and Microsoft Word to create a brag book with these travel images, much like you learn to do in Chapter 9 to create a family letter.

COLOR YOUR WORLD
Filling the page with bold colors, such as these desert hues, helps set the tone for the images.

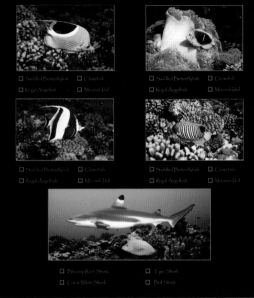

Clownfish

A clownfish cruises about his protective
anemone. You can see from the pressure
on the anemone that the current was strong
during this part of our dive, but mostly the
water was calm, warm and clear.

CREATE GAMES AND QUIZZES

You can do more in a scrapbook than just present images
and words. Keep your readers engaged by including a quiz
in your travel scrapbook. Make sure you give them the
answers on the following pages! (Photos by Ken Riddick.)

Capture More Than Just Photos on Your Wedding Day

Wedding albums are usually made up of carefully posed photos of the bride and groom sur-
rounded by family and friends, but when you create a scrapbook for a wedding, you have a
chance to include words, such as the toast from the best man, the couple's vows, and any
special songs or poems shared during the service.

Look for ways to use details from the ceremony and reception in your designs. You
could include pressed flowers, snippets of wrapping paper from gifts, or something from a
centerpiece to add color, texture, and even three-dimensional elements to your designs.

GIVE THE GREATEST GIFT

A photograph of a wrapped gift makes a
lovely background for this wedding page
design. (Photos by Zach Goldberg.)

Reward Your Hero

Sporting events and hobbies are often a significant part of a child's life, and capturing them with pictures and words can help children know that their efforts are appreciated. Adding captions, quotes from instructors and friends, ribbons, badges, and other memorabilia can bring the page to life.

To add a three-dimensional touch, consider printing your computer-designed pages and pasting physical objects, like a badge, onto the page afterward. You may also be able to scan some things, like ribbons or flat medals, and copy them onto the page. This offers the dual benefit of preserving the original element and making it easier to create multiple copies of the same page because you don't have to attach a one-of-a-kind object with glue.

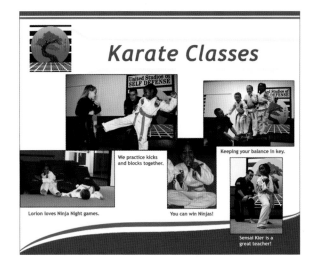

KARATE KID
Show your children how much you admire them by creating a scrapbook dedicated to their hobbies and sports. (Photos by David LaFontaine.)

Celebrate the Holidays

Halloween is a fun time to take photos because costumes and pumpkin carving make such interesting subjects. Taking images from different angles and at varied distances gives you more variety to choose from when you design your pages and will help you create more interesting layouts.

Holidays such as Thanksgiving, Christmas, and Hanukah are ideal times to capture friends and family who are not always together during the rest of the year. Make the most of these special occasions by taking lots of photos, and make sure you get more than one picture of everyone. The more images you have to choose from, the better everyone is likely to look in your scrapbook pages. Make a habit of taking two to four images of each scene or pose and you'll dramatically improve your chances of capturing everyone with their eyes open and without goofy expressions. (If you *want* goofy expressions, it's even more important to take lots of photos to get just the right pose.)

If you can get a combination of photos taken outside as well as inside, you will also add to your variety of choices later.

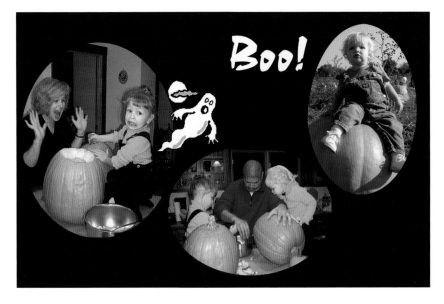

BOO!
A little text goes a long way when you have lots of pictures to tell the story. (Photos by Kevin and Stephanie Warner.)

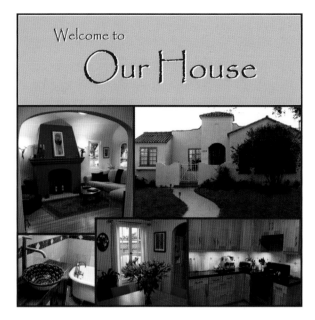

SHOWCASE YOUR SHOWPLACE
Combining multiple photos in one montage provides a tour of a new home at a glance.

Moving to a new home is an important time to reach out to family and friends, and a "virtual tour" is the next best thing to having them as guests. A photo montage, such as this collection of images from a newly renovated home, makes a great cover design.

When you photograph a house, try to capture the best lighting in each room, even if it means taking pictures at different times of day. For example, your living room may look best in the morning light, but your kitchen may catch the best light in the evening hours.

To give the feeling of a tour, start your scrapbook or brag book with a photo of the outside of the house, then a photo of the front door, then the entrance way, and then continue through the house room by room. It's easy to miss parts of the house when you add photos randomly, and you'll convey a better sense of the layout of your home if you present the images as if you were walking someone through.

Look for Inspiration & Resources Online and Off

I'm amazed at the vast array of books, magazines, and online resources dedicated to scrapbooking. Among the many advantages of using your computer for scrapbooking are all of the great resources you can find on the Internet— from page designs and layout examples, to papers, stamps, and so much more. Although some of these online services charge for their template designs and other scrapbooking goodies, you'll find lots of free ideas on these sites as well.

Creating Keepsakes
In addition to publishing one of the most popular magazines on scrapbooking, Creating Keepsakes features a wide range of resources and products on their Web site (www.creatingkeepsakes.com).

Memory Makers
Another big player in the world of traditional scrapbooks, Memory Makers offers loads of design ideas and other resources on their Web site (www.memorymakersmagazine.com), as well as books and magazines.

Scrapbook-bytes.com
The slogan on this Web site, "Changing the Scrapbooking world one computer at a time," speaks to their dedication. In addition to many great templates and design packages you can purchase on the site, you'll find a gallery of designs submitted by visitors. This site offers more interactivity than most, with a chat room and discussion area where you can compare notes with other scrapbookers.

Scrapbook-elements.com
Dedicated to digital scrapbooking, the Scrapbook Elements Web site features tips, suggestions, and a wide range of products in their online store that are especially designed for scrapbooking on your computer.

Digital Scrapbooking Resources
For more help with digital scrapbooking, visit the Digital Scrapbook Place at www.digitalscrapbook-place.com or Digital Scrapbooking Graphics at www.scrapbookgraphics.com

Digital Scrapbook Page

One of the best ways to create a scrapbook on a computer is to use a dedicated scrapbooking program like Scrapbook Factory Deluxe. In this section, I introduce you to this best-selling program and show you step-by-step how easy it is to create scrapbook pages with pre-designed templates. If you don't have this program, looking over these steps will give you an idea of how it works and what you can do with it, and should help you make a more informed decision about whether you think it's worth the $29.95 price tag.

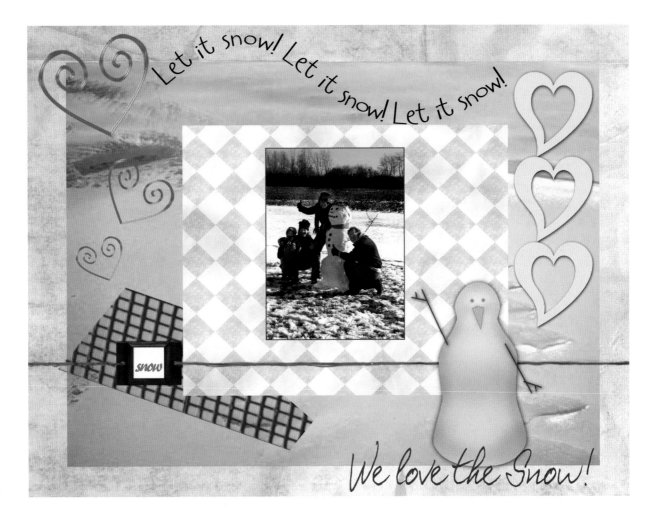

SNOW DAY
You can save your completed scrapbook designs in a variety of formats, including JPEGs, TIFFs, and PDF files, and you can print or e-mail your designs when you're finished. (See Appendix B, Sharing Your Digital Creations, for more on printing and other options for sharing your family projects.)

Using a Template

The easiest way to create a scrapbook page with Scrapbook Factory Deluxe is by using one of their many pre-designed templates.

1. Your first step after you start the program is to select the kind of project you want to create; in this case, I've chosen Scrapbook to reveal the templates and design elements for creating scrapbook pages.

2. Choose any scrapbook design from the many options featured in the program. You'll first want to choose a category from the left. In this example, I chose Family and Friends. Moving the scrollbar on the right reveals a long list of designs within the category you select, each displayed as a small image. In this example, I chose the design called First Snow.

3. When you choose a design, the selected template opens in the Customize window where you can change the text on the page. I changed the text at the bottom of the scrapbook page to say, "We love the snow!" by altering it in the corresponding text box.

4. To add an image to the page, double-click with your mouse on the box that says "Double Click to Replace." In the Replace Graphic window that opens, navigate around your hard drive by clicking on folder names until you find the image you want. The images in each folder are displayed in the Replace Graphic window. Click the small preview of the image to select the one you want, and then click OK.

5. Once your image is added to the page, you can click on any corner and drag to resize it. To move an image, click in the center of the image and drag it anywhere on the page.

6. To change the font or formatting of the text on the page, double-click on any section of text to open the Edit Text window. In this example, I double-clicked on the words "Let it snow. Let it snow. Let it snow." Click on the tabs across the top of the Edit Text window to reveal a variety of editing tools that enable you to change the font, the color, and to even add special effects, such as the way the type in this example curves like a wave.

Saving Your Page

When you are finished creating your page, you can save it in a variety of ways, such as:

- Choose Save and your page will be stored in Scrapbook Factory Deluxe; you can open and edit it from within the program anytime you want.

- If you select Save As, you can save your page with a new name and leave any earlier saved version unchanged.

- Choose Save as PDF, and your page will be saved in Adobe's Portable Document Format, which is a good option if you want to e-mail your page as an attachment.

- Select Export as Image if you want to save your page in an image format such as GIF, JPEG, or TIFF. This option is best if you want to further alter the page in a program such as Photoshop Elements. This is also the only option that enables you to specify the resolution of your design (see Chapter 3 for more information about image resolution).

- The Publish as HTML option is a bit misleading. It can't publish a complex scrapbook page as an HTML (or Web) page. Instead when you select this option, you are offered the chance to select a new HTML template from a very limited list of options. If you want to create a Web page, you are better off following the instructions in Chapter 5 of this book.

- Choose Double-Sided Print Wizard and the program will print test pages based on your specified printer options, which you can then use to determine how to place a piece of paper to print on the second side after the first side is printed.

- Choose the Envelope Setup Wizard to adjust the program's settings to print envelopes in your printer, but note that you can't automatically create an envelope based on your page design.

Making Custom Pages

You can also create custom scrapbook pages starting with a blank page and choosing any of the backgrounds, text formatting options, and images included in the program, as well as adding your own images. When you create custom pages in Scrapbook Factory Deluxe, you can:

1. Create a blank page and use the Insert Background option to choose from a wide range of background designs for your scrapbook pages.

2. Use the Insert Graphics option to add your own images or choose from any of the clip art included in the program.

3. Choose the Insert Text option to add text to your pages and then format it with any of the included fonts, colors, and other formatting options.

Multimedia Scrapbooks

Multimedia has become quite the buzz word these days, as Web sites feature video, audio, and other "multimedia" files. But when you think about it, scrapbooks have been multimedia for longer than the Internet has even existed. Text, photos, background textures, graphics, and all the other elements that make up pages are truly multimedia, in the original sense of the word.

Most of the examples in this chapter are two-dimensional because they were created on a computer, but don't forget that you can keep working on your digital page designs even after you print them out by adding three-dimensional objects, such as the ribbon from a flower girl's bouquet at a wedding, or the embossed invitation from a graduation ceremony.

Make Your Own Website
IT'S FAST & EASY!

Make a Website for Your...
BUSINESS, ASSOCIATION, FOUNDATION
CORPORATE EVENT, PORTFOLIO, CLASS
FAMILY, HOBBY, VIRTUALLY ANYTHING...

$9.95 paid monthly.
Includes Everything !

5

Hello World:
Build an Easy Family Web Site

Ever wondered why even six-year-olds have their own Web sites these days? It's because Web pages are so easy to make! If you can fill out a form and hit a submit button, you can publish your own words and photos on the Internet today. More than seven million people in the U.S. have created personal sites, and family Web sites have become an increasingly popular way to share photos, news, and history. Follow the steps in this chapter to create your own Web site so you can:

- **Publish photos from class reunions, family reunions, and other special gatherings**

- **Introduce a new baby**

- **Manage wedding plans, including offering directions and creating online gift registries**

- **Share favorite family recipes**

- **Discuss hobbies, pets, sports, and other interests**

Start thinking about what you want on your family Web site—and get ready to go online!

✳ Choosing the Best Web Design Option ✳

One of the most confusing aspects of Web design is that there are so many different ways to create a Web site and so many different kinds of sites. Browse through the Internet and you'll find everything from big corporate sites that cost millions of dollars to simple online photo albums you can create for free—even if you have no technical expertise at all.

If all you want to do is share photos, you may be best served by one of the free online photos services, like Shutterfly or Kodak Gallery. If you like writing, you may want to create a blog, a kind of online journal that has become increasingly popular, in large part because blogs are so easy to update. If you prefer to build your own custom Web site, you'll need special software and a service provider, but you'll be able to design anything you want (and have the skills to create).

Deciding what kind of Web site is best for you is an important first step, but don't worry too much about making the right decision. You can always try something else later. I generally recommend that you start simply, with an online photo album or a service that does nearly everything for you. Then you can graduate to something that requires more time, like a custom Web site.

To help you sort through the options, the following descriptions are designed to show you the different kinds of Web sites you can create and what is required for each one. In the second part of this chapter, you will find step-by-step instructions for creating your own site with an online Web service geared toward families.

BABY UPDATE

A blog (see page 93) is a great option if you want to make daily updates, like on the Trixie Update, which features a new picture every day in the photo section. This blog was created by Trixie's work-at-home dad so her mom can check in on them from the office.

Preparing Your Images for the Web

Artwork and photos enrich any Web site, but if your images are not in the right format they won't look their best and they may take a prohibitively long time to download to your visitor's computer.

If the pictures or art you want to include on your site are not even in digital format, your first step should be to scan them (or have them scanned for you). You'll find instructions and tips for doing that at the end of Chapter 1.

The next step is to save your images as GIF or JPEG files (depending on the kind of image you're using) and optimize them, so they download faster. Chapter 3 explains which file formats work best on the Web and how to make sure your images download fast from your Web site.

Tip

Online services make it easy for you to upload and display all your favorite photos and images on the Internet. However, uploading photos can take a little time, especially if you use a dial-up connection to get to the Web or want to upload a lot of photos for an album or slideshow. Don't get discouraged if uploading takes a while and consider having a second activity ready—knitting, perhaps, or a good book—so you have something to do while your photos upload.

If you want to post a few photos on the Internet right away and you're not too worried about the page design or adding lots of text, you may be happy with an online photo album service. One of the best things about these services is that they are incredibly simple to use, and, even better, they're free! All of these sites make their money by making it easy for you—or anyone else with access to your photo album—to order prints for a fee.

When you create an online photo album with one of these services, you simply use a Web browser to upload your images and they become instantly available on the Internet to anyone who has your user ID and password. (Passwords are required to ensure privacy, so you can restrict who views your personal images.)

You'll find detailed instructions for creating an online photo album with Shutterfly in Chapter 10. Here are descriptions of a few of the most popular photo album sites.

Kodak Gallery

Like other photo sites, Kodak Gallery (www.kodak gallery.com), formerly called Ofoto, offers online photo album services for free and makes money by charging for prints. If you're interested in high-quality prints, this may be your best choice (but it's not your cheapest in terms of cost per print). Kodak Gallery boasts that all of their prints are archival quality, meaning they'll last for years (images you print on a typical ink jet printer at home are likely to fade with time). In addition to regular prints, Kodak Gallery offers a few specialized services, like the ability to create and order calendars, books, and many other products with your pictures.

Online Photo Albums: Pros & Cons

Advantages
These sites are best for sharing photos quickly and, as a bonus, they provide printing services that make it easy for anyone with access to your online photo album to order prints of your pictures.

Limitations
You can't control the design of your photo album pages and you can't add many words (usually just a brief caption).

Costs
You can create an online photo album for free; these services make their money by charging for prints.

TELL ME A SECRET
Online photo album sites like Kodak Gallery make it easy for you to showcase photos on the Web for free. (Photo by Mary Bortmas.)

TEA FOR THREE
At Shutterfly.com you can turn your photos into greeting cards, albums, and even coffee mugs. (Photo by Mary Bortmas.)

Shutterfly

Shutterfly (www.shutterfly.com) also enables you to post and share photos for free, and sells printing services much like Kodak Gallery. Some users say the interface is more intuitive at Shutterfly, and Shutterfly offers a range of specialized options that make it easy to create your own personalized greeting cards, albums, calendars, T-shirts, coffee cups, and more. You'll find instructions for creating an online photo album at Shutterfly in Chapter 10.

Yahoo! Photos

Yahoo! Photos is one of many services at this popular site. It provides online photo album services and low prices for prints. You can reach this service through the main page of Yahoo! (www.yahoo.com) or go directly to Yahoo! Photos by typing photos.yahoo.com into your browser.

Flickr

Although it doesn't offer printing services, Flickr (www.flickr.com) is arguably the most sophisticated online photo site because it enables you to upload a lot more photos and features their unique Organize tools, which can help you keep track of your images. You can add more elaborate captions and other text using Flickr, and even post photos to a blog from the site. Although you can keep your photo albums private, their most unusual service is the ability to share your photos and search through photos posted by other Flickr users by entering a keyword or browsing an online album. (Of course, you have the option of keeping any or all of your own images private.)

If you want a free Web site, and you don't mind sharing your Web pages with advertisers, you'll find a few online services that let you do it yourself at no cost. Most of these services offer a collection of templates you can use to create your site and you won't need any special software.

AOL Hometown

Arguably the easiest of the free Web site services, you don't have to be a paying AOL member to use AOL Hometown (hometown.aol.com). You can choose from a wide range of templates to create sites for your family, hobby, and more. But what AOL offers in ease of use, it misses when it comes to depth. Many of the templates offer only one page and others offer only a few.

Tripod

With Tripod (www.tripod.lycos.com), you can create a simple Web site, a blog, or an online photo album. You can join Tripod for free, and this service allows you to type, delete, or format text; add and resize photos; and perform other functions. Tripod provides site management tools, an image library, and an online image-editing tool called GIFWorks.

On the downside, the program can be confusing to use. The biggest negative is the ads. You can pay a fee instead of sharing your pages with advertisers, but then you're probably better off with one of the more customized services, such as MyEvent.com, which is covered later in this chapter.

Angelfire

Angelfire (www.angelfire.lycos.com) has the steepest learning curve, but if you choose this service and become adept, you'll find it quite capable. Like Tripod, Angelfire offers GIFWorks for image editing. The downside of Angelfire is that you'll have to work in HTML code, which makes Web design a lot more complicated than it needs to be.

The other negative is that it seems impossible to log in without Angelfire trying to sell its services, and its free version posts lots of ads on your Web pages.

Free Web Site Services: Pros & Cons

Advantages
The price is right.

Limitations
You'll have no control over the advertisements that share your pages. The software and services on these sites can be confusing to new users and you'll get little or no help from customer support.

Costs
You can upgrade your site by paying a monthly or annual fee, but if you do that you might as well use one of the more specialized services such as MyEvent.com, which is covered later in this chapter.

ADVERTISER-SUPPORTED SITES
Tripod makes it easy for you to create a Web site, photo album, or blog for free, but you'll have to share your pages with their advertisers.

The fastest, easiest way to create a well-designed Web site with no ads is to use an online service, such as MyEvent.com, eWedding.com, or Babyjellybeans.com. These services provide everything you need, from domain registration to hosting services to template designs and online editing programs.

Pre-designed templates provided by these services make it easy to create a Web site for a wedding, new baby, bar mitzvah, and many other family-oriented events. We chose to feature MyEvent.com in this book (at the end of this chapter) because you can create a variety of Web sites in one place. In addition to an intuitive Web design system, MyEvent.com offers advanced features, such as planning tools, maps, and hotel reservation systems.

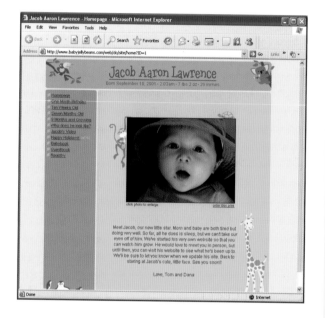

IT'S A BABY!
Babyjellybeans.com features templates and online Web services designed to make it easy to create a baby site like this one.

Online Web Design Services: Pros & Cons

Advantages
These specialized Web design services provide everything you need to create a professional-looking Web site.

Limitations
These companies charge for their services so you won't get a Web site for free as you will on the advertiser-supported sites.

Costs
Prices range from about $5 to $20 per month.

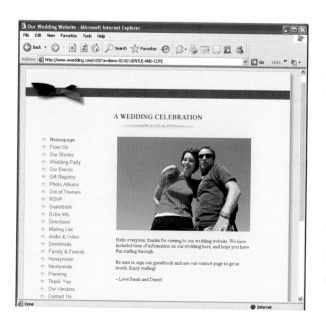

SOMETHING OLD, SOMETHING NEW ON THE WEB
You can make a Web site like this one for your wedding using the services eWedding.com provides.

According to a recent story in the *New York Times,* some 8,500 families have created blogs. Blogs are a kind of Web site that serve as online journals. Blogs have gotten a lot of press lately because they've become popular among business leaders, politicians, journalists, and, increasingly, families.

If you want to create a blog, you'll find a wide variety of software programs designed to facilitate easy updates, such as Moveable Type and the program available at Blogging.com. If you plan to make frequent updates to your site, a blog is an ideal option.

Blogs have become popular among families because they are so easy to create and provide an ideal way to keep friends and family informed on a regular basis. Check out some of the wonderful family blogs already online, including TrixieUpdate.com and BusyMom.net.

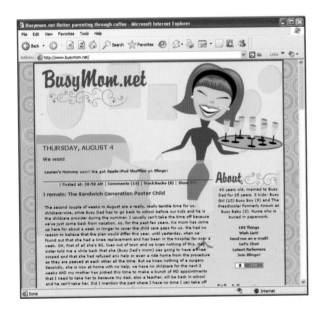

BUSY WRITER
You'll find a great example of a family blog at www.busymom.net, where a very busy family does a remarkable job of finding time to update their site.

Blogs and Online Journals: Pros & Cons

Advantages
Blogs are an increasingly popular way to create online journals that are easy to update. Blogs are also highly interactive and have built-in features that make it easy for your visitors to add comments to your site.

Limitations
You'll find limited design options for creating blogs.

Costs
Prices range from free to about $200. For personal use, you'll find many free options.

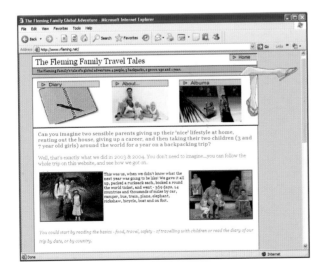

WORLD TRAVELERS
When the Flemings set off on their world adventure they started a blog at www.rfleming.net. Visit the site to discover the many countries they visited and the discoveries they made along the way.

✳ Custom Web Sites ✳

Creating a custom Web site is not rocket science, but it is harder than tying your shoes, and most of us took a few years to master that skill. However, with the latest Web design programs on the market, even a beginner can create a completely customized Web site.

If you choose this option, you create your Web pages on your computer and then transfer them to a Web server after you're happy with how they look. This development process makes it easy to experiment and helps ensure no one sees your work before you're ready. And remember, you can always start with a simple site and add more advanced features as you gain confidence and learn more skills. Once you've built your Web pages, uploading them to a server is push-button easy with the software programs described here.

Microsoft FrontPage

If you're already familiar with Microsoft Word, Excel, and other Office products, you may find Microsoft FrontPage more familiar and easier to use than some of the other Web design programs on the market. FrontPage has grown up with the Web and has become both more capable and more functional in the process. Lots of tools and features help you perform all the basic tasks that go into making a Web page. FrontPage includes several features that require support on your server, so check with your service provider to make sure it supports FrontPage Extensions. You can download a trial version at www.microsoft.com/frontpage.

Macromedia Dreamweaver

Macromedia Dreamweaver (www.dreamweaver.com) is a seasoned and trusted Web site editing program preferred by most professional Web designers. This award-winning software offers loads of advanced tools you can grow into, as well as basic tools, templates, and interactive features that make your page-building fun and easy from the moment you begin your site. You can find Dreamweaver at most software and office supply stores, and you can download a free trial version at www.dreamweaver.com.

MAY ALL YOUR DREAMS COME TRUE
Macromedia Dreamweaver is one of the most popular Web design programs on the market, and it's the program I use for all of my custom Web sites, including the site I created for this book at www.digitalfamily.com.

✳ ✳ ✳ ✳ ✳ ✳ ✳ ✳ ✳ ✳ ✳ ✳

Custom Web Sites: Pros & Cons

Advantages
You can completely customize your site, create any design you want, and have more control over your site's pages and images.

Limitations
Designing a custom site requires more time and technical expertise than using a specialized online service or creating a blog.

Costs
Web design software ranges from free to about $400, and you'll need to pay for a service provider to host your site, usually $5 to $10 per month.

The most sophisticated Web sites on the Internet, such as the online store at Disney.com or the news site at MSNBC.com, were created using complex programming and databases. Combining a database that records information about users with the ability to generate pages automatically is what enables Amazon.com to greet you by name when you return to their site, track your orders as you buy books, and even make recommendations based on your previous purchases.

These kinds of sites require very sophisticated programming, technical experience, and more expensive hosting and computer power than simpler, more static sites. They cost from hundreds to even millions of dollars to design and run. I definitely don't suggest that you begin with a database-driven Web site. You don't need anything this sophisticated anyway, unless you want to sell lots of products or publish dozens of articles and photos to your site every day.

How Web Pages Work

If you are reading this chapter, you probably already know something about surfing the Web. You have seen that Web sites can be both fun and useful, and you may even have friends or coworkers who have made their own family sites.

If so, you may have heard them talk about HTML and FTP and their favorite Web-editing software. If you still don't understand what they're talking about, don't worry: You don't need to understand all the technical details to create a great-looking family Web site.

Basically, Web pages work because Web-browser software programs—such as Internet Explorer, Netscape, FireFox, and others—know how to interpret HTML, which stands for HyperText Markup Language. Web designers use HTML code to lay out pages, insert photos and artwork, format text, add colors, and so forth. Browsers then display the pages based on the coding of the HTML.

Although learning HTML can be an interesting challenge, I've chosen to feature easier ways to create a Web site. My goal is to help you focus your attention on the words and photos that will make your site interesting to your friends and family when they visit. Unless you love the tech stuff, use an online service, such as MyEvent.com, which is covered in the following pages.

BREAKING THE CODE
HTML coding may look cryptic until you learn what it means. Fortunately with today's range of Web design programs and online options, you don't have to learn to decipher it.

Family Web Site

Of all the possible online Web site tools available, MyEvent.com is one of the friendliest and simplest to use. I chose to feature this online design service because it is family-oriented and provides many special features that are hard to create for yourself, such as password protection for privacy and hotel reservations for weddings and family reunions. You can even include video, music, and lots of photos and text.

The templates at this service are specially designed for the kinds of sites you're most likely to want for your family, from weddings to new babies to family reunions, and with the customizable templates they offer, you can build sites for your hobbies, birthdays, and anything else you can imagine.

MyEvent.com has been in business several years and has a large and growing membership. Their standard price is $9.95 per month, but you can test-drive the service for free for seven days to see how it works, and as a special bonus for purchasing this book, the folks at MyEvent.com will give you a 20-percent discount just for entering this code: DF4050.

Although the main site is MyEvent.com, you'll find links to other services, such as the Makes Websites service that enables you to customize templates to create any kind of design. Although the following steps are specific to the Makes Websites system, the basic concepts you learn here apply to almost any online Web site service.

HOME, HOME ON THE WEB

You can create a Web site for any occasion, such as the family history site pictured here.

Registering and Selecting a Template

The only program you need to create a Web site at MyEvent.com is a Web browser like Internet Explorer or Netscape. Enter the URL www.myevent.com in the Address field and you're already well on your way to creating your own family Web site.

Your first task will be to create your member account using MyEvent's user-friendly form. Before beginning, think a while about what to call your site (Site Name). This may be a decision you'll want to share with other family members. Do some brainstorming together until you hit on the best choice. You can also choose a Subtitle for your site.

When you create a new Web site you are automatically assigned an address (or domain), such as www.yourwebsiteaddress.myevent.com. However, you have the option of registering your own domain name so that you can have a more personal address, such as www.ourfamily.com.

1. First choose a name for your Web site and a Web site address. The rest of the registration form is simple. Items marked with an asterisk (*) are required to open an account. Choose a username and password you'll remember and click the button labeled Begin Free Trial.

2. Your first Web design task is to review templates and choose a layout and color scheme for your site. After you have decided, click Submit. Your entire site will automatically display with the choice you have made.

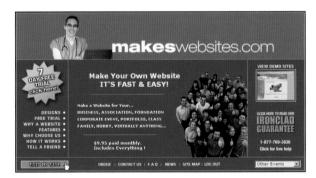

3. After selecting a template, you'll return to the MyEvent home page. Click on the button labeled Edit My Site and your Web browser will automatically open your Control Panel, where you will be warmly welcomed with your new Web site address.

Help Is On the Way

MyEvent provides outstanding customer service, at least between the hours of 9 a.m. and 5 p.m. (EST). The Contact Us portion of the Web site contains a form for submitting questions (which are answered fairly quickly) and a phone number that usually reaches a person promptly. You can also click Live Help on the home page and open an online chat session with someone at the help desk.

The Help section of the site is also worth inspecting, especially the FAQs (frequently asked questions) where you may learn a few things you hadn't even thought to ask yet.

Get to Know Your Control Panel

From the My Control Panel page, you'll create, manage, and edit the pages of your site, administer your account information, and seek help from tech support if you need it.

The Control Panel provides three primary navigation menus. Spend some time investigating the various options by simply clicking through the menus.

Account Administration

You can use the black-on-white buttons across the top of the page to edit pages, manage your account, place orders for added features, contact tech support, read online help information, and log out.

Web Site Administration

Your choices from the round-cornered, white-on-blue tabs include previewing your site (this opens a new browser window displaying your site with its most recent changes), changing the design (i.e., selecting a different layout and color scheme for your site), adding or removing pages, changing the order of your pages, and creating password protection for any pages you wish to keep private.

Edit Pages

Use the dark-blue-on-light-blue buttons down the left side to move from page to page and to edit, delete, and create content as you choose. Also, notice the Helpful Hints box with just-in-time tips for making pages. Next to each of these options, you'll find the words "Read More." Click any of these Read More links to display a small pop-up window with specific instructions for that task.

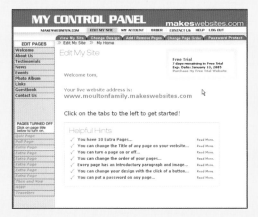

BE IN CONTROL
The navigation menus are readily available on your MyEvent Control Panel.

First Page: The Home Page

You probably already have good ideas about what to include on your site, such as a page for each family member, complete with hobbies and interests, and photo albums of favorite events or vacations. No matter what you put on your site, you should create a home page that briefly introduces the main features of your site and invites visitors to browse and enjoy themselves.

Your home page could also be called your welcome page. It's the page that will show up first whenever anyone enters your Web site address into a browser.

> **Note**
> If you are working on your site and walk away for a period of time, your session will eventually time out. If that happens, simply log back in to pick up where you left off.

1. Look at the Edit Pages menu in the left-hand column of your Control Panel. Without clicking the mouse button, move your cursor onto the top menu (Welcome) to reveal a cascading submenu. The options represent the various parts of your home page, and you can edit any of them. To get started, move your cursor onto Page Header and click.

***Page Title:** Lifeti

2. Click in the text area for Page Title and type a meaningful title or greeting for your home page. Here's your chance to be more creative than just using the word "Welcome," even though that's a friendly choice. You can change this later if you think of a better title. In this example, the home page is renamed "Lifetimes" to reflect the theme of the Moulton Family site.

3. Just below the Page Title field is a larger text area with a Formatting toolbar across the top. Here you'll type the major portion of the text for this page. Click in the box and type a subhead and a paragraph or two describing your site. Because you can edit this anytime, don't fret about making your prose perfect. On any home page, it's a good idea for the message to be a brief, friendly overview about the site.

4. If you are familiar with using word processing software (such as Microsoft Word), you'll find the Formatting toolbar quite familiar. You can use these tools to change the size of type, its color, its font, how it aligns, and more. Simply click your cursor and drag it across the words you wish to format; then begin making choices.

Write Where You Like

If you prefer to write in a program like Microsoft Word, which offers advanced word processing features like spell check, you can compose your text in Word and then use copy and paste to move it into your Web site. To do that, simply click and drag to select the text you want in your word processing document and choose Edit → Copy. Then switch over to your browser program, click to insert your text in the form where you want to add your text and use Edit → Paste. (Note that you can have both your word processing program and your browser program open at the same time on your computer to make it easy to switch back and forth between programs.)

Tip

To format text within the editing tools at MyEvent.com, click and drag to highlight the words you wish to affect, and then select any of the options from the Formatting toolbar.

5. You're not done yet—after all, you have the option to include a photo or some artwork on this page—but now that you have chosen a design, created a page title, and typed and formatted some text, it's a good time to see what your site looks like in a browser. First, you must save the work you have done so that the MyEvent server knows to display your page with your most recent edits. Near the bottom of the Control Panel page is a button labeled Submit. Click it.

6. After a few seconds, your screen will refresh (it goes blank and then redisplays the Control Panel), and a notice will appear near the top of the page telling you that your Web site has been updated.

8. Look toward the bottom of the Control Panel, just above the Submit button, for a field labeled Picture. Click the Browse button next to that field.

7. Now look at the top of the Control Panel page and use your cursor to click the tab labeled View My Site. It's a good habit to check your work periodically in a browser to see how it's going to look.

 Your Web site opens in a new browser window where you can see what you've done so far. Now close the browser window to return to your Control Panel and the page you have been working on and continue with these instructions to add a photo.

9. Navigate through your hard drive to find the photo you want. Click on the photo to highlight it, and then click Open. Click the Submit button to update the page. Once your photo is uploaded, click the View My Site tab to open your site in a new window. Your photo should be in place. It is sized automatically by settings created by MyEvent to work well within your layout. When ready to go back to the editor, just close the browser window, and you should see your photo in place in the Picture field.

10. Click in the field labeled Photo Caption and type a brief description for the photo.

11. Click into the Layout drop-down menu to choose the alignment you want for the photo. The small thumbnail to the left of the menu will display how the type will wrap around the photo. Click on your choice (which you can change later) and click Submit.

12. Click the View My Site tab and you should start to feel the joy of being a Web designer. In the box labeled Refining Your Web Pages, you'll find a few more features to play with.

Note
You can also use the Picture field for artwork you create, such as a custom headline for the title of your site. For help preparing artwork and text boxes for your Web site or any other projects in this book, see Chapter 3.

Changing Your Page Design

Each site created with MyEvent.com uses one of several design templates. Each template includes artwork and color choices that are consistent throughout all pages so your site has a professional and appealing visual appearance.

You have already chosen a design, but remember you can change it any time (even every month or week or day, if you like). Feel free to experiment. To change your site design, click the blue tab labeled Change Design at the top of the Control Panel.

Refining Your Web Pages

You have the option of adding lots of fun features to your Web pages. Return to the Control Panel and look at the other options under Edit Features to discover your choices. Depending on your site topic and your personal preferences, you may or may not want to use these options.

Main Page Options

Here you can change your Website Name and Subtitle, and you can turn other page options on or off.

Video and Music

You can upload your own video files. You cannot exceed 10MB in size, so you're limited to short clips, but you can still feature important moments, like a baby's first steps or a segment of a child's dance class. Video editing is beyond the scope of this book, but I recommend you use the Windows Media, Real Media, or QuickTime formats for video on the Web.

You can also upload music files (up to 5MB in size). In either case, the method is similar to uploading photo files: Click the Browse button next to the File field, browse your hard drive to find the file you want to upload, click to select it, type in a descriptive caption, and click Submit to begin the upload process. (Note that video and audio files take even longer to upload than images, so this can take several minutes if you have a slow Internet connection.)

You can also pick a song for your site from MyEvent's music library, which includes several familiar pop tunes and a half dozen or so classical selections. Click any radio button to make a choice and then scroll to the top of the page to a built-in player to listen to your selection. If you like it, click Submit to complete your selection and add it to your page.

Weather, Counter, Count Down, and Tell a Friend

Turn these features on and they are automatically formatted for you. As you'd expect, Weather displays the forecast for a city of your choice; the Counter tracks the number of visitors to your site; Count Down displays the number of days until or since an event (if you enter a date); and Tell a Friend automatically opens an e-mail message, making it easy for visitors to send an e-mail about your site to anyone they know.

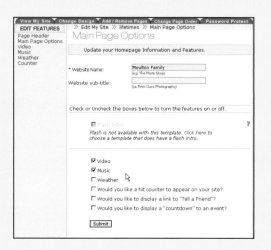

TURN IT ON
The Main Page Options include the ability to turn multimedia features on or off.

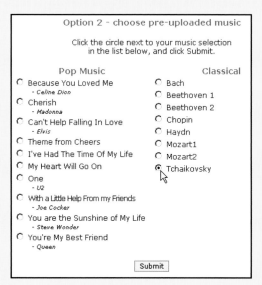

SIGHTS AND SOUNDS
You can add audio or video clips as easily as you can upload an image.

DIGITAL JUKEBOX
You can add a tune to your site from a built-in playlist.

Adding Depth: Second-level Pages

Now that you have made a home page, you are ready to expand your site. After all, this is what the Web is all about: linking information together. You can do whatever you like with your site, but as a general rule, the second-level pages should build on your introduction, adding more detailed information.

With MyEvent.com, adding pages is simple and fun. Everything you learned about creating your home page—using the Control Panel, typing in your content and formatting the text, inserting photos or artwork, clicking Submit, and previewing your page in a browser—still applies.

MyEvent.com gives you built-in pages for common sections, such as News, Events, About Us, and you can also turn on Extra Pages, which you can rename and customize to suit any subject.

Second-level pages also have a feature the home page does not: the ability to insert multiple paragraphs with additional copy and more photos.

1. From your Control Panel, without clicking the mouse button, move your cursor onto the button for any of the standard pages to reveal a cascading sub-menu. Move your cursor to Page Header and click.

You'll edit the Page Header for these pages just as you did the home page. You can enter and format copy, add a photo and a caption, click the Submit button, and preview the page.

2. To add extra pages, click on any Extra Page in the Control Panel.

3. Enter a meaningful title; then click the button labeled Turn This Page On. Use the same method to turn on Quiz, Poll, or other specialty pages.

Once extra pages are activated, you can edit the Page Header, just as you did with the home page.

4. You can add paragraphs to your second-level pages. From the Control Panel, without clicking the mouse button, move your cursor onto the button for any second-level page to reveal a cascading submenu. Move your cursor to Paragraphs and click.

5. The Paragraphs page should look familiar (see step 3 on page 99). Notice the text area field with a Formatting toolbar; the Layout controls; the Photo Caption and Picture fields, complete with a Browse button; and finally, the Submit button.

The greatest difference is near the top of the page, in the yellow bar. These instructions read "Enter each paragraph of the page below," followed by "Scroll down to see what has already been entered."

As you did on the home page, type some copy in the Paragraph Text field and format it if you wish, or simply choose to allow the default formatting of your chosen design template. Browse for a picture and enter a photo caption. Click Submit.

6. The Paragraphs page will refresh, after which the Paragraph Text field is empty, the Photo Caption field is empty, and the Picture field is empty. Oops? Don't worry if you make a mistake at any stage of this process. Just read the red instructions again for a clue to where you might have gone wrong: In this case, "Scroll down to see what has already been entered."

There it is, farther down on the Paragraphs page. Notice the field that shows this paragraph's position on the page (which you can change) and the buttons for Edit and Delete. You can change this copy or photo as often as you like—or get rid of it altogether.

Notice the Click Here link for changing the display order of the paragraphs. Just follow the instructions and you'll see how easy it is to rearrange text and other elements on your pages.

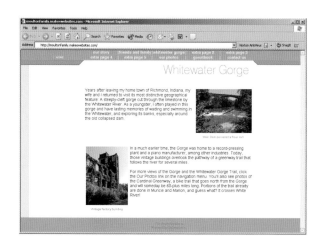

7. Click the tab labeled View My Site and see how your site is coming along.

To make your pages more interesting, consider staggering your photos and copy to the left and right. Notice that both the waterfall and the building face inward—that makes for a relaxed, cohesive design and helps keep the viewer's eye in the heart of the page, where you want it.

You can now add all the paragraphs and photos you want, but keep in mind that MyEvent also includes a Photo Album feature better suited for posting lots of pictures and making slideshows.

Adding a Photo Album

What family Web site would be complete without a photo album? Fortunately, it's easy to post albums, add captions, and view slideshows with MyEvent. As is often the case in Web design, the bigger job is getting the photos ready. You find instructions for editing and optimizing images for the Web in Chapter 3.

1. From your Control Panel, move your cursor onto the button for Our Photos; then move your cursor over and down the cascading submenu to Photo Album Titles and click the mouse button.

2. Click Photo Album 1 either in the cascading submenu or under the Edit Features menu. They both work the same.

3. Click in the field for Title of Album 1 and type a descriptive name. Click Update.

4. You have seen this before. Browse to find and upload photos and enter a photo caption. Click Submit. Repeat the process with a second photo and a third and so on.

Scroll down to see what has already been entered, and click the Change the Display Order link to rearrange your photos as often as you want.

5. After you add a slideshow, preview your site to see how it looks.

Tip
You can also send photos you want to upload to MyEvent.com by e-mail or even surface mail (MyEvent will scan them). Read the instructions to find out how this service works.

Adding and Removing Pages

On the Add/Remove Pages tab in your MyEvent Control Panel, you can choose which pages to display. This is really, really helpful and here is why. When you first start to build your family Web site, you're likely to discover how much fun it can be—so much so that you find yourself doing more than you originally thought you would. Each photo you add and every story you tell is likely to make you think of another, and another—all too special to leave out. That's the good news!

Here's where the challenges come in. You may soon find yourself torn between wanting to add every story and photo you can think of, and feeling eager to share your site with your friends and the relatives as quickly as possible.

I find the best way to handle this situation is to identify what you consider the most important parts of your Web site and focus on those first. As soon as you have that much of your site complete, go ahead and share it—just let everyone know there is more to come.

The Add/Remove Pages feature can help you manage the conundrum of having more ideas than you have time. If you've started to build a few pages, but don't want to have to finish them before you site goes live, you can turn off incomplete pages so they won't display on your site. That way, you can continue to work on some pages, while publishing the rest. This is also a useful feature if you want to have someone else review or edit your pages before you publish them (which is always a good idea). When you're finished with a page, simply turn it on by clicking the check box, and it's ready to go.

Oh, and don't forget to let your friends and family know to revisit the site every time you add fresh information.

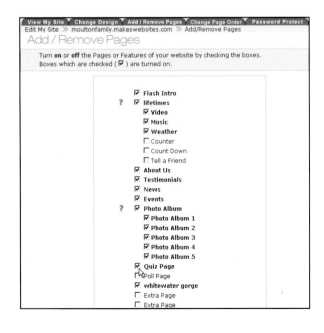

1. From your Control Panel, click the tab labeled Add/Remove Pages.

2. Click the check boxes of the pages you have ready; leave the others for another day.

When you have made your choice of pages to display, click the Submit button at the bottom of the page. In a moment, your Web browser window will refresh—in other words, the window will become blank, after which the content will reappear—and you can be confident your site structure has been updated.

Later, if you change your mind, just repeat the process to make any additional changes—it is your Web site after all.

Finishing Touches

You can also choose the order in which pages appear in the navigation menus of your Web site, and this is a real plus. Your visitors will appreciate the time you took to think about a logical arrangement for all that content you're making available.

1. Choose the Change Page Order tab from the Control Panel, and use the drop-down boxes to arrange your pages. For each page, choose the page it should follow.

2. To add security to some or all of your site, click the Password Protect tab and choose which pages to guard. Be sure to let your friends and family in on the password, or give them a hint only they will guess! A good trick is to use something like the name of a favorite pet or the street you live on so you can give them a hint that they'll know, but strangers would not be likely to guess.

An Easy Web Site Leaves Time for Fun

This is your site, so make it reflect you. You have seen that MyEvent is an easy-to-use Web site builder. Sure, some options are decided for you, but you still have lots of choices about how you customize your site. The best thing about it is that all the things you need to do—manage your site, tell your stories, post your photos—are so simple you shouldn't have to work so hard that you don't have time to enjoy your site. That means you're likely to keep your site fresh and invigorated for a long time to come, and still have time to do fun things away from your computer so you have new stories to add.

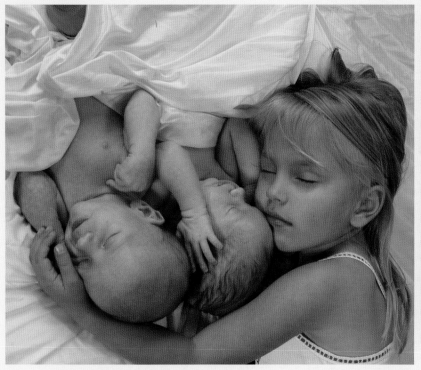

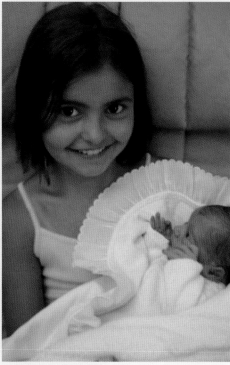

We love all our angels!

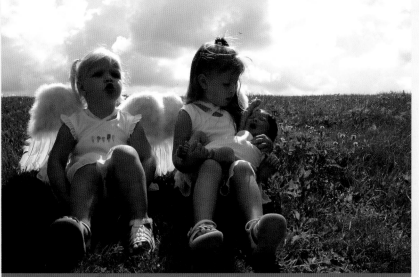

HIS FIRST DAY

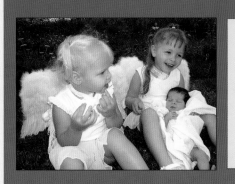

First came Mikayla

Then came Savannah

And now we have Jessica

You are all our little angels

and we love you all so much!

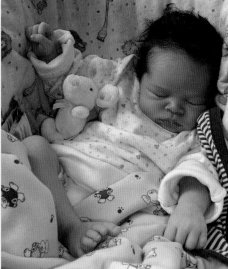

CHAPTER 6

Small Wonders:
Create Baby Books & Announcements

This chapter focuses entirely on "the art of the baby." Here you'll find instructions and templates for combining photographs, graphics, and text to create beautiful heirlooms you and your family will save, cherish, and read again and again.

When a new baby comes into the family, everyone wants to see photos right away. That's why this chapter starts with the fastest and easiest ways to share photos and progresses to more time-consuming projects. In the following pages you'll discover how to:

- **Use e-mail to get that first baby photo out right away**
- **Create a baby book you can use to follow a baby's growth**
- **Design pages to show off multiple baby pictures at once**
- **Take better photos of your baby to make your baby books extra special**

With the techniques and ideas you'll learn in this chapter, you'll be able to create a record of your child's life that will be cherished for years to come.

What better news to spread than the arrival of a new baby? Although there will be special people you want to telephone right away, you probably have too many friends and family to call in your first few happy moments. Fortunately, this modern era of electronic communication makes it possible to send everyone a quick note about the new arrival, complete with festive type, a photograph, and all the pertinent birth details.

If you prefer traditional surface mail, or if there are people on your list who do not use e-mail, you may want to create and print personalized announcements. You'll find tips and instructions for creating printed announcements in Chapter 7.

Another great way to announce a baby's arrival is to use one of the popular e-card or baby Web sites, such as Baby's Story, a free online service at www.babysstory.com (make sure you type both S's in

the middle of the address) or Babies Online (www.babiesonline.com). Baby's Story offers a number of ways to share your good news, including free baby books and e-card announcements. You can preview your card before you send it and make changes to the message or the formatting. Babies Online also gives you the option to create a pregnancy journal.

Sending an e-card is an especially good option when you want to share a photo with friends or family who don't have fast Internet connections. That's because when you "send" your card to any e-mail address you enter, the service e-mails a text message with a link to a page created on their Web site, so your photograph does not have to be downloaded to a user's inbox.

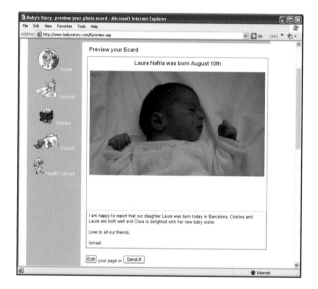

INTRODUCING LAURA!
Sending an e-card through a Web site like Baby's Story makes it easy to share a photo without overloading your friends' and family's e-mail accounts.

Involve the Whole Family

New moms and dads suddenly find themselves busier than they ever imagined they could be—after all, a baby will do nothing less than change your entire life. Consider delegating the task of sending an electronic announcement to a doting aunt or grandpa who enjoys computers, and e-mail, and Web sites. Before the baby arrives, you can have the fun of working together on what the announcement will look like and say and gathering the e-mail addresses; then when the baby is born, your techno-helper can fill in the details about time of birth, length, and weight, attach a photo of the newborn and click the Send button for you. (Then you can spend your time enjoying your newborn.)

YOU make it — Easy E-mail Announcement

E-mail is an ideal way to send timely announcements, so it's an obvious choice for those first baby pictures. Even if you use an e-card service, you may also want to create an e-mail announcement for your friends with fast Internet connections. Just keep in mind that the day your baby is born you'll have many other things to think about, so it's a good idea to plan ahead, gather all the e-mail addresses you'll need, and compose your message in advance, leaving space for the last minute details, such as length and weight.

Most e-mail programs will let you save your message in the Drafts folder without sending it. Then when the day arrives, it is a simple matter to fill in the blanks, attach a photo, and hit the Send key.

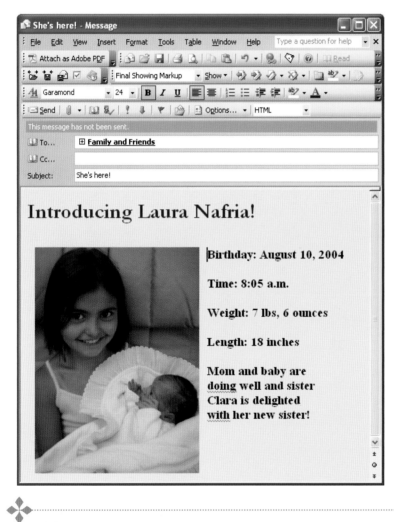

OUR HAPPY DAY!
When you create a custom e-mail message you can add as much or as little text as you want.

Tip
Before you attach a photo or insert a photo in your e-mail message, make sure you've optimized it, meaning you've reduced the file size so that it won't take forever to download and clog up your friends' and family's inboxes. In Chapter 3 you'll find instructions for optimizing your images before you e-mail them or post them to a Web site.

1. Create a Group or Distribution List with multiple names and addresses so you can send a message to many people at once automatically.

Because e-mail programs vary, consult the Help menu in your program for instructions on building a group list. If you use Microsoft Outlook, choose File → New → Distribution List and enter as many e-mail addresses as you want. When you send other news in the future, you can use this same group address so you don't forget anyone!

2. Compose your message. Most e-mail programs have easy-to-use tools for formatting text. After you've typed in some text, click and drag on the type to select it; then click the formatting icons to change type size and color and to emphasize some words with bold or italic styling. You also can pick a fun typeface or font.

3. Make sure the baby's picture is on your computer. Then, from the Insert pull-down menu, choose Insert → Picture → From File and find the photo.

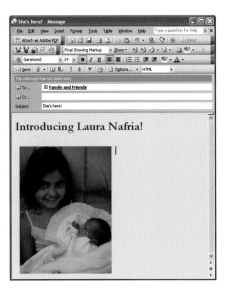

4. Click Open and the photo will appear in the body of your e-mail. If you need to resize the photo, click on it and drag a corner point. Hold the Shift key while you drag so that the height and width proportions stay the same. Add the rest of your text as you did in step 2.

When you're ready, click Send, and share your happy news.

Tip

Most e-mail programs will let you save a message without sending it by choosing File → Save. When you're ready to send it later, simply open the saved message, make any changes or additions you want, and click Send. (You should find your saved message in a folder in your e-mail program called Drafts or Saved Messages.)

Take a dash of creativity, a photo, a footprint, and a measure of love and you can easily create professional-looking baby books for your children (and their children) to cherish.

You can design a baby book just like you design digital scrapbook pages, and all of the tips and exercises in Chapter 4 can also be used in your baby books. As you think about what you want to include, consider developing a timeline of events, starting with the news that a baby is on the way, events that happen even before the baby is born, and then all the firsts—first photo, first feeding, first steps, first ride in a car, even first grade!

A baby book can be so much more than just a photo album. Think of your baby book as a chronicle of your little one's early life. Children love to read stories about themselves, and as soon as they are big enough to hold the baby book in their own little hands, they are likely to become the most appreciative audience of this special keepsake.

Many of the designs in this chapter were inspired by my sister-in-law Stephanie's handcrafted baby books. I use her photos, her stories, and her ideas in these pages, but I've re-created them on a computer to demonstrate these digital techniques. To keep things simple, I created these pages using the basic tools in Word to create these pages and edited the images in Photoshop Elements. (You'll find instructions for editing your images in Chapter 3 and tips for working with Microsoft Word in Appendix A, MS Word Quick Reference Guide.)

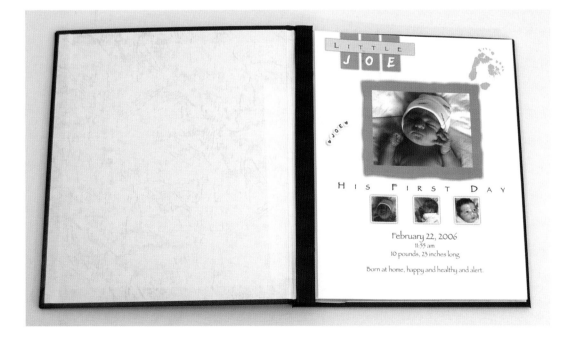

PROFESSIONALLY BOUND

When you're finished creating your baby book, have the pages bound at a craft store or copy shop for a professional finish. Also consider printing the cover pages for your book on very heavy card stock to create a sturdier book.

Note

To make it easier to create the examples in this chapter, you can download pre-designed Microsoft Word templates from the Digital Family Web site at www.digitalfamily.com. (Just follow the link to the Digital Family Album section and follow the instructions for downloading the Baby Book templates.)

Welcome Home!

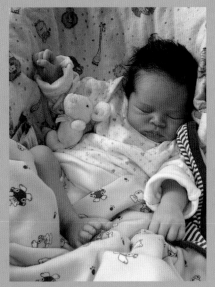

Jessica Chevonne, I imagined your face before you were even conceived. Your big sisters, daddy, and I never even discussed the possibility of not having another baby. We all knew that we wanted you. We couldn't wait to share our love and our lives with you so we prayed and waited for God to bless us a third time. It did not take long. At the ultrasound we discovered you to be a healthy, thumb-sucking, baby girl. We were delighted. I cried and I held your daddy's hand and gazed at the ultrasound machine. At long last, August 8 arrived and daddy chose your name to be Jessica, which means blessed by God.

"It will be just like the Kjos house, honey," I said. What had been my mom's blessing was now to be my own -- three little sweetie girls to bless our hearts and bless our lives.

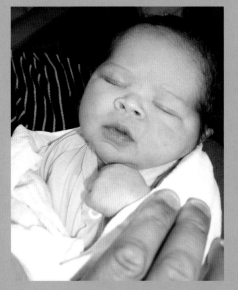

It's so sweet to have you home now so we can all snuggle in bed together while daddy reads us books.

We love you, our little Jessica.

HOME SWEET HOME
Celebrate your newborn's first day at home with a welcome page in your baby book. (Photos by Stephanie Kjos Warner.)

YOU make it | Welcome Home Page

It's always nice to include a page in your baby book to commemorate the day your new family member leaves the hospital. You can include many things on this page, from photos of family and friends holding the baby to cards and messages you receive.

Although the following project and template were designed to be a welcome home page, this layout works well for other special events as well, such as baby's first bath, Daddy feeding the baby with a bottle, or siblings looking over the edge of a crib at a new brother or sister.

Start with a Picture and a Headline

It's a good practice to prepare your digital photos and any artwork you want to use before you start working on the layout and save your images into a folder on your computer where they will be easy to find as you're working on the design. (You'll find instructions for editing images in Chapter 3.)

1. Go to www.digitalfamily.com and download one of the Baby Book templates (in this example, I used the file named Welcome-template.doc). Open the template and you'll see the words Headline and Story. (Note that you can change the background and headline colors.)

2. Double-click the word Headline. Type a title for your page and change the font, size, and color to suit your taste. In the example, I changed the word Headline to "Welcome Home!" and used a font called Cheddar Salad (yes, that's really what it's called) because I like the handwritten look. When you're working on a baby book, I recommend fonts and colors that give your layout a light and lively mood.

About the Templates

All the example templates measure 8.5 inches wide by 11 inches high and have generous margins to make it easy for you to print your pages on standard paper on your home printer. You have the option to make these pages larger, however, by using Page Setup, which you will find under the File menu. If you do so, you will want to resize and reposition the text and picture boxes so your enlarged layout remains balanced.

3. Now add your photo. Click to insert your cursor into the document below the word Story; you'll see your cursor blinking. Then choose Insert → Picture → From File. Find the picture on your computer, click to select it, and click Insert.

Add Your Story

Even if you add images to a page in a word processing program you still format and enter text the same way; you just need to pay a little attention to whether you want the text to appear before or after your image and if you want the text to wrap. You'll find out how to do all that in the following steps.

2. As you add to your story, the photo gets pushed down the page. You want the text to wrap around the photo so the image is beside the text. This may seem a little tricky at first, but you'll get the hang of it.

Double-click on the photo to open the Format Picture dialog box. Click the Layout Tab to see the Text Wrapping tools and click to select the icon labeled Square, the one with horizontal lines around the dog. Then click to select the button next to the Left alignment button.

4. Click on the photo to select it, then grab one of the corner points and drag it to resize the photo. Press and hold the Shift key as you resize the photo to maintain its proportions. You may adjust the size of the photo again as you work and add text.

1. It's time to create your story. Double-click the word "story" to select it and start typing to replace it with your own text. You can click and drag to select your text and use the formatting tools in the toolbar to change the font, alignment, size and other formatting options any time as you work.

3. Now you can click and drag to move your photo up or down the page and the text will flow around it. Another way to move an image is to click it once to select it and then nudge its position with the arrow keys on your keyboard—right, left, up, or down.

Now finish typing your story, and reformat the text as needed.

4. If you want to use the clip art included with your word processing program, as I've done in this example, choose Insert → Picture → Clip Art.

To be able to drag the artwork anywhere on the page and overlap other images or text, double-click on it, and in the Picture Format dialog box choose the text-wrapping style In Front of Text.

5. Add more artwork and give each piece a wrapping style of In Front of Text; then move those images where you want them to appear on the page.

Note

Microsoft Word and other such programs come packaged with clip art, arranged in a searchable library by popular subject areas such as animals, transportation, and sports and leisure. You also have the option of downloading additional clip art from the software company's Web site, which is how I got the clip art images of the dragonfly and butterfly shown here. Follow the instructions in your program to add clip art.

6. Add any other images, artwork, or text you want and position them on the page. In this example, I added another photograph of the baby, double-clicked to open the Format Picture dialog box, and set alignment to Square and Right to arrange it in the bottom right corner of the page.

7. If you want to change the color around the Headline in this template, double-click on the text box to open the Format Text Box dialog box and use the pull-down menu to change the Fill Color. To change the color of the page, choose Format → Background and select any color from the color box.

This page design is intentionally simple to make it easy for you to learn how to insert images, adjust alignment, change colors, and move elements around a page. Now that you've got a handle on these basic concepts, try your own variations on this design, adding more images and clip art or moving pictures to different parts of the page.

While the experience of holding your newborn is still fresh, create a page that expresses your feelings as new parents. I designed this parents' page based on a page my sister-in-law Stephanie created with messages written by her and my brother Kevin just after their first child was born. I love the way they each wrote directly to the baby and how Stephanie balanced the design by placing a photo in the middle of the page to divide the two messages.

This page design could be used for many other occasions, such as a baby shower page with a list of who attended and their gifts, or a grandparents' page with photos of grandpa and grandma hugging the expectant mother, or a page that features an ultrasound of your baby (ask your doctor for a copy on a CD when you go in for your next appointment).

My precious Mikayla, I am thankful for so many tings! I am blessed by God to have Kevin and you as my family! I never ever thought I could love someone as much as I love you. My favorite time with you is immediately after you nurse. I love to stroke your beautiful soft hair and look at your adorable face. Sometimes you hold my hand and you smile. You are the sunshine of my life. I pray that I will be the mommy to you that my mom was to me. I want us to always have a loving relationship and I want to always be there for you. There is so much to look forward to! We have the rest of our lives to grow together. For now, I will enjoy you day by day. I love you Mikayla Marie.

God Bless you.

-- Mommy

On July 26, 2000, during the early morning hours you came into our lives. This was by far the most exciting and emotional event of my lifetime. For nine months prior to your birth, I prayed for your health and spirit. These prayers were answered when you were born. We are blessed to have created such a miracle. The most precious times for me have been holding you in my arms while we look into each others eyes. I try to imagine what you are thinking. I see so much life in you and the I see the love you have for us as parents. I look forward to the life we will spend together. I want you to know you are my sunshine and daddy loves you.

God bless you.

-- Daddy

DEAR BABY

For this page of Mikayla's baby book, Kevin and Stephanie each wrote a greeting to the newborn and wrapped their messages around a photo to create a memorable personal page she's sure to enjoy long after she's grown.

1. Prepare your digital photo and artwork and save them in a folder on your computer.

From the DigitalFamily.com Web site, download the file named Parents-page-template.doc. Open the template. You'll find the right and left columns filled with text to show how much space you have for your messages.

2. Click and drag to select the text in the left side and replace it with a greeting. Format the text with the font, size, and color you prefer.

Repeat this process to add a message in the right column. This design looks best if you use the same font and text size, but you can express your individuality by choosing different text colors.

3. To align the text as you see in the finished example, click and drag to select all of the text in the left column. Choose Align Right from the Formatting toolbar.

Repeat for the right column, but choose Align Left and both columns will justify neatly to the center of the page.

4. You're ready to add a picture. Click to place your cursor in the top left corner of the page (don't worry, you'll move it later) and choose Insert → Picture → From File. Click to select the image you want to use, and click Insert. Your layout may jump about a bit when the photo is added to the page but that's okay.

Double-click the photo, and in the Format Picture dialog box choose the Square wrapping style and leave the alignment set to Other. Then click and drag the image to move it to the center of the page so the columns of type flow around it on both sides. If the first column is too long and bumps the second one to the next page, don't worry, you'll fix that in the final step.

5. You can add clip art by choosing Insert → Picture → Clip Art. If one message is longer than the other, you can add an image to that side of the layout.

Double-click each image and in the Picture Format dialog box, choose the text wrapping style In Front of Text if you want your artwork to overlap other elements on the page or choose Square if you want the text to wrap around it as I did in this example.

Sibling Page

It's not always easy sharing your parents' attention, but getting your own page in your new sibling's baby book can help. Show all your little angels how important they are by creating a design that features all your children.

In the previous projects, you saw how to insert art and place it anywhere you'd like in a design, and you learned a few basics about adding text and working with two-column layouts. In this example, you'll find out how to insert free-floating text boxes that you can move anywhere on a page. You'll also learn how to resize text boxes, add background colors and borders, and even how to float text over an image.

We love all our angels!

First came Mikayla
Then came Savannah
And now we have Jessica

You are all our little angels
and we love you all so much!

WRITTEN IN THE SKY
By creating a text box and removing the background you can add words that seem to "float" over your images. (Photos by Stephanie Kjos Warner.)

Tip
Although it's easy to add text and place it over your images in Word, you'll have even more formatting options and design control in a program like Photoshop Elements. See Chapter 3 to learn how to work with text in Elements before you insert your images into a design in a program like Word.

1. There is no template for this exercise because it's designed to show you how to place text anywhere on a page. Create a new document by choosing File → New. Here I created a standard, letter-size page.

Next, add the images you want for this design by choosing Insert → Image → From File. If you want to move your images around the page, double-click to open the Format Picture dialog and choose In Front of Text under Layout. To wrap text around an image, choose Square or Tight.

2. Choose Insert → Text Box; ignore any box that may automatically appear, and instead click your cursor and drag to create a small box where you want it on the page, even right on top of an image as I've done in this example.

After you draw the box, you can click and drag any of the anchor points to resize the text box, or click on the border in between anchor points and drag to move the box.

3. Click to place your cursor inside the text box and type to enter your text. Click and drag to select it; and use the Formatting toolbar to style it, just as you did in the previous projects.

4. Now for the cool part. Double-click the border of the box and in the Format Text Box dialog box that opens click on the Tab that says Colors and Lines.

In the Fill section, click the pull-down arrow next to Color and choose No Fill. In the Border section, click the pull-down arrow next to Line and choose No Line. Click OK and notice that the box disappears and your text seems to float over the picture.

5. Now repeat step 2 to create another text box that is not over an image. Double-click the border of the box and in the Format Text Box dialog box that opens click on Colors and Lines. Use the pull-down arrow to set the Fill Color to whatever color you want. You can also change the text color in the Formatting toolbar at the top of your screen; just make sure you have enough contrast so that your words are readable.

To add a color to the background of the page, choose Format → Background and select any color from the Color box.

No matter what the parents do, every child is different; even twins have unique smiles, personalities, and dispositions. Make sure your baby books have their own personalities as well by varying the designs, colors, and fonts. Here are a few more design ideas to get your own creative juices flowing. Feel free to copy any of the designs you like in this book and, better yet, build on them, combine them, vary them, and make them your own.

LOOK, LOOK, LOOK!
A series of similar images capture a child's curiousity. Making one photo larger than the others creates a more interesting design.

SHE'S GOT MY NOSE
A collection of closely cropped photos can help you appreciate the delicate features of a baby—and how much she looks like her parents!

She's got your eyes

Alexis Ann Coltrane

Born: August 16, 2005
7 lbs, 8 oz
19 inches long
and perfect in every way

Your voice

Your face

My lips

My nose

your peaceful way

And so much love from both of us

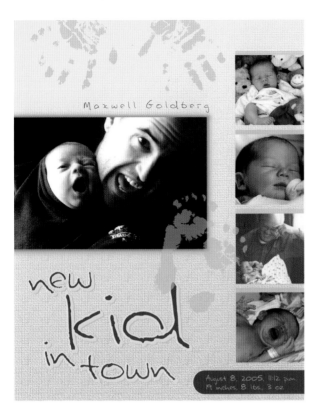

Maxwell Goldberg

new kid in town

August 8, 2005, 11:12 p.m.
19 inches, 8 lbs, 3 oz

TWO-HEADED DADDY

Complement an eye-catching main image with a collection of small images to tell a more complete story. (Photos by Zach Goldberg.)

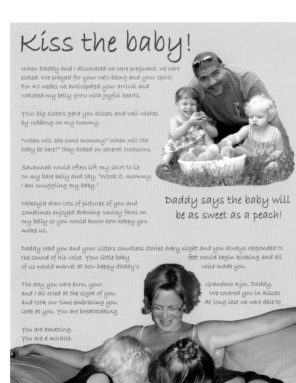

Kiss the baby!

When Daddy and I discovered we were pregnant, we were elated. We prayed for your well-being and your spirit. For 40 weeks we anticipated your arrival and watched my belly grow with joyful hearts.

Your big sisters gave you kisses and well wishes by rubbing on my tummy.

"When will she come mommy? When will the baby be here?" they asked on several occasions.

Savannah would often lift my shirt to lie on my bare belly and say, "Wook it, mommy, I am snuggling my baby."

Mikayla drew lots of pictures of you and sometimes enjoyed drawing smiley faces on my belly so you would know how happy you make us.

Daddy read you and your sisters countless stories every night and you always responded to the sound of his voice. Your little baby of us would marvel at how happy daddy's feet would begin kicking and all voice made you.

The day you were born, your and I all cried at the sight of you. and took our time embracing you. look at you. You are breathtaking.

Grandma Kjos, Daddy, We covered you in kisses At long last we were able to

You are amazing.
You are a miracle.

Daddy says the baby will be as sweet as a peach!

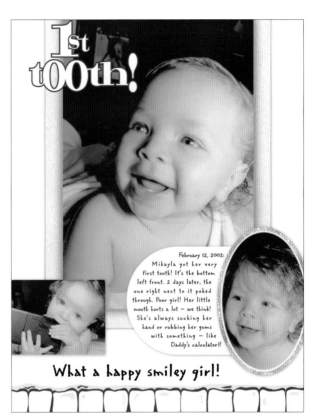

1st tooth!

February 12, 2002: Mikayla got her very first tooth! It's the bottom left front. 2 days later, the one right next to it poked through. Poor girl! Her little mouth hurts a lot — we think! She's always sucking her hand or rubbing her gums with something — like Daddy's calculator!

What a happy smiley girl!

THE TOOTH FAIRY

Using black-and-white images creates an old-fashioned effect. Are you old enough to remember when TV was only in black and white? (Photos by Stephanie Kjos Warner.)

GET READY!

Including older children in the design of a baby book even before the new baby is born can help them feel more involved and better prepared for the arrival of a new sibling. (Photos by Kevin and Stephanie Warner.)

You may never take more photos than when you're a new parent. Babies change so fast that you want to capture every moment, every smile, every "new" thing they do. A good way to make sure you keep a regular chronicle of your baby's growth is to take at least one photo at the same time every week, like every Sunday morning. After several weeks of this, you'll have a nice collection of images that tell the story of your baby's development. The images in this last section are included to give you a few more tips about capturing the best of your baby.

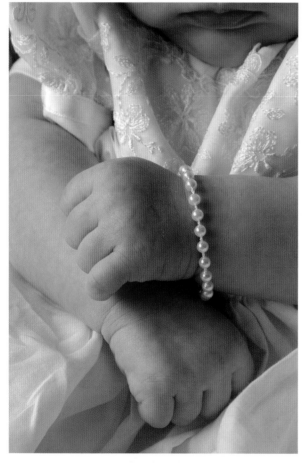

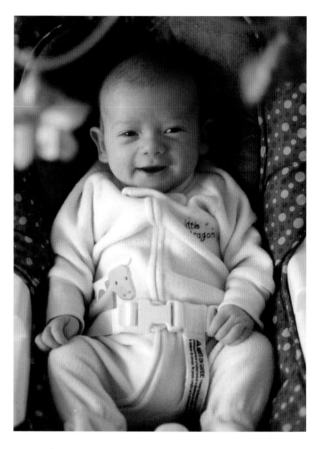

SMILE!
If you're having trouble getting a baby to look at the camera, try jiggling a favorite toy, or even your car keys, right behind the photographer. (Photo by Zach Goldberg.)

FOCUS ON THE DETAILS
Photos of tiny feet and hands make an ideal complement to a baby picture in a scrapbook page or baby book. (Photos by Mary Bortmas.)

THREE HEADS ARE BETTER THAN ONE
Varying the direction of the heads provides balance and calls attention to the differences between newborn twins and their older sister. (Photo by Mary Bortmas.)

BOYS WILL BE BOYS
Take a family portrait with "the belly." Here three little boys surround their mom and sibling-to-be for an adorable image that is sure to be a special part of this family's photo collection. (Photo by Mary Bortmas.)

Designs for Life

The projects and lessons in this chapter are designed to help you create a beautiful baby book with a variety of designs and stories. Now that you've learned these skills, you're well prepared to create more scrapbooks, brag books, and other keepsakes for your family for years to come.

As your children grow, don't just make books about them, ask them to help and include their artwork, ideas, stories, and designs in the pages you create for and about them. Family storytelling is an art and it is best learned from someone close to you (like a parent or grandparent). If you enjoy creating special memories for your family, share that passion with your children, grandchildren, nieces and nephews, and turn all your special projects into activities your family can do together.

Mikayla, Happy Person, 2004 (3 years old)

From an
empty lot . . .

. . . to a
home we
love a lot!

Please join us for a casual open house.
Saturday, March 12, from 1 to 4 p.m. / 1823 Anson Boulevard

tom & mindy

CHAPTER 7

When You Care Even More:

Design Your Own Greeting Cards

When you create your own greeting cards you have the opportunity to add a personal touch. Whether you want your cards to be thoughtful, clever, entertaining, or funny, this chapter shows you how to create different styles of cards with your own artwork, photos, text, and headlines. All you need is a word processing program, such as Microsoft Word. In this chapter, you'll discover how to create professional-looking cards for any occasion, including:

- **Birthday and anniversary cards**
- **Party, graduation, and wedding invitations**
- **Mother's Day, Father's Day, and Grandparent's Day cards**
- **Thank-you notes**

Once you've created your cards, you can print them to mail or deliver by hand, or save them in an Internet-friendly format to e-mail over the Internet.

T'was the night before Christmas and all through the place,
Our faces were smiling, we'd finished the race.

The stockings were hung and the tree was bedecked.
The whole house was clean (it had been a wreck).

The wreath on the door, the lights in the yard,
But something is missing? I forgot Christmas cards!

So, as you rest and relax in the glow of good cheer,
Take this as a wish for a Happy New Year!

HAPPY NEW YEAR!
The rhyme on this card was written to make up for sending
out our Christmas cards a little late one year.

YOU make it Print & Fold Card

Every year Uncle Tom's family sends holiday cards he makes himself.
Before the advent of the computer, he cut and pasted drawings done by
the kids and mixed them with hand-lettered messages of good cheer.
Now he uses the computer to design their cards, scanning colorful draw-
ings and photos and blending them with artfully formatted greetings.

One year, with all the preparations for the sea-
son—gift buying and wrapping, home and tree deco-
rating—Tom completely forgot about making the
card! After a lot of thought and a little inspiration, he
wrote a poem about his error, using *The Night Before
Christmas* as his starting point.

To illustrate the poem, Tom drew a picture of their
front door, decorated for the holidays, and scanned it.
With the drawing and the poem on one side, and a pic-
ture of their smiling faces on the inside, he made the
perfect card to show family and friends how they had
already celebrated the holidays, wishing them a happy
New Year instead of the typical Christmas greeting.

Tom designed this card to print on one side of a
letter-size page, which allows you to print the card from
a desktop printer. If your mailing list is long, you can
then take a clean original print to the local copy shop.

This card fits into envelopes you can buy in
any office supply store, and it stands up on its own
for displaying.

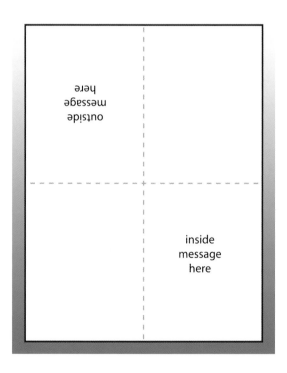

THE LAYOUT
This card is designed so that the outside message is
printed in the upper left quarter of the page and the
inside message is printed on the bottom right quarter.

FOLD AND FOLD AGAIN
The card is then folded twice (first along the short
dimension, then along the long dimension) to create a
four-panel card with each panel measuring 4.25 inches
wide by 5.5 inches high.

Note
To make it even easier for you to create these
cards, you'll find templates, artwork, and
other goodies on our Web site at www.digital
family.com. Follow the link to the Greeting
Cards section.

Setting Up the Layout

Before you begin, gather your photo and art files and save them in a folder on your computer. If you need help scanning and saving photos, see Chapters 1, which covers scanning and Chapter 3, which discusses image-editing techniques.

The first part of these instructions shows you how to set up a page with the proper size and orientation for this card design. However, if you download the templates in the Greeting Cards section of our Web site (see Note on page 129), you can skip this step, open the template called Fold-template.doc, and jump ahead to "Creating the Inside Message."

1. Create a new document. Then from the File pull-down menu, choose Page Setup. On the Paper Size tab, set the page size at 8.5 by 11 inches (letter-size) in Portrait orientation. On the Margins tab, set the Top, Bottom, Left, and Right margins at zero. This will allow you to position text and images easily, though you must remember that your printer will not print all the way to the edge of the page. Click OK.

3. Position the Line tool crosshair at the top of the page, near the 4.25-inch mark on the ruler. Press and hold the Shift key; then click and drag the tool down the page to the bottom. The Shift key restricts movement of your cursor to horizontal or vertical only to help you draw a straight line.

2. To position items in the correct place on the page, it helps to put in guidelines marking the folds. You'll remove these lines before you print the completed card. Choose the Line tool from the Drawing toolbar and note that your cursor becomes a crosshair.

4. With this line selected, choose AutoShape from the Format pull-down menu and choose a Dashed line under Colors and Lines. On the Layout tab, choose Behind Text for the Wrapping style and then click Advanced. Set the Horizontal position to Absolute and 4.25 inches to the left.

Click OK for Advanced Layout, then click OK for Format AutoShape to apply your formatting choices to the line.

Draw another line across the middle of the page from left to right. Format this line to be dashed and positioned 5.5 inches from the top of the page. Your page is now divided into the areas you will use for positioning text and images.

Creating the Inside Message

Start with the inside message. This is the easiest, because it will appear in the two panels at the bottom of your layout and all the text and images will be right side up.

1. Choose Text Box from the Insert pull-down menu or click the Text Box tool on the Drawing toolbar.

Click and drag to draw a text box in the lower right quarter of the page, staying within the guidelines you just made. You then can use the arrow cursor to move or resize the box as much as you want.

2. Click in the box to begin typing. To format your text, click and drag to highlight it, and then choose the type size and font style from the Formatting toolbar or by choosing Format → Font. Other options, such as alignment, line spacing, and indents are available when you choose Format → Paragraph.

3. Now add a photo to the left inside panel. From the Insert pull-down menu, choose Picture → From File and locate the photo you want.

4. When the photo appears on the page, click to select it. Choose Format → Picture or double-click on the photo to bring up the Format Picture dialog box. Select In Front of Text on the Layout tab. Click OK and notice that the anchor points on the photo change to white boxes. You can now move the photo anywhere you want by dragging it.

Tip

Get creative with background color. The default style of a text box in Microsoft Word is white with a black outline. To change that, choose Text Box from the Format menu. Pick a different background color, or perhaps no color if the text box is floating in front of a photo. You may want to choose a different font color if you change the background; mixing and matching colors is a great way to show your style.

Designing the Front Panel

Adding text and artwork to the front panel is a little trickier because you'll need to make the message and images upside down; but don't worry, it will all come out right in the end. You can make text run upside down in one of two ways: Either create the text in an image-editing program, such as Photoshop Elements (see Chapter 3), or use the WordArt feature in Microsoft Word. This card is a great opportunity to use WordArt.

1. Click the WordArt icon on the Drawing toolbar. If the WordArt icon is not visible, choose View → Toolbars → Drawing to display the toolbar at the bottom of your screen.

2. This opens the WordArt Gallery, which contains more than two dozen variations of slanted, shaded, beveled, bent, curved, and colorful type. Because this card features a poem with several lines of text, a simple style may be the best choice for readability. Select a style and click OK.

3. In the Edit WordArt Text dialog box, choose type font, size, and style. Click to insert your cursor and type your greeting in the main box. WordArt limits the number of characters in each item. Type up to two lines and click OK and the text will appear on the page. Repeat this step to add more text or use Copy and Paste to copy the text once it appears on the page, replacing the words after you've added the type.

4. For formatting options, click once on the text to open the WordArt tool palette. Click the WordArt Shape button to choose a shape, such as Wave 1, which was used in this example. You can also change the text color, alignment, and character spacing.

5. To create a staggered effect like you see here, click to select a section of the text and tap the arrow keys on the keyboard a couple times to nudge it to the right; then click the Align Right icon in the toolbar. Repeat this step for other sections of text as desired.

6. Now it's time to flip your text upside down, but first you need to group all of your text into a single, selectable unit. Press and hold the Shift key as you click to select each section of text. With all of the text you want to flip selected, click the arrow next to Draw at the left of the Drawing toolbar and choose Group. Anchor points will appear around the entire selection of text.

7. With the group still selected, click the circular arrow next to Draw, choose Rotate or Flip and then choose Flip Vertical to flip the text upside down. You can also insert an image. You have two options: You can insert an image that is oriented upside down (as you learn to do in Chapter 3) or insert an image, select it, and then flip it in Word the same way you just flipped the text.

To make sure your image fits with the card, double-click it to open the Format Picture dialog box, choose In Front of Text, and drag the artwork to your desired position on the page. To resize text or an image, click to select it and use your cursor to drag the corner points until it is the desired size. To move text or an image, click and drag.

8. If you want to add a colored background, choose the Rectangle tool from the Drawing toolbar, and click and drag a box that covers the entire area where you want to add color. Double-click the new rectangle and choose a color as the Fill; then choose Behind Text as the Wrapping style.

9. Before you print your card, make sure you remove the guides you drew (or the ones that are in the template). Just click on them one at a time and press the Delete key.

 # Simple Note Card

This card has no message inside, so setup is easy. To conserve paper, you can create a copy of the card design when you're done and print two per page. I recommend you print a note card like this on heavy paper or card stock, which you can easily find in most office supply and craft stores.

THE LAYOUT
Artwork or a photo appears on the front panel of this note card, and the inside is blank, leaving you space to add a handwritten message.

Mikayla, Happy Person, 2004 (3 years old)

LITTLE PICASSO
My aunt and uncle, who helped write and create the designs for this book, are experienced grandparents who know just how special it is to receive a card with a child's drawing. They created this card for my mother by scanning a drawing from her granddaughter and using it to illustrate a note card that is easy to show off to friends.

Step-by-Step Setup

Before you begin, save the photo or art file you want to use into a folder on your computer. You'll find tips for scanning and downloading images off the Internet at the end of Chapter 1. Download the template called Note-template.doc from the Greeting Cards section of the DigitalFamily.com Web site, or, to set up your own document in Word, follow these steps.

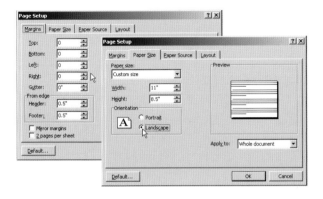

1. Create a new document and use File → Page Setup to set the page size at 11 by 8.5 inches (letter-size) with Landscape orientation. Set the Top, Bottom, Left, and Right margins to zero so you can position text and images with greater flexibility.

2. To set up the layout to print two cards on one page, use the Drawing toolbar to draw guidelines (as in steps 2 through 4 on page 130) so you'll know where to cut after printing and where to place the image on the front.

 Once you have the template open or have created a new page and added guidelines, follow these steps to create a note card like the one featured on the facing page.

Adding Artwork

After you have your document layout set up, the first thing you want to do is insert your photo or artwork on the front panel. Ideally, its proportions will be similar to the shape of the template (if not, consider redesigning the template by moving the guidelines or reorienting the page to better fit your image).

1. Choose Insert → Picture → From File. In the Insert Picture dialog box navigate to the folder where you saved your artwork on your hard drive. Click on its file name and click the Insert button to select it. The artwork will automatically appear on the page where the cursor is—in this example, the image was inserted into the upper left corner of the page.

2. Click once to select the photo and you'll see anchor points appear at the corners and on the sides. These indicate that the photo is the active selection on the page, so anything you do now will affect that photo. Choose Format → Picture, specify In Front of Text on the Layout tab, and click OK.

Notice that this action turns the anchor points white and makes it possible to now click and drag to move the picture anywhere on the page. In the example, the artwork is inserted into the lower left corner of the page.

3. You can resize your image by placing your cursor over any corner anchor point until it turns into a diagonal arrow. Then click and drag the corner point diagonally until the artwork is the size you want it.

4. To add text, choose Insert → Text Box (or from the Drawing toolbar, choose the Text Box tool). Click and drag the cursor to create a text box anywhere on the page—you can move anywhere on the page after it's created.

5. Type any text you want, such as the artist's name, the title of the work, and the year. (You might want to add the age of the artist, especially if she's three!)

Using the Formatting toolbar, choose a typeface, point size, and a type color that complements the artwork.

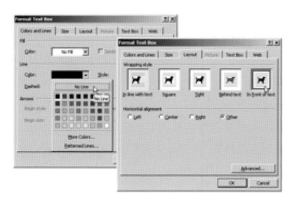

6. Choose Format → Text Box. On the Colors and Lines tab, choose No Fill and No Line. On the Layout tab, choose In Front of Text and click OK. The text box will now be transparent with no border and you can place it on top of the artwork on the front panel.

7. Use your cursor to drag the text box on top of the artwork or below it. Adjust the type size, style, or color as you like.

Duplicate, Print, and Fold

There! Your note card design is complete. Now it is time to duplicate it so you can print two cards at a time.

1. From the Drawing toolbar, choose the Select Objects tool (the white arrow). Position the arrow cursor at the lower left corner of the page, and click and drag a marquee around all the items in your card design (images, text, etc.) to select them. Don't include the cut and fold lines in your selection; you don't need to copy those.

3. From the Drawing toolbar, choose the Rectangle tool and drag a rectangle that covers most of the vertical trim or cut line of your card. Use the Format AutoShape dialog box to format it with No Line but keep the white fill color. This will give you small tick marks so you can use a ruler and a craft knife to cut the two note cards apart after printing.

2. Position your cursor over the selected objects and press the Control key. Notice that the cursor now has a plus sign (+), indicating it will make a copy. Click and drag the objects to the right. As you drag, press and hold the Shift key so you can drag the objects in a straight line. When the items look centered in the right-hand bottom panel, let go of the mouse first and then the Control and Shift keys.

Accordion Photo Gallery Card

When my uncle Tom and aunt Mindy built their house, they used a digital camera to record the process for future reference and to keep extended family up-to-date on each stage of the construction. They ended up with thousands of pictures, showing the foundation, the wiring, the wall studs, and finally the finished house.

When they planned an open house party, it seemed natural that the invitation should include photos of their new home. In designing the card, they decided an accordion-fold design was the perfect way to show off several photos at once and still print on a single-sided page. The best part is that this card design can stand up on a table or shelf to serve as its own photo gallery.

THE ACCORDION-FOLD CARD
The card featured in this project has five panels, each 3 inches wide and 5 inches tall, which means that two cards fit well on a sheet of 11- by 17-inch paper. You may adapt these instructions to design a card that is different in size, shape, or number of folds.

FROM FOUNDATION TO HOUSE WARMING
The finished invitation, trimmed and ready to fold.

Designing the Card

If you have worked through the other projects in this chapter, you probably already have a pretty good idea how the accordion-fold card will work. The instructions that follow assume you are using the template called Accordion-template.doc from the Greeting Cards section of the DigitalFamily.com Web site, but you can use the steps on page 130 to create a new document and draw guidelines where the folds should go. Similarly, you can adjust the template from the Web site to the size and number of folds you want for your card design.

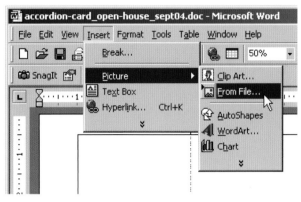

1. Before you begin, gather the photos or artwork you want to use and save them in a folder on your computer. Open the template and save it into the same folder as your photos, so everything is in one place where it will be easy to find as you are creating your card.

2. First, add all your elements above the horizontal cut (solid) line. To add the first photos, choose Insert → Picture → From File.

3. In the Insert Picture dialog box, navigate to the folder where you saved your photos. Select the first photo and click the Insert button in the lower right corner of the dialog box. Repeat this step until all of your photos have been added to the template.

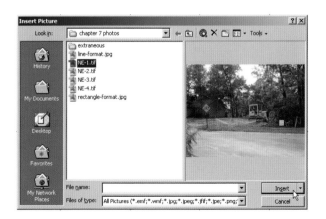

4. Click directly on each photo in turn and you'll see anchor points appear in the corners and on the sides, indicating that the photo is the active selection.

Select Picture from the Format pull-down menu; then choose In Front of Text on the Layout tab and click OK.

Notice that the anchor points are now white. That means you may click on the picture and move it around the page wherever you want. If you want to resize a photo, move your cursor over any corner anchor point and when it turns into a diagonal arrow, click and drag the corner diagonally until the photo is the size you want. Notice in this photo that the cursor is a diagonal arrow in the upper right corner of the selected picture.

5. Resize and arrange all of the photos until you are pleased with the result. Remember, you're using a computer so you can change your mind as many times as you like. Let your imagination guide you and don't be afraid to experiment.

Note

When you make photos smaller, they often become a little sharper. When you make photos larger, they may become jagged and rough. The amount of jaggedness depends on the format and resolution of your image, which you can learn more about in Chapter 3.

6. To add text to this rambling layout, you'll need to create a text box that can be moved and resized. Choose Insert → Text Box (or click the Text Box tool icon on the Drawing toolbar), and then click and drag to draw a text box where you want it.

Click to insert your cursor in the text box and begin typing. Remember, you can always adjust the size and positioning of the box by clicking and dragging. Format the text using the tools in the Formatting toolbar.

7. To create trim lines, select the 15- by 10-inch rectangle that indicates the edge of the two cards and choose Format → AutoShape. On the Color and Lines tab, choose a background color. Set the Line for No Line. Click OK.

To add borders to your images, click to select a photo and choose Format → Picture. On the Colors and Lines tab, specify the color, weight (meaning thickness), and style for the border of each photo.

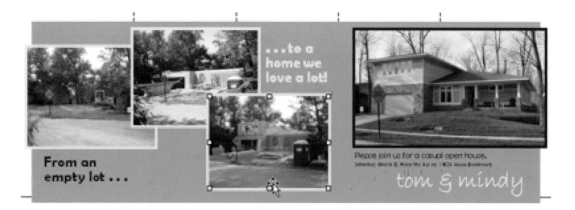

8. To print two cards per page, press and hold the Shift key and click on all the photos and text boxes one at a time to select them all together. Choose Edit → Copy, then release the Shift key and click to place your cursor in the other side of the template and choose Edit → Paste.

To adjust the positioning of the second card, hold down the Shift key again and select just the elements of the copied card. With all of them selected, keep holding down the Shift key and use the arrow keys on your keyboard to move everything into position. That's it!

Save this document and print it on 11- by 17-inch paper. Cover-weight paper or card stock will help the card stand up better. See Appendix B, Sharing Your Digital Creations, for tips on printing and e-mailing.

Trimming and Folding Tips

Before the card is trimmed, score the fold lines to make them easier to fold. To do this you need a straightedge, such as a metal ruler, and you also need something with a dull metal edge—the edge of a spoon works well. Place the ruler on the paper, parallel to one of the dashed lines. Press firmly on the ruler and run the edge of the spoon down the line from top to bottom, creating a crease in the paper. This will be your guide for folding the card after it is cut out. Score the other dashed lines as well.

Now trim the card! Place the ruler across the center of the page, using the cut lines as a guide, and cut along the edge with a sharp craft or utility knife. Then cut 1 inch off each end and cut ½ inch off the top of the first card and the bottom of the second card.

Fold the card. Carefully consider whether the first panel should fold to the outside or inside. Each successive panel will alternate the direction of the fold.

Tip
Did you ever cut out paper dolls? For a fun variation on an accordion card, plan the design so you cut shapes while it's folded that fan out into a unique pattern!

You can create a greeting card for any holiday or special occasion. To help you come up with your own ideas, here are a few more greeting cards we've created that we hope will inspire you. You can make variations on the projects in this chapter or use the techniques you learned to set up your own layouts. With a little bit of creativity, there's no limit to the possibilities!

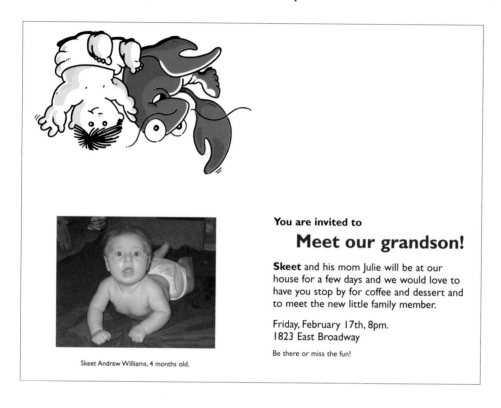

You are invited to

Meet our grandson!

Skeet and his mom Julie will be at our house for a few days and we would love to have you stop by for coffee and dessert and to meet the new little family member.

Friday, February 17th, 8pm.
1823 East Broadway

Be there or miss the fun!

Skeet Andrew Williams, 4 months old.

MAKE WAVES FOR A NEW BABY
This wider variation on the simple print-and-fold card stands up on its own when it's finished.

A STORK BROUGHT YOU
This tall, skinny card prints perfectly on both sides of a letter-size sheet of paper, then folds in half on the long dimension and fits inside a standard business envelope. Most office supply stores carry envelopes in many colors.

PEACE TO THE EARTH
This variation on the accordion-fold card design works well for wide pieces of artwork or panoramic photos.

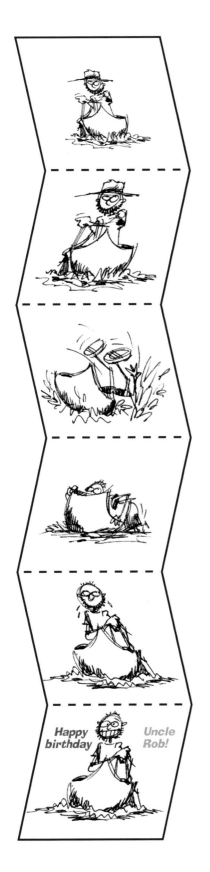

NO ENVELOPE REQUIRED

Make your own personalized, self-mailing note cards. Choose a clever saying and some cute art to scan and print on cover stock at a size that fits within postal regulations when folded. Lightly score the stock to create two front flaps. Whenever you want to send someone a note, write your message on the inside, fold and seal the two front flaps with a color-coordinated wafer seal, and stamp and address the back. A real time saver!

COMIC-STRIP STYLE

This vertical variation on the accordion-fold card looks like a film strip or comic and is a great way to display a series of drawings to tell a story.

MEOW!

A photo of a well-dressed ghoul, goblin, or kitty cat makes an excellent image for a Halloween greeting card. (See Chapter 3 for instructions on cutting your favorite goblins out of an image like this.)

Although you can e-mail any of the cards described earlier in this chapter (as you'll learn in Appendix B, Sharing Your Digital Creations), you may find it easier and faster to use one of the many e-card Web sites on the Internet to send photo cards to family and friends. Here are descriptions of some of the most popular ones.

CardFountain.com has lots of cute e-cards in many categories. You can add one photo or up to eight photos that display in a photo-flipper on the card. Look in the Help section to find step-by-step instructions to add a photo or create multiple photo cards. You have to be a member, but there is a free 2-week trial (membership is $13.95 per year and you have to enter a valid credit card to get the free trial). Also note that some features on this Web site work only in Internet Explorer, not in other browsers. Despite the limitations, I like this site because it's one of the few that enable you to personalize your cards with your own photos.

You must be a member to send the cute animated greeting cards at **AmericanGreetings.com**. After a free one-month trial, the cost is $13.95 a year and you must enter a valid credit card to get the free trial.

PhotoEcards.com has very cute card templates and also provides a number of ways to modify your photos, such as eliminating the background, when you customize the cards. This site charges a pay-per-use fee of five cents per card.

Featuring some of the most beautiful e-cards on the Web, **BlueMountain.com** allows you to attach a photo and send it with your card, but you can't create a personalized photo card. BlueMountain.com also offers a free one-month trial membership before they begin charging you an annual membership fee to send e-cards through their site.

NIP AND CROP
Simple image-editing features make it easy to alter your images as you personalize the cards at PhotoEcards.com.

Have Fun Making Your Own Cards

Creating personalized, custom greeting cards may be some of the most fun you have with digital tools. In addition to the examples shown here, I hope you'll come up with your own ideas for fun and rewarding card designs. When you do, I welcome you to share those with us by submitting your work through our Web site at www.digitalfamily.com.

Surprise your friends and family with cards made especially for them, and consider saving all your greeting card designs as a kind of digital scrapbook you can enjoy again and again in the years to come.

June 2006

Sunday June 11	Dinner at Grandma's, 7 p.m. — take dessert
Monday June 12	Mom is meeting with client, 4 p.m. to 7 p.m.
Tuesday June 13	
Wednesday June 14	Last day of school
Thursday June 15	**Kate is 16!**
Friday June 16	Family movie night
Saturday June 17	Pedal & Park at Art Fair, work 10 a.m. to 2 p.m.

May 2006

Sunday	Monday	Tuesday	Wednesday	Thursday	Friday	Saturday
	1	2	3	4	5	6
7	8	9	10 Exams start	11	12	13
14 Mother's Day	15	16	17	18	19	20
21	22	23	24	25 Kevin is 41!	26	27
28	29	30	31		Plant flowers! Frost date is May 10	

Last April, we vacationed for a week in a houseboat in the Atchafalaya Basin.

JANUARY 2006

July 2005

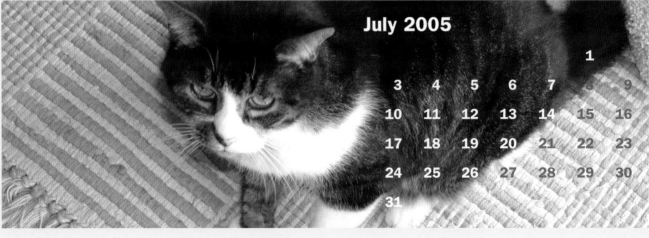

						1
3	4	5	6	7	8	9
10	11	12	13	14	15	16
17	18	19	20	21	22	23
24	25	26	27	28	29	30
31						

CHAPTER

Creative Calendars:
Keep Track of Special Family Dates

Tired of getting belated birthday cards? Give all your relatives personalized calendars with your special date circled, and they'll have no more excuses for not sending presents on time! More important, personalized family calendars are useful keepsakes that help build and strengthen family ties. How easy is it to create a family calendar? Just pick a favorite photo for each month of the year and add special dates and a few fun facts about your family. In this chapter, you'll learn how to keep your family on track with:

● **Wall calendars showcasing your own pictures and special events**

● **Daily reminder calendars**

● **Freestanding calendars you can display on a desk or table**

● **Shared online calendars**

By setting up your own layouts using the directions in this chapter, or using the pre-designed calendar templates on the DigitalFamily.com Web site, you can easily arrange your photos and text to create practical, one-of-a-kind gifts your friends and relatives can use throughout the year.

✳ Keeping Up-to-Date in the Digital Age ✳

The frenzy of modern family life can leave you feeling frazzled as you race from home to work to school, and all the other places in between. Although computers can't solve your time crunch, the calendars featured in this chapter can ease some of the stress by helping your family keep track of all the where's and when's.

Creating Calendars with a Word Processing Program

My extended family is typical—everyone going in different directions, staying active with work, school, band concerts, hobbies, and volunteer activities. Remembering who has to be where and when can be a challenge for everyone. But the same kinds of calendars don't work well for everyone. That's why Tom and Mindy and I came up with the idea to feature three different kinds of calendars in this chapter—a monthly wall calendar, a free-standing calendar that shows off a photograph, and a weekly reminder calendar that can be easily updated.

Word processing programs are a great choice for creating family calendars, because they make it simple to insert color photos and artwork and create tables with rows and columns for every day of the week. In this chapter you'll quickly discover how to use any word processing program to make any of the calendar styles featured in here.

Most word processing programs include a variety of templates for creating calendars on the installation CD or make them available on the company's Web site. With a little searching, you can find a wide range of calendar templates and easily download your favorites.

To personalize your calendars, you can add your own photos and artwork, as well as special dates. For help with scanning artwork, using digital cameras, and saving and editing photos, see Chapters 1 through 3.

Note

If you want to create one of the calendars featured in this chapter, you'll find the templates you need at www.digitalfamily.com. Follow the links to Digital Family Album and Calendars to find instructions on how to select and download templates and graphics. The templates are designed to fit standard paper sizes so you can print them from your own desktop printer or at any local copy shop.

Creating an Online Calendar

An online calendar is a great way for a family on the go to keep track of each other's schedules because everyone can share one password and post events to a common calendar. For example, Dad can type in school events, Mom can note late business meetings, and the kids can add the schedules for their own sports activities, or block out some shared family time to unwind together.

Of the various online calendar options, my favorite one is Yahoo! Calendar at www.yahoo.com, because it's a feature-rich organizer that gives you lots of options for managing your time—and it's free! The controls are easy to understand and you can change the colors and layout as often as you desire.

Yahoo! Calendar is easy to use. You just click the tabs across the top of the calendar to switch the display from Day to Week to Month to Year, or to view lists of Events or Tasks.

The system has a Reminder feature that sends you timely e-mail messages about scheduled events, and, with sharing activated, multiple people can post to the same calendar and e-mail automatic updates to each other. You can also print your Yahoo! calendar if you want to have a copy away from your computer.

The calendar at Yahoo! is part of a suite of personal management options that include e-mail, an address book, and a notepad. And the system is designed so you can sync with a PDA, such as a Palm or other handheld device. With just a little practice, the system is easy to use and you'll find up-to-date instructions on the Web site.

SIMPLE LAYOUT
With this easy-to-use online calendar, your whole family will be as organized as your Yahoo! Calendar layout.

STAY ON TRACK
Yahoo! Calendar's simple controls encourage you to be disciplined about adding correct dates and information in your calendar.

Ideas for Calendars

Today's technology makes it easy to create calendars for any occasion and fill them with special art and dates you want to remember. Here are a few ideas for pictures and activities to feature on a calendar to get you thinking about the best calendar designs and artwork for your family.

- Children's photos for the grandparents.

- Photos of family and home for people called into service or going off to college.

- Pictures of a dream car or boat.

- Shots of travel destinations or a new distant home for soon-to-be retirees.

- A calendar to help you keep track of personal goals.

- Old family portraits and historical photos.

- Hobby-related pictures and artwork.

- Important dates for members of a club.

- Gardening reminders about what needs to be planted, pruned, or harvested each month illustrated with seasonal images.

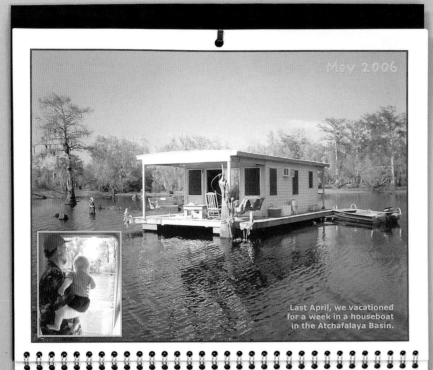

May 2006

Last April, we vacationed for a week in a houseboat in the Atchafalaya Basin.

May 2006

Sunday	Monday	Tuesday	Wednesday	Thursday	· Friday	Saturday
	1	2	3	4	5	6
7	8	9	10 Exams start	11	12	13
14 Mother's Day	15	16	17	18	19	20
21	22	23	24	25 Kevin is 41!	26	27
28	29	30	31	Plant flowers! Frost date is May 10		

LOOKING AHEAD
A personalized wall calendar can be a lively and fun part of your family's daily life. On the pages showing the dates, you can add artwork to call attention to birthdays, anniversaries, school breaks, and holidays. You can even include astronomical events such as the full moon or an eclipse.

Family Wall Calendar

Remembering special dates can be a challenge. In my extended family, we have lots of birthdays and anniversaries to keep track of, and as kids grow up and get married, more people come into the fold, adding even more dates to the list.

To help everyone remember important dates, we make a yearly calendar showing all the anniversaries and birthdays, as well as other special events, and then we decorate the calendar with photos of children and grandchildren, special occasions, and last year's birthday pictures so we can see how much everyone has grown.

Feature a Photo

The first step in making a wall calendar is to choose a special photo to represent each month. Before you begin, gather your photo and art files and save them in a folder on your computer so they'll be handy as you design your calendar. You'll find instructions for cropping, sizing, and editing images in Chapter 3. The following steps show you how to add an image to your calendar.

1. If you have a template or download the one called Wall-calendar-template.doc from the DigitalFamily.com Web site, open it and skip ahead to step 2. If do not have a template, create a new document by choosing File → New, and then choose File → Page Setup.

On the Paper Size tab, set the page size at 8.5 by 11 inches (letter-size) in Landscape orientation. On the Margins tab, set the Top, Bottom, Left, and Right margins at 0.5 inches (or half an inch). This allows you plenty of margin for printing. Click OK.

2. To add a photo, click to insert your cursor where you want the image to appear, and click Insert → Picture → From File. Click to select the picture you want to use and click Insert.

3. If you want to resize the photo, click on it and drag a corner point to make it larger or smaller. (Press and hold the Shift key as you drag to maintain the photo's proportions.)

4. Now you'll type the name of the month and year on top of the photo. To do so, click the Text Box tool on the Drawing toolbar and notice that your cursor becomes a crosshair. (If the Drawing toolbar is not visible, choose View → Toolbars → Drawing.)

Click and drag a text box anywhere on the page—you'll move the box to its correct position in a moment. The text box will have an active, blinking text cursor and be ready for you to type.

5. After typing in the name of the month and the year, triple-click the type to select it, then use the Formatting toolbar to choose a type style, size, and color. Try choosing fun text colors, such as a cool blue for January.

6. Notice that the text box has a border and a white background. You'll want to remove those so the words appear to float on top of the photo. To do so, double-click the gray hatched border of the text box to open the Format Text Box dialog box. Set Fill Color to No Fill and Line Color to No Line.

7. Click on the gray hatched border of the text box to select it and drag your cursor to move it (you can also use the arrow keys on your keyboard to move it). Experiment with different locations until you find a place where the text is readable over the image and looks good to your eye. Remember you can change the text to a lighter or darker color if necessary.

8. To add a border to your picture, select the Rectangle tool from the Drawing toolbar, click on any corner of the photo, and drag to create a box the same size around the photo. Double-click the box and set the Fill Color to No Fill so the photo shows through and then set the Line Color, Weight, and Style.

Creating a Calendar Page

If you downloaded one of our templates or are using a template that was included in your word processing program, you can skip this next section. If you want to create your own calendar page, you'll need to make a table that combines horizontal rows with vertical columns to create cells for each day and date of the month.

Do Your Homework

Before you begin laying out your calendar pages, consult a calendar to count the number of rows each month needs; most will need five rows, but in any given year, two or three months will need six rows. You'll also need a row for the name of the month and another row for the weekday names.

Of course, all months need seven columns for seven weekdays (unless you only want to show weekends), and you'll want to know which day is the first of the month and how many days there are in each month. Whew! That's why we created calendar templates for you. You'll find templates for every month for many years on the DigitalFamily.com Web site.

1. With the page open where you inserted your photo, click to insert your cursor just under the photo and choose Insert Break to create a new page below the photo.

Choose Table → Insert → Table. In the Insert Table dialog box, define the basic properties of your table. For the month of January 2006, for example, you would enter 7 columns and 7 rows (two of the rows will be for the year and the days of the week). Choose a Fixed column width of Auto and click OK.

2. Choose View → Toolbars → Tables and Borders to display the table options in the toolbar.

Click to insert your cursor in the top row of the table and choose Table → Select → Row.

3. With the top row selected, click the Merge Cells button on the Tables and Borders toolbar. This creates one wide cell across the top. Click again to make sure your cursor is in that single wide cell and type the name of the month. Use the Formatting toolbar to specify the font, style, and color.

4. The row for the month name might look better if it were a bit taller. To make it taller, float your cursor over the bottom edge of the row and notice that your cursor becomes a two-headed vertical arrow with two horizontal lines between the arrowheads. Click and hold to grab the bottom edge of the row and drag it downward to enlarge it.

Note

You also can resize a table or some of its rows using the Table Properties dialog box. Click in the row you want to change; then choose Table → Table Properties. On the Row tab, type a larger or smaller number in the Specify Height field (or click the Up/Down arrows to change the number). Click OK to see the height change. If you need to tweak the height some more, use the same technique again until you are satisfied.

5. Triple-click the month name to select it; then click the Align button on the Tables and Borders toolbar. When the Align drop-down menu appears, drag your cursor down to Align Center. Click in the second row and type the first weekday name; then use the Tab key to move on to the second column, enter the second weekday name, tab to the third column, and so on. When you have finished, choose Table → Select → Row to align and format all of the text of the weekday names simultaneously.

Click and drag the bottom of the row if you want to make it bigger or smaller.

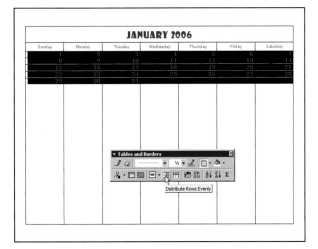

6. It's time to enter the dates. Click in the first cell and enter a number, tab to the next cell and continue. Click and drag to select all five rows and format the numbers simultaneously.

With all five rows selected, click and drag the bottom row to enlarge all of the cells.

Click the Distribute Rows Evenly button on the Tables and Borders toolbar to make all of the rows the same height.

7. You're ready for some finishing touches. Select the entire table and use the options on the Tables and Borders toolbar to change the Line Style, Line Weight, and Border Color. Click the Border button to reveal a drop-down menu, choose All Borders, and click.

To make the outermost table border a different weight and color, click the Border button and click on Outside Border to apply different styles.

Add Some Zip to Your Days

Whether you use one of our templates, or you create your own, you can add photos and artwork to the individual cells to call attention to special days. Here are some suggestions and instructions.

1. Click in any date cell. Choose Insert → Picture → From File (you can also choose Clip Art to insert any of the images included with your word processing program). Click to select the image you want and click Insert.

2. Once the artwork appears in the cell, you can resize it and make it float freely for easy positioning. Double-click on the image to display the Picture toolbar; then choose In Front of Text from the Text Wrapping tool.

Mark Special Days in Special Ways.

You can note vacation plans or spotlight an approaching landmark birthday by adding images to your calendar. This is a great way to feature drawings done by your children. You'll also find a collection of art specially designed for calendars, cards, and other family projects on the DigitalFamily.com Web site. Look for the link to artwork in the special password-protected section for this book and you'll find images organized by subjects such as holidays, sports, people, food, and other common themes, as well as instructions for downloading artwork to your computer.

Add Visual Appeal with Seasonal Pictures

Use colorful photos as fillers for those blank days at the beginning or end of the month.

Make Your Calendar a Job Jar

Use text or pictures to remind yourself (or someone else) about routine chores for the month. Format the text with a cheery typeface and paint the box with a festive background color or border.

FILL IN THE BLANK
Insert a photo; then set its Text Wrapping attribute to move it freely.

A FRIENDLY REMINDER
Place chore reminders on a particular date or next to a related photo or piece of artwork.

 # Weekly Reminder Calendar

One of the most practical calendars you can create is a weekly reminder calendar, personalized with favorite photos and colorful artwork. This works well for my uncle John and aunt Gail who have two teenagers. One week my cousin Kate illustrated her calendar with a soccer team photo, while her brother Ian opted for a track meet shot. They update their events and appointments every weekend, and then print the calendars Saturday or Sunday evening so they're ready for the week.

Weekly calendars can easily be customized to suit everyone's needs. Gail prefers her calendars printed at a reduced size to fit her day planner, while John likes to tack them to the bulletin board. When their kids were younger they punched holes in their calendars to fit their school binders. Now that Ian has gone off to college, his parents send him calendar updates attached to an e-mail message.

You'll find a template designed for a weekly calendar (Weekly-calendar-template.doc) at www.digitalfamily.com. If you download the template, you can skip the first three steps. If you prefer to create your own calendar file, the following instructions show you how.

June 2006

Sunday June 11	Dinner at Grandma's, 7 p.m. — take dessert
Monday June 12	Mom is meeting with client, 4 p.m. to 7 p.m.
Tuesday June 13	
Wednesday June 14	Last day of school
Thursday June 15	Kate is 16!
Friday June 16	Family movie night
Saturday June 17	Pedal & Park at Art Fair, work 10 a.m. to 2 p.m.

A WEEK IN THE LIFE

Get everyone on the same page with this effective and flexible resource for the whole family. It's an attractive addition to any binder, bulletin board, or weekly planner.

1. Create a New document using File → New and then choose File → Page Setup.

On the Paper Size tab, set the page size at 8.5 by 11 inches (letter-size) and Portrait orientation.

On the Margins tab, set the Top, Bottom, Left, and Right margins at 0.5 inches (or half an inch). This allows you plenty of margin for printing. Click OK.

2. Choose Table → Insert → Table. In the Insert Table dialog box, type 2 in the Number of Columns field, and type 8 in the Number of Rows field. Set Fixed Column Width to Auto and click OK.

3. Choose View → Toolbars → Tables and Borders to make the table formatting options visible.

Click your cursor in the top row of the table, then choose Table → Select Row. With the top row selected, click the Merge Cells button on the Tables and Borders toolbar.

4. In the template you created or downloaded from the DigtialFamily.com Web site, click to insert your cursor in the top row.

Choose Insert → Picture → From File. Browse to find the image you want, click to select it, and click Insert.

When the picture appears in the top row, use your cursor to click and drag a corner to resize the photo as needed (press and hold the Shift key to maintain the photo's proportions); then click the Align Right button on the Formatting toolbar to position the photo.

5. Click away from the photo, then click the Text Box tool on the Drawing toolbar and notice that your cursor becomes a crosshair. (If the Drawing toolbar is not visible, choose View → Toolbars → Drawing.) Click in the left side of the top cell and drag down and right to draw a text box.

Type the month and year in the next text box, and then format the text; the top row is done.

6. To size the remaining rows for dates and notes, float your cursor over the vertical line between the two columns. Notice that your cursor becomes a two-headed horizontal arrow with two vertical lines between the arrowheads. Click and hold to grab the vertical line and drag it to the left.

7. Click and drag with your cursor to select all seven of the bottom rows, then drag the bottom edge of the last row to the bottom margin of the page. This causes all the extra vertical space to appear in the bottom row, so click the Distribute Rows Evenly button on the Tables and Border toolbar to flow the space equally into all seven rows.

8. Select the entire table by choosing Table → Select → Table). Click the Border button on the Tables and Borders toolbar, then click the No Border icon on the drop-down submenu. Use the Line Style, Line Weight, and Border Color controls to set formatting for some new borders (such as a solid, 3-point, Aqua rule like the one shown here).

To assign your formatting to the vertical line, click the Border button, and then find and click the Inside Vertical Border button on the drop-down menu. Now change the Line Weight to 1 point, and find and click the Inside Horizontal Border button.

9. To add dates and notes, click in the left column of the first row and type the weekday name and date; then press the Tab key to move your cursor into the second column and type a description of an event. Continue pressing the Tab key and typing to enter more dates and events.

You can format your text by clicking and dragging to select it and then changing font, size, color, and alignment using the regular formatting tools at the top of your screen.

10. To add artwork or photos, click in a cell and choose Insert → Picture → From File. Find and select the photo you want and click Insert.

Click and drag a corner point to resize the photo. From the Picture toolbar, choose a Text Wrapping style that allows the photo and accompanying text to float nicely together.

Keepsake Calendar

Tom and Mindy's family has always had cats, and their kids loved them all. As the kids grew up and moved away, they always remembered one favorite feline, old Dromio, and often wondered how he was doing.

For Christmas one year, Mindy came up with the idea of giving her kids personalized calendars filled with photos of their favorite cat. Since he was getting old, most of the photos showed Dromio lounging around the house, sleeping on the rug, watching birds through the window, sleeping on the couch, staring longingly at his brush, sleeping on the bed—well, you get the idea.

After she printed and trimmed the pages, Mindy took the calendars to a local copy shop where they punched and bound them with a plastic coil across the wide top edge, which made the calendars easy to tack to a bulletin board or perch on a desktop. The kids loved this treasure and kept it to help them remember old Dromio long after he was gone.

You'll find a template (Keepsake-template.doc) for this calendar on the DigitalFamily.com Web site. If you use the template you can just insert a photo as described in step 2 on page 160. Or you can follow the directions to set up your own template.

as described in step 2 on page 160.

Tip

Prepare your photos before you begin laying out the pages. Crop and size your photos to be 10 inches wide by 3.75 inches tall. For help with cropping, sizing, and saving digital photos, see Chapter 3.

CAPTURING CATNAPS

With a quick glance, you can check the date and enjoy a favorite photo. To make this calendar focus on Dromio's personality, Mindy chose a wide format and cropped the photos for tight, close-up views. You can almost feel the softness of his multicolored coat. Because this calendar is not about keeping track of events, she placed the days of the month over each photo and left no space for making notes.

1. Create a New document by choosing File → New; then choose File → Page Setup.

On the Paper size tab, set the page size to 8.5 by 11 inches (letter-size) in Landscape orientation. On the Margins tab, set the Top, Bottom, Left, and Right margins at 0.5 inches (or half an inch). This allows you plenty of margin for printing. Click OK. You'll make two calendar pages with this single sheet of paper and then cut them apart.

2. Choose Insert → Picture → From File. Find and select the first photo you want to use and click Insert.

To precisely resize the photo, double-click the photo to display the Format Picture dialog box. On the Size tab, type the desired sizes in the numeric Height and Width fields.

Click to the right of the first photo and press the Enter key to create a line return; then repeat these steps to insert the second photo, and size and position it.

3. Click the Text Box tool on the Drawing toolbar. Click and drag the crosshair cursor to draw a text box that floats over a portion of the top photo.

Double-click the text box to display the Format Text Box dialog box. On the Colors and Lines tab, choose No Fill and No Line in the color fields. On the Text Box tab, type 0 in all four of the Internal margin fields (Left, Right, Top, and Bottom).

4. Click again in the text box, type the name of the month, and format its type style, size, and color by using the controls on the Formatting toolbar. Press Enter to insert a line return.

Choose Table → Insert → Table to open the Insert Table dialog box.

Type a numeric value of 7 for the Number of columns and 5 for the Number of rows. Click OK.

5. Click your cursor anywhere in the table. Choose the Table menu and look for Show Gridlines or Hide Gridlines. For now you want the gridlines visible to help you as you type and format the calendar; so you want Hide Gridlines to be visible, meaning Show Gridlines has been selected.

6. Click in the correct cell for the first day of the month and type the number 1. Press the Tab key to advance to the next cell and type the number 2, and so on until you have entered the correct number of days for that month.

Click in the top left cell of the table and drag over and down to select all the cells. Choose a font, size, and color, then use the Alignment tool on the Tables and Borders toolbar to align the table.

Choose Format → Paragraph to open the Paragraph dialog box, then choose a Line Spacing of Double. Click OK.

7. From the Table pull-down menu, click Hide Gridlines and review your work. Repeat the techniques for the other months, and feel free to move the calendar text to different parts of the page, depending on the photos. If a calendar floats over both dark and light portions of a photo, format part of the calendar with a light text color and part of it with a dark text color.

Once you have created all the months, print the pages on your home printer. Then trim them to the edges of the photos and see what you think. Because you will bind this calendar on the wide top edge, you may want to shift the placement of a text box or recrop a photo to accommodate the binding.

Putting It All Together

No matter which calendar design you choose, you may want to take your calendar to a local copy shop or scrapbooking store, where you can have your calendar bound with colorful plastic coils to make it more professional-looking.

You may also want to have some or all of your pages professionally printed, especially the cover pages, which will look best when printed on a good color printer on heavy paper stock.

As you create your calendars, let your imagination guide you. You can add more than one image to each calendar page, create more elaborate designs, and even add stickers or other three-dimensional objects after you print your calendars. When you're done, you'll have a handsome and practical keepsake your family can enjoy and use, month after month.

peace joy love

November 2006

Dear friends and family,

It's hard to believe that our little Samantha started first grade this year. I wish I had her energy and courage. As you can see in the photos here she has become quite adept at climbing mountains and she's sure she's got nine lives, even when her face isn't painted like a cat.

May all your days be as sweet as our baby's smile.

All your travels as peaceful as a walk in the woods.

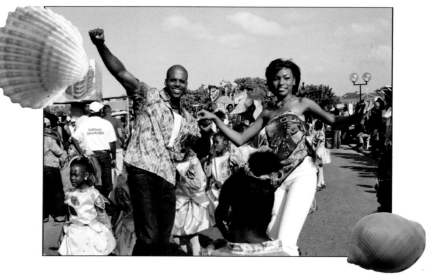

Greetings from our new home in Jamaica

CHAPTER

News Flash:
Dress Up Your Family Letters

As the holidays arrive and a new year approaches, many of us send annual letters to catch up with friends and relatives. Now that we have computers, it's so fast and easy you don't have to wait until the end of the year anymore. This chapter includes step-by-step instructions designed to help you from beginning to end as you develop a colorful, thoughtful letter for everyone in your address book. You'll find lots of design ideas to help bring your letters to life so you can:

- **Add some pizzazz to your annual holiday letters**
- **Update friends and family about special events**
- **Create personalized thank-you letters**
- **Inform friends and family about a new home or other changes**

Whether you use e-mail, snail-mail, or archive each issue on your Web site, family letters are a great way to keep all your loved ones up-to-date.

I still have copies of the holiday letters my grandmother used to send every year. The paper has yellowed a little and the images have faded, but my grandmother's pride and love still shine out in every word she wrote about her family and every photo she pasted onto the pages.

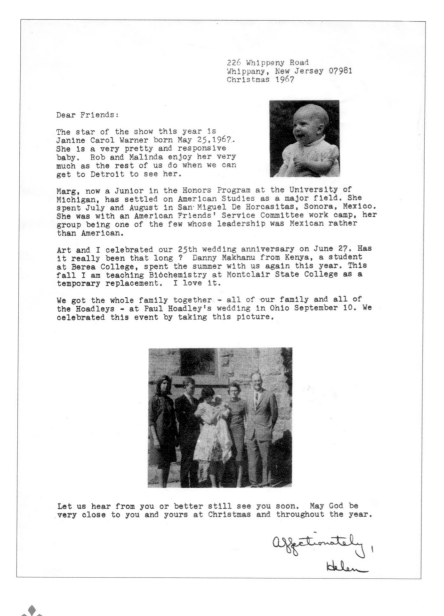

226 Whippany Road
Whippany, New Jersey 07981
Christmas 1967

Dear Friends:

The star of the show this year is Janine Carol Warner born May 25, 1967. She is a very pretty and responsive baby. Rob and Malinda enjoy her very much as the rest of us do when we can get to Detroit to see her.

Marg, now a Junior in the Honors Program at the University of Michigan, has settled on American Studies as a major field. She spent July and August in San Miguel De Horcasitas, Sonora, Mexico. She was with an American Friends' Service Committee work camp, her group being one of the few whose leadership was Mexican rather than American.

Art and I celebrated our 25th wedding anniversary on June 27. Has it really been that long ? Danny Makhanu from Kenya, a student at Berea College, spent the summer with us again this year. This fall I am teaching Biochemistry at Montclair State College as a temporary replacement. I love it.

We got the whole family together - all of our family and all of the Hoadleys - at Paul Hoadley's wedding in Ohio September 10. We celebrated this event by taking this picture.

Let us hear from you or better still see you soon. May God be very close to you and yours at Christmas and throughout the year.

Affectionately,
Helen

MY FIRST FAMILY LETTER
My grandmother was limited to a typewriter and black-and-white photos, but her annual letters kept the extended family and many friends informed about special events.

Tip
If you have collected yellowing letters or old photos from parents or grandparents, don't miss Chapter 10, which will show you how to preserve them so they can be enjoyed by generations to come—no matter what technology people may use to view them in the future.

Every year as the holidays approached, she would gather pictures and interview everyone in the family about what we were doing. Then she would compose a letter that included a message about each of us. Every graduation, wedding, and birth in our family was documented in those letters and sent off to her wide-reaching mailing list of friends, neighbors, and extended family.

Grandma put her letters together very simply. She cut the photos with a standard pair of scissors, cropping away unnecessary backgrounds and sometimes giving them rounded edges so they would fit well together on a letter-size piece of paper. Then she carefully typed the words, leaving space for the images as she typed. After the page came out of the typewriter, she glued the pictures into place. And when all that was done, she took the letter to the library, where she made black-and-white copies for a few cents a page.

We thought her letters were beautiful, but by today's standards, they seem rather quaint—devoid of any color and limited to the one typeface on her typewriter.

My grandmother lived just long enough to make a few attempts at using a home computer, but she never became very comfortable with it. I have to admire all she was able to accomplish with a simple typewriter and a pair of scissors, but if she were here today, I'm sure she'd be delighted by what she could create with the tools now available. I can just see her crafting beautiful, colorful holiday letters and reveling in how much easier it is to e-mail them than it was to handwrite all those addresses and paste on all those stamps.

The Modern Family Letter

Today's computers make composing and designing a holiday letter or family newsletter faster, easier, and lots more fun. With just a few photos, a simple image-editing program, and a common word processing program, you can create beautiful letters like the ones shown in this chapter. In the following pages, you'll discover how to create your own family letter using one of the templates included on the DigitalFamily.com Web site. In the pages that follow, you'll find step-by-step instructions for inserting your own images, adding borders, changing fonts, and even using colored backgrounds to set off text and other elements.

Share the Love

I realize there may still be a few people on your holiday mailing list who don't have e-mail, and others who just prefer to receive a printed letter. That's why all of the instructions in this chapter are designed to help you create letter designs that will work for print or e-mail. (In Appendix B, Sharing Your Digital Creations, you'll find information about how to send them either way.)

In the following project, you'll find step-by-step instructions designed to help you create a colorful letter with photos and text. No matter how you want to deliver your letter, the most important part is creating just the right message.

peace joy

love

November 2006

Dear friends and family,

It's hard to believe that our little Samantha started first grade this year. I wish I had her energy and courage. As you can see in the photos here she has become quite adept at climbing mountains and she's sure she's got nine lives, even when her face isn't painted like a cat.

Jim has never liked having his picture taken, but Sam managed to snap this playful shot of daddy "painting his face." Despite the fact that he's covered with shaving cream, I think this is one of the best pictures we have of the two of us.

The highlight of our year was getting a new dog. Alabaster brings a *joie de vivre* second only to Sam's. and is a wonderful addition to our home.

Jim, Sam, and I wish you the best of holiday seasons. May the blessings of another year be abundant, may you enjoy love and great health, and may all your dreams come true.

Love to you all,

The Rondelettes

We finally gave in to Sam and got a new puppy -- at least he can keep up with her!

SAY IT WITH STYLE
Modern family letters created on a computer can feature color,
special fonts, and much more. (Photos by Ken Milburn.)

YOU make it Family Letter

You can use any word processing or desktop publishing program to create a holiday letter or family newsletter. This chapter features instructions for creating a letter using Microsoft Word because it is one of the most common programs available today. If you use a different program, such as WordPerfect, you may need to make minor adjustments to these steps, but the basic concepts and instructions should apply no matter which program you use.

To help you get started, you'll find many templates, photos, and graphics on the Web site that serves as a companion to this book. Visit www.digital family.com and follow the links to the Family Letters section. There you'll find instructions about how to click and download templates and graphics such as the Peace, Love, and Joy banner used at the top of the letter on the facing page.

1. Start by downloading one of the family letter templates included on the DigitalFamily.com Web site. You'll find a few to choose from, but the one I used in this exercise is called Family-letter1.doc.

Open the template in Word or any other word processing program. You can write the text for your newsletter directly into the template as you would in any other Word file. To replace the text in the template, simply click and drag across it to highlight it, and type in your own words; your new text will replace the highlighted text.

You can replace the placeholder text one word, sentence, or paragraph at a time, or you can delete all the text in the template and start fresh.

Formatting Text

You can format the text of your family letter as you would in any other document, using the menu options in Word to make text bold or italic, and you can change the font and its size to alter the appearance of the text. (You'll find tips and instructions for these common tasks in Appendix A, MS Word Quick Reference Guide.) The template includes preset text formatting designed for captions and for the text of the letter. You can choose to use these presets or change them to any font or style you prefer. Don't be afraid to get creative. The templates provided on the DigitalFamily.com Web site are designed to serve as guidelines and to give you ideas, but I encourage you to make them your own.

Adding Photos to Your Letter

If you haven't added photos to a document
before, let me reassure you that it's remarkably
painless. The challenging part is getting the pho-
tos ready, but you'll find lots of instructions and
tips about cropping, resizing, and editing your
images in Chapter 3.

The instructions in this project assume you're
using the images we've provided for you on the
Web site, which are all ready to use, or that you
are using your own images and you've already
done any editing you want to do to them.

Tip

It's best not to do too much resizing in
Microsoft Word because the image can
become distorted or blurry. If you want to
do significant resizing, it's better to do it in
a graphics program, such as Photoshop
Elements, which is covered in Chapter 3.

2. To add a photo, click to place the cursor where
you would like to insert the photo. Choose Insert →
Picture → From File. In the Insert Picture dialog box
that opens, navigate around your hard drive to find
the photo you want to add. Click on the file name to
select the image. Click Insert and the image will auto-
matically appear on the page.

3. Click on the image to select it. Notice the black
handles that appear on the photo's edges. I call those
corner points. Click and drag any of the corner points
to make the image smaller or larger. Hold the Shift
key while you drag to keep the height and width pro-
portions the same.

4. Also note that you can add graphics like the
Peace, Love, and Joy banner to this design just as you
add photographs. Place the cursor where you would
like to insert the image (in this example, I've placed
my cursor in the very top part of the template).
Choose Insert → Picture → From File, select the
image you want to add, and click Insert. The image
will automatically appear on the page.

5. Add borders to your images for a more finished look. Click to select the image you want to surround with a border.

Choose Format → Borders and Shading. In the Borders dialog box, click to choose the setting you want to use: If you choose None, your image will have no border. The little icons on the left of the dialog box show what each style looks like.

Click and drag the Style slider to view the many border styles and then click to select the one you want to use. Choose a color from the Color palette and set the width of the border. The higher the number you select, the thicker the border will be. Click OK and the border will appear around the image.

6. Background colors are a great way to divide a page and set off text or other elements. To add or change a background color, click to insert the cursor into the area that you want to change. Choose Format → Borders and Shading. In the Borders and Shading dialog box, click the Shading tab. Select a color under Fill or click the More Colors button to choose from a wider selection of color options.

If you are changing the color of the text area, choose Cell from the Apply To menu. If you are changing the accent color of the caption box, choose Table from the Apply To menu. Click OK and the color will automatically be applied to the selected area.

Tip

If you change your mind and want to replace an image you've already inserted with a new one, that's easy too. Just click to select the image you want to replace and press the Delete key to remove the selected image.

7. Continue adding images and altering text in the template until you have personalized the letter and made it your own. When you have the letter the way you want it, you can print it or e-mail it. (See Appendix B, Sharing Your Digital Creations, for tips.)

Once you've learned the basics of designing a family or holiday letter like the one featured in the first part of this chapter, don't be afraid to experiment with special effects and techniques. The following examples are designed to give you a few ideas about the kinds of letters you can create and how to use images and text in your designs. (In Chapters 4 and 6 you'll find more instructions for creating designs like these using Microsoft Word.)

Our tropical honeymoon

Dear friends and family,

Thank you all so much for helping to make our wedding such a beauttiful and loving day. We feel so blessed to have found each other, and so blessed to have such a supportive and caring community of friends and family. We hope these photos convey the playful and loving experience we had on our honeymoon.

We'd tell you that we wish you could have joined us, but we love you all too much to lie.

love and kisses,

Dan and Victoria

KEEP IT SIMPLE
The large background image behind Dan and Victoria's honeymoon letter provides a common theme and invokes the feeling of a tropical vacation. Notice that the large area of water provides a simple background that doesn't detract from the text or other images.

CREATE A MOOD

The use of this large dramatic image sets a peaceful tone and makes the faces in the top left corner stand out more dramatically. Notice that the light text color works well against the dark background.

May all your days be as sweet as our baby's smile.

All your travels as peaceful as a walk in the woods.

And may you and yours have a lovely holiday season and another year filled with wonder, joy, and peace.

Send a Family Letter Any Time

Holidays aren't the only time you may want to reach out to friends and family. You can design a family letter for any special occasion or event. If you move to a new city or country, a letter with photos from your new home can help the friends and family you left behind feel closer to you. After a big vacation you can use a letter to share your photos and stories. When a child wins a sporting event, or gets a special honor in school, commemorate the occasion with a letter. Any time of year is the right time to send a loving message with your own custom design.

◆ Note

The shell images shown in this letter were created with a transparent background so they appear to almost "float" on the page. Learn how to use transparency for special effects, as well as many other great image tricks, in Chapter 3.

Greetings from our new home in Jamaica

Latisha and I are so happy to be back in my beloved homeland of Jamaica.

We loved our time with all of you in New York, but this is home for me and we are both enjoying the love and spirit of life here.

We hope you will come and visit us and we promise to be back in New York soon. You know we can't last too long without missing the nightlife, theater, and, more than anything, our dear friends.

Please write (and email) often and start planning your winter getaway to visit us!

Love,

Nathaniel and Latisha

GIVE THEM A GLIMPSE

Illustrating a letter with photos is an ideal way to announce a move and update friends and family with more than just your new address.

Add pictures | View & enhance | Share online | Order prints | Shutterfly Store

Pictures added successfully!

11 pictures were added to your album **Dad's photos**.

Pictures successfully added: 11

dad.jpeg

globe.jpeg

bath.jpeg

annabelle.jp eg

jo.jpeg

mantel.jpeg

top.jpeg

vernon.jpeg

Family Tree

4. Father (of N
William Goode
Born 5 Aug 1
Place Richmo
Married 25 A
Place New Pi

2. Father (of No. 1)
William Homer MOULTON
Born 15 Feb 1882
Place unknown
Married 21 Dec 1911
Place Parker, Indiana
Died 2 Dec 1960
Place Winchester, Indiana

5. Mother (of N
Eva Aretta KO
Born 20 Feb 18
Place (possibly
Died 13 Mar 18
Place

1. Carol MOULTON
(born Bessie Carol Moulton)
Born 3 Oct 1912
Place Parker (now Parker City), Indiana
Married 9 Oct 1932
Place Indianapolis, Marion, Indiana
Died 4 Oct 2001
Place Maumee, Lucas, Ohio
Spouse Howard E McCAIN

6. Father (of N
Frank Orloff H
Born 2 Dec 1
Place Greenfi
Married Jan
Place Franklin

CHAPTER 10

Family History:
Pay Loving Tribute

Do your children know all the amazing things their grandparents accomplished in life? And what about your genealogy; do you know where your ancestors came from and who they were?

Take the time to interview parents and grandparents while you still can, research your family tree, and use the tips in this chapter to bring out your most colorful family anecdotes and create projects that will bring those stories to life. There are so many ways to honor the people we love and remember those who came before us. In this chapter, you'll learn how to:

- **Research your family's history online**
- **Interview family members to collect valuable family lore**
- **Protect and restore priceless old photographs**
- **Create memorial letters and programs**
- **Design an online photo album to showcase family pictures**

With the tools and ideas in this chapter you'll be able to celebrate the lives and history of everyone in your family.

The sheer number of people using the Internet to research family history is evidence of how many of us have lost track of our ancestors over the years. Tracing where your family came from and creating a detailed family tree can be fascinating, surprising, and sometimes even funny.

Collecting and managing family history and genealogy can be a time-consuming process, but a growing list of helpful digital tools are making it easier. In this first section, you'll discover some of the best places to research genealogy on the Internet today.

Family Tree (Ancestry Chart)

2. Father (of No. 1)
William Homer MOULTON
Born 15 Feb 1882
Place unknown
Married 21 Dec 1911
Place Parker, Indiana
Died 2 Dec 1960
Place Winchester, Indiana

4. Father (of No. 2)
William Goode MOULTON
Born 5 Aug 1856
Place Richmond, Indiana
Married 25 Apr 1880
Place New Pittsburg, Indiana

8. Father (of No. 4)
George William MOULTON
Born 31 Dec 1819; Place unknown
Married 12 Nov 1854
Place unknown
Died 18 Apr 1887; Place unknown

9. Mother (of No. 9)
Mary Ann DAVIDSON
Born 1820; Place unknown
Died 12 Jan 1892; Place unknown

10. Father (of No. 5) unknown

5. Mother (of No. 2)
Eva Aretta KOON
Born 20 Feb 1861
Place (possibly near Centerville, Indiana)
Died 13 Mar 1890
Place

11. Mother (of No. 5) unknown

1. Carol MOULTON
(born Bessie Carol Moulton)
Born 3 Oct 1912
Place Parker (now Parker City), Indiana
Married 9 Oct 1932
Place Indianapolis, Marion, Indiana
Died 4 Oct 2001
Place Maumee, Lucas, Ohio
Spouse Howard F. McCAIN

6. Father (of No. 3)
Frank Orloff HYER
Born 2 Dec 1856
Place Greenfield, Ohio
Married Jan 1882
Place Franklin, Indiana
Died 12 Jan 1936
Place Parker, Indiana

12. Father (of No. 6)
Samuel HYER
Born 4 Mar 1830
Place Ross Co., Ohio
Married 15 May 1856; Place Ohio
Died 28 Nov 1903
Place Springfield, Ohio

13. Mother (of No. 6)
Catharine J. WELSHEIMER
Born 2 Jul 1835
Place near Greenfield, Ross Co., Ohio
Died 19 Mar 1881
Place Springfield, Clark, Ohio

3. Mother (of No. 1)
Pearle Hockett HYER
Born 5 Dec 1888
Place Franklin, Indiana
Died 2 Dec 1972
Place North Webster, Indiana

7. Mother (of No. 3)
Etta [Sarah Etta?] HOCKETT
Born 26 Aug 1860
Place Raleigh, North Carolina
Died 7 Dec 1893
Place Franklin, Indiana

14. Father (of No. 7)
Zimri HOCKETT
Born 17 Dec 1835
Place Randolph Co., North Carolina
Married 12 Nov 1855
Place Guilford Co., North Carolina
Died 1898; Place Parker, Indiana

15. Mother (of No. 7)
Malinda [Susannah Malinda?] GRIMES
Born 28 Dec 1834
Place Raleigh, Wake, North Carolina
Died 27 Apr 1882
Place Franklin, Indiana

Prepared by: John W. McCain Date: August 12, 2005

RESEARCHING YOUR ROOTS
A wealth of online resources have made it easier than ever to trace your family ancestry and create a family tree.

Note
To download many genealogy forms such as the Familiy Group Record form (see next page), you'll need Adobe's Acrobat Reader software because the form is a PDF file. If you bought your computer within the past few years or have a recent version of Internet Explorer or Netscape, you probably already have the Acrobat reader in your system. If not, you'll need to download the reader, install it on your computer, and then click on the downloaded PDF file to read it. The reader is free from the Adobe Web site at www.adobe.com/acrobat.

USGenWeb Project

The USGenWeb Project is a volunteer group of genealogists who help each other trace family history. Their Web site (www.usgenweb.org) is straightforward and easy to use, and it brings together resources and researchers from all fifty states.

When you visit the Web site, click the Researchers link in the red navigation bar near the top of the home page to find help with searching for names, using census records, and other tasks. The Getting Started page has helpful step-by-step instructions for using the USGenWeb site to search through the USGenWeb archives state-by-state or nationally, the enormous genealogy library of the Church of Jesus Christ of Latter-day Saints, and individual state genealogy projects associated with USGenWeb.

Ancestry.com

By far one of the most popular online resources for genealogy research, Ancestry.com does charge for some of its services ($189.95 annual fee at the time of publication). But if you're serious about genealogy research, you're likely to find this service, and the genealogy software they offer, well worth the expense.

Ancestry.com features an impressive array of archives and research tools, including the ability to search census records; family and local histories; immigration records; birth, marriage, and death records; as well as newspapers. You can arrange for Ancestry.com to conduct searches for you, or you can search for name matches among the thousands of family trees submitted by other site members. (Just remember to keep a healthy skepticism about other people's records; not everyone researches as carefully as you may prefer.)

You'll also find links to their affiliated sites—RootsWeb.com, a free entry-level genealogy site, and MyFamily.com, a fee-based service for building family Web sites with—guess what?—a family tree section.

More Family History Web Sites

Search around online and you'll find many helpful resources when it comes to recording family history. Here are a few to get you started:

- Texas A&M University has a list of helpful questions at fcs.tamu.edu/aging/Family_History_Questionnaire.htm.

- You'll find tips for interviews, question lists for relatives, and more at genealogy.about.com/od/oral_history.

- The American Folklife Center of the Library of Congress has a variety of helpful resources at www.loc.gov/folklife.

- You'll find great ideas at the Sense of Oral History site at George Mason University at historymatters.gmu.edu/mse/oral.

- Cyndi's List of Genealogy Sites on the Internet (www.cyndislist.com) has links to more than 240,000 sites, including adoption records, births and baptisms, house and building histories, land records, photographs—perhaps more than you want to know!

Genealogy Software Programs

There are many software programs designed to help you research and create your family tree. Here are a few to get you started.

Family Tree Maker (www.familytreemaker.com) is a robust program with features to help you build, research, and share your family tree. This program retails for $29.95.

For professional quality, turn to the **Master Genealogist.** Expect a steep learning curve but great rewards. Many genealogists consider this the best program for the highest-level work. You can view sample pages, download a free 30-day trial at www.whollygenes.com, or buy the program for between $34 and $59.

RootsMagic gets high ratings for ease of use. It allows multiple viewing options, flexible data handling, customizable record sheets, and easy file management and sharing. Check out the free demo or pay $29.95 for the program at www.rootsmagic.com.

RECORD YOUR FAMILY HISTORY
A Family Group Record form (available for free from Ancestry.com and many other sites) is designed to help you keep track of key information as you do genealogy research. You can then transfer that information to a family tree.

The older folks in our Midwestern family did not always volunteer stories; it often took a chance question to start a conversation and patience to get them to reveal the richest gems about their lives, but the rewards were worth the effort. For example, my great-uncle Vernon once recounted a surprising story about a one-armed friend who controlled gambling and liquor in their county during the 1920s and occasionally sheltered one of the most notorious gangsters of that era.

The following tips are designed to help you capture the stories in your family, so you don't have to rely on such chance discoveries.

UNCLE VERNON
This gentle man rubbed elbows with outlaws.

Choose the Right Interview Tools

If at all possible, use a tape recorder or video camera to record older family members and supplement your recording with handwritten notes.

Some people are intimidated by cameras and recording devices. Reassure them that they don't have to say everything perfectly and that it's important to you to capture their words so you can share them with family and friends for generations to come. You may even want to schedule a practice session.

A clip-on microphone positioned about 10 inches from the speaker's mouth is ideal. If you use a hand-held microphone, you should place it close to the person you're interviewing. Do not set a microphone next to the recorder or on a hard surface (it may distort the sound quality). And make sure you use new tapes; don't take the chance that the tape is too old to record well or that you might record over the last interview you did.

If you use a video recorder, try to set it up on a tripod to cut down on movement. Ideally, have a third person to run the camera, so that you can focus on the interview.

Ask the Right Questions

For many older family members, it's a treat to tell stories to young people, but often the richest stories come out only with the right question and the right attention to the answer.

Try to keep your questions open-ended to encourage descriptive answers. If your subject starts into a really good story and stops, be prepared with some encouraging questions and prompts, such as "How did that feel?" "Tell me more about that," or "Why do you think they did that?"

Bear in mind that over the years some memories blur together and dates become confused. If that happens, resist the temptation to correct—doing so may stop your subjects from telling their best stories because they worry they'll get them wrong. Instead, if you think something doesn't make sense, make a note about it and ask the question again later.

To help trigger memories, ask your subject to go through an old photo album with you and tell you about the people and things that were happening. Similarly, an old collection of recipes can help remind people of shared meals and favorite foods. Going through a collection of medals or awards can also be a great way to solicit stories.

Here are a few questions designed to help you spark those memories and draw out the best stories:

- What was the best advice you ever got from your mom or dad?

- How would your friends have described you in high school?

- How would your friends describe you today?

- Tell me about a person who had a big impact in your life.

- What did you dream of becoming when you were a child?

- What were your favorite foods when you were a kid?

- How did you meet Grandma/Grandpa?

- What do you remember about the day your first child was born?

- Have you ever witnessed a miracle or something supernatural?

- Were you ever in great danger?

- Tell me a story about your life that would surprise me.

These thought-provoking questions came from my friend Lisa Johnson, who is developing a line of question-based books, cards, and other products designed to help you have more fun and meaningful conversations. To learn more, visit www.jointheconversation.com.

Let Your Children Ask the Questions

Encourage your school-age children to interview older family members. This a powerful way for them to learn firsthand about the people who came before them.

Before the meeting, teach your children some interviewing techniques. Older family members can be intimidating to youngsters, and you want them to feel confident. Here are a few tips to help children of all ages conduct better interviews:

- Take your time, don't interrupt, and give your subject time to think.

- Ask one question at a time and make sure you listen to the entire answer before asking another question.

- Think about the answers as you go along; they may help you come up with even better questions.

- If you don't understand an answer, it's okay to say so and ask follow-up questions.

- If you don't understand a word, it's okay to ask what it means.

- When the interview is done, say thank you.

Resist the temptation to completely script your child's interview. Give her a few questions like the ones listed above, but encourage her to come up with her own questions, too. And beware—your parents may tell your children things they've never told you!

As you pursue your family tree, you are likely to acquire a collection of old photos. Older relatives may give them to you, or you may discover them hiding in family books, forgotten tins, or corners of the attic. It's also likely those photos will not all be in ideal condition. Some may be faded or torn, folded, or damaged by water. Here are a few tips and suggestions for caring for old family photos, restoring them, and preserving them for generations to come.

First, handle the photos as little as possible, and try to touch them only by the edges. Protect photos in archival-quality boxes or books to prevent further deterioration. Look for papers free of acids or other chemicals that can do long-term damage and choose albums and other materials that allow you to easily label your photos without actually writing on the prints.

Above all else, scan your photos into a digital format for long-term archiving. For help with scanning, see Chapter 1 or take your photos to a photo-processing store and have them professionally scanned. Save your digital files on your hard drive and burn them to CDs and DVDs so you have backup copies.

You can use a program like Photoshop Elements to repair damaged images and then include them in your family projects. Many of the tips and tricks covered in Chapter 3 will help you edit and enhance old photos. Here are a few more tools in Photoshop Elements that are useful when restoring old, black-and-white images.

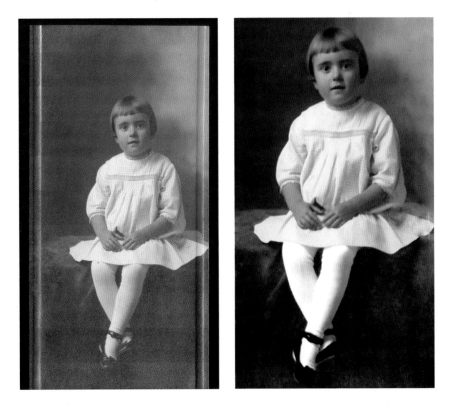

This photo of my grandmother faded over the years and was badly damaged by the frame it was in. With Photoshop Elements, it took only a few clicks to restore it (right).

CROPPING

One of the easiest ways to improve this image was to crop it to get rid of some of the damaged edges and create a photo that focuses your attention better on the subject. (See page 52 for instructions on cropping images.)

THE HEALING BRUSH TOOL

The Healing Brush tool may be the single most useful tool for repairing photos.

Start by selecting the Healing Brush tool from the Toolbox and setting the size and other options you want in the Options bar at the top of the screen. If you make it too big, the repairs will be more obvious.

To fix something like the wrinkled edge on this image, position the cursor over an area that isn't damaged and press the Alt key and click at the same time (on a Windows computer) or press the Option key and click (on a Mac) to get a good sample.

Then move your cursor to the area you want to repair, and click and drag to paint the area with the selected pattern. The Healing Brush also adjusts the pixels around the area to help it blend in.

REMOVING SPECKLES

Like many old photos, this one suffered from gray speckles. Photoshop Elements has a special tool to help fix this problem. Choose Filter → Noise → Dust & Scratches to open this tool.

Use the Hand tool to adjust the image in the preview screen and then experiment with the Radius and Threshold settings until you see improvement in the image. It doesn't take much—a setting of 1 or 2 may be more than enough to soften the scratches; any more than that may result in a blurry image. You may also be able to remove some of the signs of wear and tear by choosing Filter → Noise → Despeckle.

ADJUSTING COLORS

I like to scan old photographs like this with the scanner set for a color image to capture the best details, and then choose Image → Mode → Grayscale after I've cleaned it up to convert the image to black and white.

You may want to adjust the lights and darks further by choosing Enhance → Adjust Lighting and using any of the three options for balancing light and dark. Experiment with all three until you find the best solution for your image.

✳ Memorial Letters & Programs ✳

Creating memorial letters and programs is a beautiful way to share your thoughts, stories, and feelings about those you love. These days, letters and programs can be created in a program like Microsoft Word with photos and text just like the family letters you learn to make in Chapter 9. You may want to invite family and friends to also create letters in memory of a loved one and then gather them together to be bound into a book. When you create projects like this on a computer, it's easy to make copies for everyone involved.

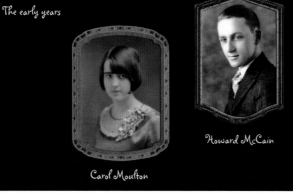

PICTURING THE PAST
Historic photos are a wonderful way to illustrate a memorial letter. These old photographs of my grandmother gave us all a glimpse of her in younger days.

If you are preparing for a memorial service, consider designing a program that is more than just the details of the service. When my grandfather passed away, one of the ways we celebrated his life was by creating a program that featured some of his favorite poems.

My grandpa loved to commit classic poetry to memory and recite it to us, especially at bedtime. He had a few favorites that all of us came to associate with him, and the program filled with his favorite poems served as a beautiful gift for everyone who attended his memorial service.

The first task was to find the seven most-recited poems and transcribe the text into a word processing document, a process that took some diligent searching of libraries and books. Then we inserted that text into a Word document formatted to be letter-size in Landscape orientation, with two columns per page. We made the margins and the text

gutter between the text columns wide to divide the paper into two half-size pages that measured 5.5 inches wide by 8.5 inches each, and inserted column breaks to flow only one poem onto each half-size page.

We then crafted a cover design, bringing the total to four complete sheets. We printed clean master sheets to take to the local copy shop, where we made multiple two-sided copies, collated the sheets, and used the shop's long-reach stapler to insert two staples halfway into the 11-inch length of the paired sheets. After stapling, we folded each pair of sheets to create eight-page booklets.

IN LOVING MEMORY
This collection of poetry made a loving tribute to my grandfather and a precious gift for everyone who attended his memorial services.

Share Your Memories Online

A variety of Web sites offer special remembrance services—some personal and some designed for people to share their grief and feelings with other people.

Collectively the contributors to these sites honor the memory of each other's loved ones, and many people find comfort reading messages from others who share their feelings and have faced similar losses. One of the most active memorial sites is located at at dmoz.org/Society/Death/In_Memoriam/. At this free site, you'll find memorial messages and collections divided into categories and dedicated to firefighters, law enforcement officers, people who have died of AIDS, and so many others.

Another support site is at www.1000deaths.com, a free service for friends and family of people who have committed suicide. You can post photos and memorial letters on this site and participate in e-mail lists and other online support groups.

To find the best place to share your memories, try entering key words related to your loved one at Google.com or another search engine. As you find sites that look interesting, take a careful look at sections titled About This Site or Terms of Use and beware that some sites charge for posting letters and photos.

 Photo Tribute Site

Once photos are in a digital format, you can easily post them to any one of several online photo album services. Not only is this a great way to share your collection with friends and family, but if they want copies of these family heirlooms they can order paper prints from these sites. At the beginning of Chapter 5, you'll find a list of the most popular online photo sites. Here are instructions for using Shutterfly, one of the more popular services.

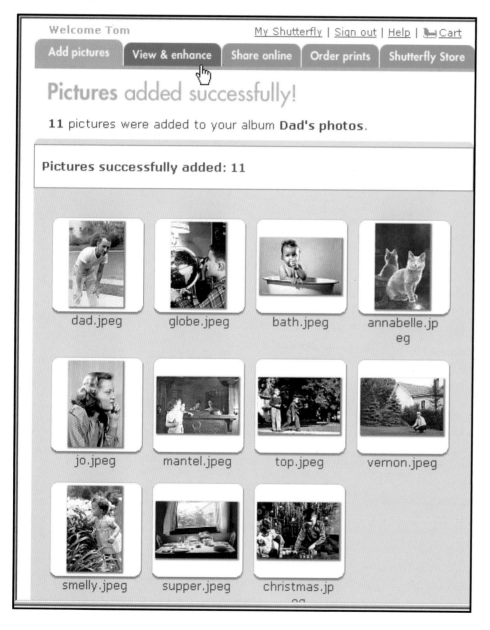

OLD PHOTOS IN A NEW WORLD
This online photo album was created by my uncle Tom and dedicated to my grandfather's shutterbug hobby during the 1940s and 1950s. Consider it a tribute to his passion for capturing his young family's life on film.

1. Point your browser at www.shutterfly.com. Before you can create a photo album you have to join Shutterfly as a new member. This is a fast, easy process, and it's free!

Once you're a member, you will be given password-protected access to your own My Shutterfly page, where you can manage your account and add or edit photo albums.

2. Click the navigation tab labeled Add pictures.

Tip

Don't forget your password. When you return to Shutterfly in the future, you can choose the link for Sign-in and then enter your e-mail address (which is your user name) and your Password (which you choose). When you do so, you will be taken to your personal My Shutterfly page.

3. Click the radio button for A New Album. Click in the field (which will show the current date) and type a title for your album. Give your album a title you will recognize and remember. Click Next.

4. Click Choose Pictures and browse your hard drive to find the photos you want to include.

Click the check boxes for the pictures you want. Click Add Selected Pictures. Notice that Select All is an option. Shutterfly will tell you when your upload is complete. Click View Pictures.

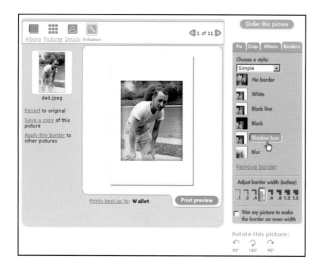

5. Now you can manage your photo album. Click the navigation tab labeled Enhance to organize and caption your photos. You can also use Shutterfly's basic image-editing tools to crop photos, fix red eye, and more (although you'll have more control and far more options with a program like Photoshop Elements, covered in Chapter 3).

6. Compose brief Titles and Descriptions to enhance your album. The titles you add will appear on all your pages; descriptions display only in the slideshow and on the back of prints. Click Save Now when you're done adding text.

7. You can use Shuttefly's notification services to tell friends and family you have created a photo album. Start by clicking Share Online, then select the photos you want to share and click Next. Choose who to send an invitation to (you can create and use a Shutterfly Address Book), type a message, and click Share Now.

Your invitees will receive an e-mail message with a clickable link that will open a Web browser window displaying your photo album. They do not need to join Shutterfly to see the pictures, but they will need your e-mail address and password if they don't have the special link that is included in the message.

Sharing Family History

Family stories are a great feature in any Web site or scrapbook, and you can illustrate them with photos and family trees, as well as links to related stories and Web sites.

Here are a few ways you may want to share your family stories:

Create a scrapbook with a single question and answer on each page and decorate the pages with photos and souvenirs (see Chapter 4 for digital scrapbooking tips).

Add a genealogy or family history section to your Web site and create links to related Web sites. For example, if a grandmother served in the United Service Organizations during World War II, create a link to the USO home page (see Chapter 5 for Web design options).

Create a family calendar with a historic family photo and story for each month (see Chapter 8 for instructions to create calendars). And when the time comes, create a memorial letter that commemorates the life of a loved one (Chapter 9 has ideas for creating family letters with photos and other illustrations).

You can do so many things in Microsoft Word that entire books have been written on the subject. We can't tell you everything you need to know about Word, but in this appendix you'll find brief explanations of some of the most common things you'll need to do in Word to complete the projects in the rest of this book.

Menus

As with most software programs, Word has several menus displayed across the top of the window. From left to right, the menus are File, Edit, View, Insert, Format, Tools, Table, Window, and Help. Each menu contains several commands. When you point to a menu title with your cursor, the menu opens to display some or all of the commands available. You can drag your mouse down to highlight the option you want. With the option highlighted, you can click to select it with your mouse or press the Enter key (Return on a Mac). If you see an ellipsis (...) or arrow after a menu item you'll find additional options in a pull-out menu or a dialog box when you highlight it with your cursor.

Dialog Boxes

Dialog boxes open when you choose certain commands or perform certain actions. Dialog boxes contain drop-down lists, view windows, check boxes, radio buttons, sliders, and other ways to refine commands. For example, when you choose Font from the Format menu, a dialog box opens in which you can choose different fonts and sizes, make the text italic or bold, change the color of the text, and so on.

Note

Throughout this book when I want to give an instruction that uses a menu, I do so by using arrows like this →. For example, to create a new document, choose File → New → Blank Document. To save a document, choose File → Save.

When you click on a Menu in Word, you open a pull-down menu with many options. The Help menu, for example, includes lots of information about using the program.

The Font dialog box.

✳✳✳✳✳✳✳✳✳✳✳✳

One Task, Many Options

Many people who are new to computers are confused by the fact that there are multiple ways to execute almost any command in a program. This is supposed to make your life easier (or at least give you more options), but it can be very confusing at first. For example, you can specify font options in the Font dialog box under the Format menu bar, but you can also make formatting selections from the Formatting toolbar (see Toolbars, page 186) or use key commands (see page 186).

Toolbars

You can use the toolbars in Word to perform some tasks more easily than you can by using menus. The Standard toolbar and the Formatting toolbar are automatically displayed at the top of your window unless you close them.

If you want to use a toolbar that is not visible by default, such as the Drawing toolbar, click on the View menu and point to Toolbars to display a list of all the toolbars available. The toolbars with checks next to them are already being displayed. To display an additional toolbar, move to that toolbar's name and click. The list of toolbars will close and the toolbar you chose will be displayed. When you finish using that toolbar, you can hide it by selecting the name again to uncheck it.

To use a tool on a toolbar, first hold your cursor over the tool without clicking. The tool will become highlighted, and you should also see a small label telling you the name of the tool.

Click on a tool to perform the action represented by the tool. For example, on the Drawing toolbar, if you click the Line tool your cursor will change to a crosshair that you can use to draw a line. Note: To use tools on the Drawing toolbar, you need to be in Print Layout view (views are explained on the next page).

The View menu showing the Toolbars pull-out menu.

Key Commands

Some people like to use key commands, or shortcuts, instead of menus and toolbars. For most key commands, you hold down a key or two, press another key, and then release all the keys. For example, a shortcut for opening a new blank file is Control + N. That means you hold down the Control key (it's marked Ctrl on most keyboards) and press N; then release both keys. On a Macintosh, you do the same thing, but you hold down the Command (or Apple) key. If you use a key command that affects text, such as Bold, you must first select the text. Here are some common key commands:

Command	Windows	Macintosh
Print	Control + P	Command + P
Open	Control + O	Command + O
Undo	Control + Z	Command + Z
Redo	Control + Y	Command + Y
Save	Control + S	Command + S
Underline	Control + U	Command + U
Bold	Control + B	Command + B
Italic	Control + I	Command + I
Copy	Control + C	Command + C
Cut	Control + X	Command + X
Paste	Control + V	Command + V

Understanding Views

You can display a document in various views in Word. The views have slightly different names, depending on which version of Word you're using, but they work the same way. You choose the view you want by clicking an icon in the lower left corner of the window or by choosing a view from the View menu. Here's how some of them work:

Normal view displays all text and basic formatting, such as line spacing, font, type size, and italics, but columns and graphics often do not display well in Normal view. **Web layout view** displays the document as it would appear in a Web browser if saved in HTML. **Print Layout view** shows you how your document will look when printed. **Outline view** displays the document in outline form. This view is useful for organizing text. **Reading Layout view** enlarges the text and closes most of the toolbars, making it easier to read a document on your computer screen.

Finding a File or Folder on Your Hard Drive

I have seen many people get confused about how files and folders are stored on their computer hard drives. If you don't understand this basic concept, it's easy to lose files you're working on. Here are a few points to help you get the idea of how this works.

When you want to open a file, you choose File → Open to display the Open dialog box. Think of the Open dialog box as a window into your hard drive. The Look In box at the top shows which folder on your hard drive you're looking at. The large box in the middle lists all folders and files that are inside the folder in the Look In box. You can click on the down arrow next to the Look In box to access a list of all the folders on your hard drive. To open a folder on the list, double-click on the folder name, or highlight it, and click Open. To open a file on the list, double-click on the file name, or highlight it, and click Open.

To the right of the Look In box are some icons. You can click on the one that looks like a file folder with an upward-pointing arrow to move up one level in the list. On the left side of the Open dialog box are icons for My Documents, My Recent Documents, Desktop, and My Computer. These are shortcuts that take you to the main folders on your computer.

The Open dialog box.

Entering Text

To enter text, type just as you would if you were using a typewriter. To capitalize, hold down the Shift key while typing the letter. When you get to the end of a line, Word automatically wraps your words down to the next line. To start a new paragraph, press Enter (on a Windows computer) or Return (on a Mac) and then type some more.

Inserting or Replacing Text

One of the greatest advantages of using a computer instead of a typewriter is the ability to easily insert, replace, and delete text. You can insert text in the middle of a line or paragraph when you are in Insert mode. Most computers are automatically set to Insert mode, but if you're ever using your computer and start to overwrite text, it probably just means you've somehow switched your computer to Overtype mode. Don't worry, it's easy to get back. To change from one mode to the other, just press the Insert key on your keyboard once and then go back to typing as usual.

Selecting Text

Before you can change text, you must select it. To select text, click your cursor and then drag it across the words you want to change. The selected text will be highlighted. Whatever command you choose now will affect only the selected text. For example, if you select some words and click the Bold icon, the selected words will get darker (bold).

Copying and Pasting Text

In Microsoft Word, you can select text in one area of the document and save that text so you can put a copy of it somewhere else. When you copy text, it is stored in a special location called the Clipboard. To copy text, first select it. Then choose Edit → Copy. Move your cursor to where you want to put the copied text. Click to insert your cursor and choose Edit → Paste. Everything you selected should now appear in the new spot.

You can copy and paste text from one document into another or even from program into another if you feel adventurous. For example, you can highlight text on a Web site, copy it, and then paste that text into a Word document. You can also copy and paste graphics or clip art.

Saving a File

When you save a file you make a copy of it on your hard drive. To save a document, choose File → Save. The Save dialog box will open and show a folder on your hard drive. A good place to save files is in the My Documents folder, so be sure that's the folder you see in the Save In box or use the pull-down list to change to a different folder. Then type a file name in the File Name box (some versions of Word automatically insert the first few words of the file as a suggested name). Be sure to choose a name that you will remember so you can find it later, such as "Mustafa Family 2005 Calendar." Then click Save.

You can also use the Save As option to save a copy of a document (a good trick for creating backups before you make changes). Choose File → Save As and in the Save As dialog make sure to give the file a new name. When you use this option, your original document is saved and a new document is created with your new name. Then you can make changes to the new file without affecting your original file.

The Undo Command

The Undo command is one of the most useful commands in Word! If you do something and then change your mind, you can choose Undo from the Edit menu. The Undo command is versatile: It changes to say Undo Paste or Undo Typing or whatever to show you exactly what it will undo. You can even undo multiple steps by selecting Undo over and over again. To use this command, choose File → Undo. You can repeat this step as many times as you like to retrace your steps. If you change your mind again, you can even "redo" by choosing File → Redo.

You'll probably want to use a combination of snail mail and the Internet to insure that your photos and memory projects reach your friends and families the way they prefer. Here are a few ways you can share the love with your family and some tips for how best to prepare your files and photos for the journey.

Printing on a Home Printer

For less than $100 you can buy a great color printer capable of printing all of the projects featured in this book. The price goes up as the print quality increases. Also, make sure you compare the cost of ink cartridges when you're shopping around.

Printers come with detailed instructions for installation, and although I can't include all the possible instructions in this book, I can tell you that once you have a printer connected, printing is an easy process.

When you're ready to print a document in Word, Photoshop Elements, or almost any other program you might use, simply choose File → Print. In the Print dialog box that opens, specify the number of copies you want and which pages you want to print. Choose File → Page Setup to adjust settings for paper size and orientation. You can also usually print by clicking the Print icon on the Standard toolbar.

✳ ✳ ✳ ✳ ✳ ✳ ✳ ✳ ✳ ✳ ✳ ✳ ✳

Send or Print the Best Version

The most important thing to consider as you prepare your projects for print or display on the Internet is the format. The basic concept is this: If you're going to print a picture, you want the highest possible resolution so the print looks good. If you're going to e-mail a picture or post it on the Internet, you want the smallest file size so it downloads quickly. In Chapter 3, you'll find a detailed explanation of image formats and how to convert images to higher and lower resolution.

Using a Printing Service

If you don't have a printer, or you want a very high-quality print, or you want to print something special, like a T-shirt or coffee cup, consider taking your digital images to a copy center or professional printer. You can even send images and complete projects to professional printers over the Internet. To find printing companies, search Google (or any other search engine) for services in your area or printers that accept files over the Internet.

Once you choose the service you want to use, make sure you study the submission guidelines that describe the best resolution, sizing, etc., for the image or project you are printing. To submit your images, you'll need to e-mail them, upload them through the printer's Web site, or save them to a CD that you bring to the printer.

Sending E-mail Attachments

If all you're sending in an e-mail is text, your words will usually arrive as you intended. But as soon as you start adding images and any of the fancy formatting options used in the projects in this book, not everyone on your e-mail list may be able to view your memories the way you designed them. A scrapbook page that looks perfect on your PC may end up all askew when viewed on your mother's Macintosh. Here are a few suggestions to help you avoid problems that can happen when you send attachments.

First, find out which programs your friends and family have on their computers. If you send a document created in Photoshop and Aunt Mary Ellen doesn't have Photoshop, she may not be able to open it. However, she may be able to view a Microsoft Word document just fine.

Image file formats are especially important. If you're e-mailing an image, you want to first optimize it, a process (covered in Chapter 3) that involves converting your image and reducing the file size so that it downloads faster.

One of the most universally accepted formats these days is the Portable Document Format (PDF). You can convert pages from Word, Quark, Photoshop, and other programs into PDFs using Adobe's online tools or the Adobe Acrobat program. PDFs can be viewed in most recent versions of browsers or you can download a viewer for free at www.adobe.com.

If your friends and family have slow connections to the Internet, you'll save them some trouble if you post the photos to a Web page. You can do this most easily using one of the online photo album services described in Chapter 5.

When you send an image with an e-mail message you have the option of attaching it, as you will learn in the steps below, or inserting the image so that it will appear in the body of the message. You'll find instructions for inserting an image into an e-mail message at the beginning of Chapter 6.

Most e-mail programs handle attachments the same way: You "attach" a document, like an image file, to an e-mail message, and when you send it, a copy of the file goes along for the ride. In this example, I've used Microsoft Outlook, but with minor adjustments these general instructions should apply to any e-mail program you use.

1. Launch your e-mail program and create a new message as you usually would. Fill in the address and subject line.

Click on the Insert or Attach Files button on your e-mail program. This option differs from program to program, but you should find a button or pull-down menu at the top of the e-mail screen.

2. Browse through your hard drive for the image or file you want to send. (Choose View → Preview→ Thumbnails to see previews of your images.)

After you have attached your file, the name will appear in the attachments field, usually just under the subject line of your e-mail message. Include at least a brief message to explain what the attachment is and click the Send button. (Remember that an e-mail with an attachment can take longer to send, so be patient.)

Sharing Files Between Macs and PCs

If you're sending files from a Macintosh computer to a Windows PCs, it is a good idea to add a file extension to the end of the file name before you send it. File extensions are usually three or four characters and represent the format of the file. For example, GIF image files use the extension '.gif' while MS Word files use '.doc'.

Problems arise because PCs need file extensions to identify file types and Macs don't. If you create a document on a PC, the extension is automatically added. Mac OS X computers give you the option to add the extension when you save a file, but older systems do not. Adding ".gif" or ".doc" to a file on your Mac won't change anything there, but on a PC those few letters may be all it takes to identify the program needed to open the file.

Creating CDs and DVDs

You can share photos and anything else that can display on a computer or TV screen by burning them to a CD or DVD. You can save hundreds of pages to one CD, and even more to a DVD. Once you have your photos and projects on these little plastic discs, you can carry them to the homes of family and friends where you can "play" them on a computer or DVD player. Blank, writable CDs and DVDs are available at any office supply or computer store.

Think of "burning" a CD as similar to saving a file to a disk or printing a page—it's really that easy. There are a variety of programs available for creating and copying DVDs and CDs, but most new computers have these features built in. If your computer does not have a CD or DVD burner, you can buy one

separately and plug it into your computer. You must have a CD drive that is capable of reading and *writing* CDs. This is usually indicated by the letters CD/RW (meaning Read Write) or the words CD Writer on the door of the CD drive.

Whether your CD or DVD burner came with your computer, or you bought it separately, the manual that came with it should include instructions for creating CDs. Each system is slightly different and the steps will vary depending on the program, but these instructions for creating a CD in Windows XP should give you the general idea of how it works, even if you're not using Windows.

Before you burn a CD, you need to prepare the files you want to copy. You may want to copy all of your images into one folder or a collection of folders to get them organized before you copy them to a CD.

1. Insert a blank, writable CD into the CD drive on your computer.

Click on the My Computer icon on your desktop or choose Start → My Computer and then open the folder where you stored your files. Click to select the files or folders you want to copy. To select more than one file or folder, press and hold down the Control key while you click the files.

If your images and other files are in the My Pictures folder, you can click Copy to CD or Copy All Items to CD under Picture Tasks and skip to step 3.

2. If Copy to CD is not an option, look under File and Folder Tasks and click Copy This File, Copy This Folder, or Copy the Selected Items.

In the Copy Items dialog box, click the CD recording drive, and then click Copy. In My Computer, double-click to open the CD recording drive. Windows will display a temporary area where the files are held before they are copied to the CD-ROM.

Verify that the files you intend to copy appear under Files Ready to be Written to the CD.

3. Under CD Writing Tasks, click Write These Files to CD. Windows will display the CD Writing Wizard. Follow the instructions in the Wizard.

After you create a CD, it's always a good idea to click the CD icon and open the CD to confirm that your files copied correctly.

Index